The Nikon Creative Lighting System

Mike Hagen is an avid adventurer who combines his passion for the outdoors with excellence in photography. He is a skilled digital photography instructor, location photographer, class leader, and editorial writer.

He started Out There Images (OTI) in 1998 as a way to share his passion for photography with the rest of the world. Mike is well known for his intensity, energy, and enthusiasm. If you participate in a workshop with him, you will be pleasantly surprised by his generosity and infectious enthusiasm for imparting his knowledge to all participants.

Based in Washington State, USA, Mike has traveled extensively throughout the American West as well as the rest of the world. Travel and adventure are his passion, so you'll frequently find him somewhere far away from civilization, camera in hand, having a ball in the outdoors.

Mike Hagen - Author

Mike Hagen has worn many hats in his short lifetime. He graduated from college with a Mechanical Engineering degree and worked in Semiconductor Manufacturing for 10 years. He is currently a small business owner, a freelance writer, and a professional photographer. His passions are traveling, creating, writing, photography, and teaching. He is happily married and the father of two beautiful children.

Mike aspires to live life to the fullest and to help others do the same. His enthusiasm and zest for life are infectious. His devotion to God and family guides everything he does.

Mike can be reached at:
Out There Images, Inc.
PO Box 1966
Gig Harbor, WA 98335
mike@outthereimages.com
www.outthereimages.com

Out There Images, Inc. – "Get Out And Learn!"

The Nikon Creative Lighting System

Mike Hagen

Mike Hagen (www.outthereimages.com)

Editor: Gerhard Rossbach
Production editor: Joan Dixon
Copyeditor: Cynthia Anderson
Proof reader: Sarah Castellanos
Layout and type: Jan Martí, Command Z
Cover design: Helmut Kraus, www.exclam.de
Cover photo: Nikon U.S.A.
Back cover photo: Mike Hagen
Printer: Friesens Corporation, Altona, Canada
Printed in Canada

1st Edition
© Nikonians North America, Inc.
Rocky Nook, Inc.
26 West Mission Street Ste 3
Santa Barbara, CA 93101-2432

Library of Congress Cataloging-in-Publication Data

Hagen, Mike.
 The Nikon creative lighting system : using the SB-600, SB-800, SB-900, and R1C1 flashes /
Mike Hagen. -- 1st ed.
 p. cm.
 ISBN 978-1-933952-41-3 (alk. paper)
 1. Electronic flash photography. 2. Nikon camera. I. Title.
 TR606.H34 2009
 778.7'2--dc22
 2008049332

Distributed by O'Reilly Media
1005 Gravenstein Highway North
Sebastopol, CA 95472

This book is printed on acid-free paper.

Table of Contents

Foreword

It is a great pleasure to present this book, the second publication in the Nikonians Press series. Both volumes are easy-to-read reference books aimed to reinforce what the Nikonians Academy Workshops teaches throughout North America (soon expanding to Europe).

Author, Mike Hagen, is an avid adventurer who combines his passion for the outdoors with excellence in photography. He is a skilled digital photography instructor, location photographer, workshop leader, and editorial writer. He started Out There Images in 1998 as a way to share his passion for photography with others.

Powered by nikonians.org, the worldwide home for Nikon Photographers of all skill levels, the Nikonians Academy was created to extend into a small classroom setting an even more intense sharing, learning, and inspiring experience than is found in the Nikonians community forums.

In early 2005, Mike was appointed Director of the Nikonians Academy and he has been giving such sharing, learning, and inspiring experiences to over 6,000 students since then. All of the students are raving about it, whether taking a class with Mike as well as with other instructors. Mike's skills as an excellent teacher have helped him become very successful in engaging instructors for the Academy who share and live the same academic values.

Mike is well known for his intensity, energy, and enthusiasm. If you have the opportunity to participate in a workshop with him, you will be pleasantly surprised by his patience, generosity, and infectious enthusiasm for imparting his knowledge to all participants. Those same virtues, along with his thorough knowledge of the subject matter, are obvious in the pages of this volume we present.

For many years, the use of flash was confined to the professionals. The taking of flash pictures was a dreaded nightmare and seemed reserved for the few professionals who made their living with it. Efficient handling of a slide rule and measuring tape seemed indispensable. It was not until 1988 when the Nikon flash system took "a quantum leap forward" with the introduction of the SB-24, opening the doors to us common mortals, and even to the occasional snap shooter—with cameras such as the N8008s or F4s—allowing for full fledged, natural looking TTL (Through The Lens) auto flash.

Nikon engineers later surprised us further with i-TTL, where the "i", which was meant for intelligent, became an "i" for incredible. This innovation opened the door for the use of multiple flashes, and the simple slave units were no longer needed. Such capability was not only integrated into the new Speedlights, but it also allowed for several groups of flash units and communication with them through several channels. And so the amazing Creative Lighting System was born.

How it works and how to make the best of it for individual conditions is what this book is all about, made easy by Mike Hagen.

Nikonians is very proud of this joint venture with Rocky Nook, and we work together to present more volumes to the hungry world for knowledge from Nikon users.

We do hope you enjoy it.

Bo Stahlbrandt and J. Ramon Palacios
Founders and Administrators
www.nikonians.org

CLS Background

What Are CLS and iTTL?

In Nikon's terminology, CLS and iTTL both frequently refer to the same thing. The two terms are often used interchangeably, even though they stand for different words.

CLS stands for "Creative Lighting System" and references the entire Nikon wireless flash system. It includes the flashes, cameras, and accessories that all work together in the system.

iTTL stands for "Intelligent Through The Lens". The "i" does not mean intelligent in the sense that the flash system is really thinking, but rather that the system communicates between the flashes and the camera body with wireless flash pulses. These pulses of light (pre-flashes) are used by the camera body to judge brightness, colors, and exposure.

The term "Through The Lens" indicates that the camera body is integral to the operation of the flash system because it meters flash output through the lens. In fact, unless you have an iTTL-compatible camera, you can't shoot in wireless mode with CLS flashes. When you take a photograph, the camera's matrix metering system analyzes light reflected back from the scene by the preflash, and then quickly makes a flash output decision before it opens up the shutter.

iTTL is a relatively new system from Nikon that is better and more configurable than their previous D-TTL system. Nikon CLS wireless communication can control multiple Remote flashes automatically. In order to take full advantage of the Nikon wireless system, you must use a CLS-compatible Commander flash and a CLS-compatible Remote flash. Sometimes the Commander flash is called the "Master", and sometimes the Remote flash is called the "Slave".

Here's the cool part of the Nikon flash system: the iTTL mode works with your camera's standard pop-up flash; with an SB-600, SB-800, SB-900, SU-800, or R1C1 mounted on-camera; or in wireless mode. For example, if you are using your D300's pop-up flash, and it is programmed for TTL (CSM e3), then your D300 is operating in iTTL mode (figure 1.1). This just means that the flash will use pre-flashes to better gauge the final exposure.

Another example is if you have your SB-600, SB-800, or SB-900 flash mounted on the camera and the back of the flash says TTL BL, then you are in iTTL mode (figure 1.2). Again, this just means the flash will fire preflashes to get the final exposure.

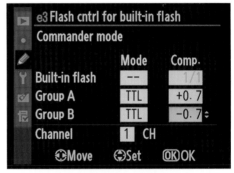

Figure 1.1 - D70 CSM 19 flash mode is set for TTL. This means the pop-up flash is set for TTL, which really means iTTL.

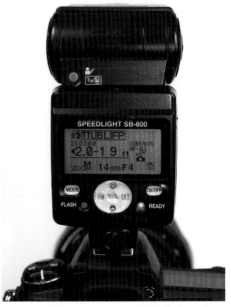

Figure 1.2 - SB-800 is set up in TTL BL flash mode

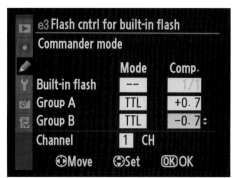

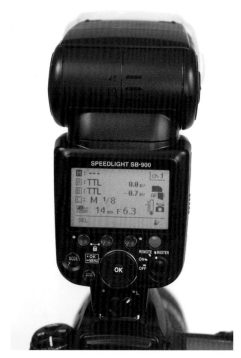

Figure 1.3 - D700 CSM e3 flash mode is set for Commander mode. This means the pop-up flash is a Commander unit, and it is driving the Remote flashes as TTL flashes. The remote flashes are actually operating in iTTL mode.

Figure 1.4 - SB-900 is in wireless Commander mode showing TTL for Group A

Here is one more example: if you are using your system with wireless flashes, and the Commander flash unit says "TTL" for any of the groups, then you are still using the iTTL system since the camera is evaluating the pre-flashes. Figure 1.3 shows what this looks like in a D700. Figure 1.4 shows what this looks like when the SB-900 is configured as a Commander flash unit. Again, the system uses pre-flashes to determine the appropriate exposure.

Whenever you have Nikon strobes set up in wireless mode, the camera uses pre-flashes from all the Remote flashes to determine exposure. Imagine that! The camera can actually judge light output from all the Remote flashes before the shutter opens, and then it can control the flash for the real exposure when it takes the shot. I tell you, this system is amazing!

When you are using an SB-800, SB-900, or SU-800 as an on-camera Commander flash, the system works as described in figure 1.5 and shown in figure 1.6. The Speedlight sends a pre-flash before the camera shutter opens up. The camera reads the pre-flash information and very quickly makes a calculation which it will use during the real flash. When the camera shutter opens to take the photo, the flash fires and gives the correct exposure for the scene (or what we hope is correct!).

Even though this system is fairly smart and does a good job most of the time, it can still be faked out. Chapter 14 will cover some common flash scenarios, such as strong backlighting and bright white subjects, that tend to confuse the iTTL system.

There are a number of different types of Commander flash units available from Nikon. The Commander flash unit can be an SB-800, SB-900, or SU-800 Speedlight. There

are also some Nikon digital SLR cameras with pop-up flashes that can be programmed to operate as Commanders, such as the D70, D70s, D80, D90, D200, D300, and D700.

There are many SLR cameras in the Nikon product line with pop-up flashes that aren't capable of being Commander units, such as the D40, D40x, D50, and D60. The cameras will allow you to use an SB-800, SB-900, or SU-800 as a Commander, but they don't allow you to use the built-in flash as a Commander.

Preflash Sequence

1. Press shutter release
2. Speedlight sends preflash
3. Matrix meter reads reflected light
4. Camera makes new output calculation
5. Shutter opens
6. Speedlight fires "real" flash
7. Shutter closes

Figure 1.5 - The iTTL preflash sequence

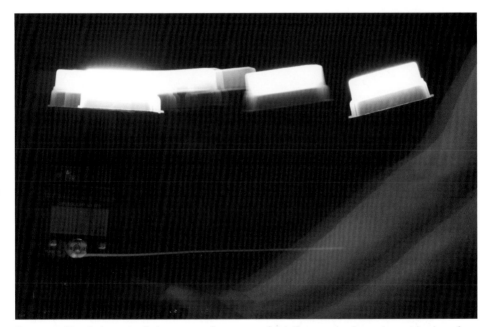

Figure 1.6 - Here is the entire flash sequence from start to finish. You can clearly see the rapid pulses of light from the Commander flash (top row) as it completes its preflash sequence and "real" flash sequence. This photo was taken by opening the shutter on one camera while firing the flashes on a light stand. The Commander is on top and the remote flashes are down below. You can see each flash fire the preflashes, and then the real flash at the end of the process.

What Works with iTTL?

Any of Nikon's newer CLS compatible flashes work with the wireless flash system (table 1.1). Also, newer Nikon film and digital SLRs work with the iTTL system (table 1.2).

CLS Compatible Flashes

Flash	Capabilities
SB-600	Dedicated
	Remote
SB-800	Dedicated
	Commander
	Remote
SB-900	Dedicated
	Commander
	Remote
SU-800	Commander
	Remote
SB-R200	Remote

Table 1.1 - These Nikon flashes are compatible with the Nikon CLS flash system

CLS Compatible Cameras

D40/D40x
D60
D70/D70s
D80/D90
D200/D300/D700
D2H/D2X/D3
F6

Table 1.2 - These Nikon SLR cameras are compatible with the Nikon CLS flash system

What Doesn't Work with iTTL?

Unfortunately, Nikon's previous flash technology does not fully integrate with the newer iTTL flash system. If you have an older Speedlight such as the SB-26 or SB-80, it won't fully integrate with iTTL because it can't "see" the preflashes. Tables 1.3 and 1.4 show which flashes and cameras are not compatible with the Nikon CLS.

Nikon Flashes Not CLS Compatible

SB-24
SB-26
SB-28
SB-50/SB-50DX
SB-80/SB-80DX
SB-400

Table 1.3 - These Nikon flashes are not compatible with the Nikon CLS

Nikon Cameras Not CLS Compatible

D1/D1X/D1H
D100
F4/F5
F100
N80
N90/N90s

Table 1.4 - These Nikon SLR cameras are not compatible with the Nikon CLS

It is important to note the vast majority of Nikon's camera bodies made before 2004 are not CLS compatible. This means the SB-600, SB-800, and SB-900 won't work in wireless mode (or in iTTL mode, for that matter) with cameras such as the D100, N90s, F5, D1, FM-10, or the venerable F3.

There are other digital camera systems that use Nikon bodies but are manufactured by other companies, such as Fuji and Kodak. At the time of this writing, camera systems such as the Fuji S2, Fuji S3, Kodak DCS 14n, etc., do not support CLS. The Fuji S5 camera does support the new iTTL wireless flash system from Nikon since it is fundamentally a Nikon D200 with a Fuji imaging sensor and Fuji software.

Can I Use the SB-600, SB-800, or SB-900 on My Old Camera Body?

If you have an SB-600, SB-800, or SB-900 and want to use it on the older Nikon camera bodies or with the Fuji/Kodak systems, they will work just fine in non-iTTL flash modes such as:

- TTL (i.e., regular TTL)
- Non-TTL Auto Flash (A or AA)
- Manual Flash (M)

I use my SB-600 and SB-800 flashes on older film cameras and they work great! For example, figures 1.7 and 1.8 show an SB-800 mounted on a Nikon FM-10 and a Nikon N80. In both situations, the flash works just fine. On the FM-10 it will work as a Manual or A flash; on the N80 it will work as a Manual, A, AA, or TTL flash.

Figure 1.7 - Nikon FM-10 film camera with the SB-800 used as a Manual (M) mode flash. This flash would also work in A mode.

Figure 1.8 - Nikon N80 film camera with the SB-800 used as an Auto mode flash. This flash would also work in TTL mode and M mode.

What is D-TTL?

Although a thorough discussion of D-TTL is beyond the scope of this book, it makes sense to at least understand what it is ... so we know what it isn't!

D-TTL was Nikon's first successful attempt at automating flash exposures by incorporating focus distance into the exposure calculation. Nikon began integrating computer chips into their lenses that would "talk" to the camera body and tell it at what distance it was focused. These lenses are called D lenses since they encode focus distance as a part of their general operation.

Once the camera body calculates the focusing distance, it can then tell the flash how much power to put out for the subject. This system assumes that the subject is the same distance from the flash and the lens, and produces relatively accurate exposures very quickly.

Before the D-TTL system, photographers had to rely on manual flash exposure calculation or use "Auto Thyristor" types of flashes (i.e., Vivitar 283). D-TTL was a great leap forward and dramatically reduced the time photographers had to spend fiddling with their flashes. It also produced excellent results (figure 1.9).

D-TTL flash systems do not perform the pre-flash function, therefore they are not compatible with iTTL flash systems. What this means is that an older SB26, SB28, or SB50-DX won't work directly with the newer iTTL cameras like the D60, D70, or D300. In other words, the older flashes are not *forward* compatible.

I know I just said that the D-TTL flashes aren't forward compatible with iTTL cameras; however, you *can* use them in Manual mode or A mode on the D40, D50, D60, D70, D80, D90, D200, D300, D700, D2X, D2H, D3, and F6.

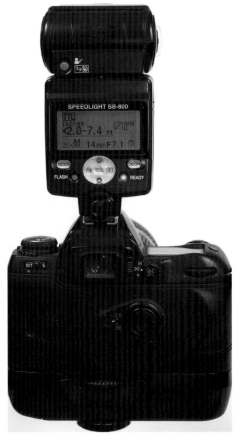

Figure 1.9 - Nikon N80 film camera with SB-800 used as a TTL mode flash. This mode is actually the older D-TTL mode that uses lens focusing distance to help the flash determine proper exposure.

Capabilities of CLS

One of the neatest capabilities of the Nikon CLS is the ability to control multiple flashes without wires attached. This basically means you can set up Remote flashes in the field and then control

them independently from the Commander flash. If one of the flash units is putting out too much light, you can tell it to power down by 0.3 stops or 1.7 stops or whatever (figure 1.10).

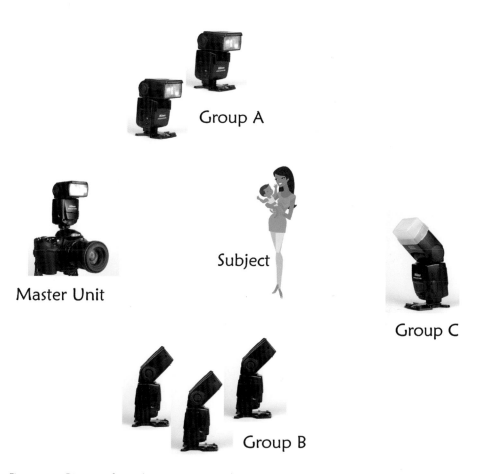

Group A

Master Unit

Subject

Group C

Group B

Figure 1.10 - Diagram of a wireless setup. Each Group can contain one flash or multiple flashes, and they are all controlled by the Commander flash unit mounted on the camera body (or the pop-up flash from a D70/D80/D200/D300/D700).

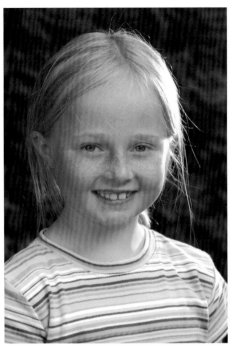

Figure 1.11 - Here is a portrait taken with a similar setup to the diagram in figure 1.10. Three Remote Groups and one Commander unit were required to make this shot. See figure 1.12 for the actual setup.

The system is very flexible and quick, so it allows you as a working photographer to set up shots in a minimal amount of time and get stunning results. For example, it only took a few minutes to set up, shoot, and dismantle the photograph in figure 1.11.

If you use the SB-800, SB-900, or SU-800 as a Commander unit, you can control up to three separate Groups of flashes. For example, you can set up a key (main) light, a fill light for the subject, and a third light for the background (figure 1.12). All three flashes (or Groups of flashes) can be controlled independently.

Each Group can then have multiple flashes in it. For example, Group A can have three Remote units, Group B can have one Remote unit, and Group C can have five Remote units. Each flash within the Group is controlled by the Commander flash. If you program the Commander flash to make Group A brighter by +1 stop, then all the flashes in Group A will put out +1 stop of light.

Beyond the relatively simple control of Remote flashes in TTL mode, you can control Remote flashes in Manual mode as well as in Auto flash mode. Manual mode means that *you* determine the amount of power the flash outputs every time (i.e., 1/16 power). Auto Aperture means the flash will fire and determine its own exposure using its built-in light sensor. The exposure from the Auto flash setting will be independent from the camera's TTL exposure control. These two topics are discussed in more detail in the SB-600 chapter (chapter 4), the SB-800 chapter (chapter 5), and the SB-900 chapter (chapter 6).

Additionally, the CLS allows for stroboscopic flash and group stroboscopic flash. This is a great tool for people who want to take multiple flash exposures for each frame/exposure. This function is discussed in more detail in the SB-800 and SB-900 chapters (chapters 5 and 6).

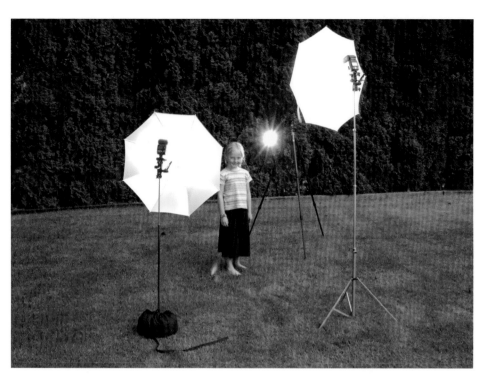

Figure 1.12 - Here is the setup used for the photo in figure 1.11. The flash on the left is a wireless SB-600, on the right is an SB-800, and behind is an additional SB-800. Notice that there are no wires! All of the Remote flashes are controlled by the Commander SB-800 on the D2X camera.

Quick Start Guide

Just Show Me How to Set it Up!

This chapter is for folks who want a quick start guide to using their flashes. Keep reading the book to learn the background and theory, but this chapter will help you get started.

Using Your Flash (SB-600, SB-800, or SB-900) on the Camera

1. Turn off camera and flash
2. Place flash on camera
3. Turn on camera and flash
4. Set camera light meter to Matrix
5. Set camera flash sync mode to Normal or Slow + Rear
6. Push MODE button on flash until you see TTL BL
7. Set power on flash with +/- buttons (i.e., -2/3 or +1.3)
8. Take picture

Using Your Flash (SB-600, SB-800, or SB-900) with a TTL Remote Cord (SC-17, SC-28, or SC-29)

1. Turn off camera and flash
2. Mount TTL cable to flash and camera
3. Turn on camera and flash
4. Set camera light meter to Matrix
5. Set camera flash sync mode to Normal or Slow + Rear
6. Push MODE button on flash until you see TTL BL
7. Set power on flash with +/- buttons (i.e., -0.7 or +1 1/3)
8. Take picture

Using Your SB-600 Flash as a Wireless Remote (Slave)

1. Turn on flash
2. Simultaneously press the ZOOM and - buttons for two seconds
3. Press + button until you see the squiggly arrow box
4. Press MODE button until you see ON
5. Press ON/OFF button
6. Press MODE button to navigate to Channel
7. Press + or - button to change Channel
8. Press MODE button to navigate to Group
9. Press + or - button to change Group
10. Make sure Commander (Master) flash is set to same Channel and Group
11. Take picture

Using Your SB-800 Flash as a Wireless Remote (Slave)

1. Turn on flash
2. Press SEL button for two seconds
3. Press the ZOOM buttons and/or the + and - buttons until you navigate to the squiggly arrow box
4. Press SEL button
5. Press - button until you navigate to REMOTE
6. Press SEL button
7. Press ON/OFF button quickly
8. Press SEL button to navigate to Channel
9. Press + or - button to change Channel
10. Press SEL button to navigate to Group
11. Press + or - button to change Group
12. Make sure Commander (Master) flash is set to same Channel and Group
13. Take picture

Using Your SB-800 Flash as a Wireless Commander (Master)

1. Mount flash on camera
2. Turn on flash and camera
3. Hold SEL button for two seconds
4. Press the ZOOM buttons and/or the + and - buttons until you navigate to the squiggly arrow box
5. Press SEL button
6. Press - button until you navigate to MASTER
7. Press SEL button
8. Press ON/OFF button
9. Press SEL button to navigate to Master, Group A, Group B, Group C, and CH settings
10. Press + and - buttons to change flash output
11. Press MODE button to change Group flash mode
12. Make sure Remote flashes are set to same Channel and Groups
13. Take picture

Using Your SB-900 Flash as a Wireless Remote (Slave)

1. Turn flash power switch to REMOTE
2. Press Function Button 1 to access Group
3. Rotate Selector Dial to set Group
4. Press Function Button 2 to access Channel
5. Rotate Selector Dial to set Channel
6. Make sure Commander (Master) flash is set to same Channel and Group
7. Take picture

Using Your SB-900 Flash as a Wireless Commander (Master)

1. Turn flash power switch to MASTER
2. Press Function Button 1 to navigate to Master, Group A, Group B, and Group C settings
3. Press MODE button to change to TTL, A, M or - - -
4. Press Function Button 2 to navigate to flash output
5. Rotate Selector Dial to change flash output
6. Press the OK button
7. Press Function Button 2 to access Channel
8. Make sure Remote flashes are set to same Channel and Groups
9. Take picture

Using Your SU-800 Flash as a Wireless Commander (Master)

1. Open SU-800 battery chamber and set switch to Commander mode
2. Turn on flash
3. Press SEL button to navigate to Group A, Group B, Group C, and CH settings
4. Press MODE button to change to TTL, A, M or - - -
5. Press left arrow or right arrow to change value of Group or Channel
6. Make sure Remote flashes are set to same Channel and Groups
7. Take picture

Using Your SBR-200 Flash as a Wireless Remote (Slave)

1. Turn on flash
2. Rotate Channel dial to correct channel
3. Rotate Group dial to correct group
4. Make sure Commander (Master) flash is set to same Channel and Group
5. Take picture

Using Your D70 Pop-Up as a Wireless Commander (Master)

1. Turn on camera
2. Press MENU button on back of camera
3. Go to CSM 19
4. Choose Commander mode
5. Choose TTL
6. Pop up the flash by pressing the FLASH button on camera body
7. Set shutter sync to Normal or Slow + Rear
8. Make sure Remote flashes are set to CH 3, Group A
9. Take picture

Using Your D80 Pop-Up as a Wireless Commander (Master)

1. Turn on camera
2. Press MENU button on back of camera
3. Go to CSM 22
4. Choose Commander mode
5. Press Multiselector on the right to navigate between Built-in, Group A, Group B, and Channel
6. Press Multiselector up and down to change values in MODE and COMPENSATION boxes
7. Press the OK button
8. Pop up the flash by pressing the FLASH button on camera body
9. Set shutter sync to Normal or Slow + Rear
10. Make sure Remote flashes are set to same Channel and Groups
11. Take picture

Using Your D200, D300, or D700 as a Wireless Commander (Master)

1. Turn on camera
2. Press MENU button on back of camera
3. Go to CSM e3
4. Choose Commander mode
5. Press Multiselector on the right to navigate between Built-in, Group A, Group B, and Channel
6. Press Multiselector up and down to change values in MODE and COMPENSATION boxes
7. Press the ENTER or OK button
8. Pop up the flash by pressing the FLASH button on camera body
9. Set shutter sync to Normal or Slow + Rear
10. Make sure Remote flashes are set to same Channel and Groups
11. Take picture

Using Your D90 Pop-Up as a Wireless Commander (Master)

1. Turn on camera
2. Press MENU button on back of camera
3. Go to CSM e2
4. Choose Commander mode
5. Press Multiselector to the right to navigate between Built-in, Group A, Group B, and Channel
6. Press Multiselector up and down to change values in MODE and COMPENSATION boxes
7. Press the OK button
8. Pop up the flash by pressing the FLASH button on camera body
9. Set shutter sync to Normal or Slow + Rear
10. Make sure Remote flashes are set to same Channel and Groups
11. Take picture

Using Your D2H, D2Hs, D2X, D2Xs, or D3 as a Wireless Commander (Master)

1. Mount SB-800, SB-900, or SU-800 flash on top of camera
2. Set up the flash as a Commander (instructions above)
3. Take picture

Using Your D40, D40x, D50, or D60 as a Wireless Commander (Master)

1. Mount SB-800, SB-900, or SU-800 flash on top of camera
2. Set up the flash as a Commander (instructions above)
3. Take picture

Flash Theory

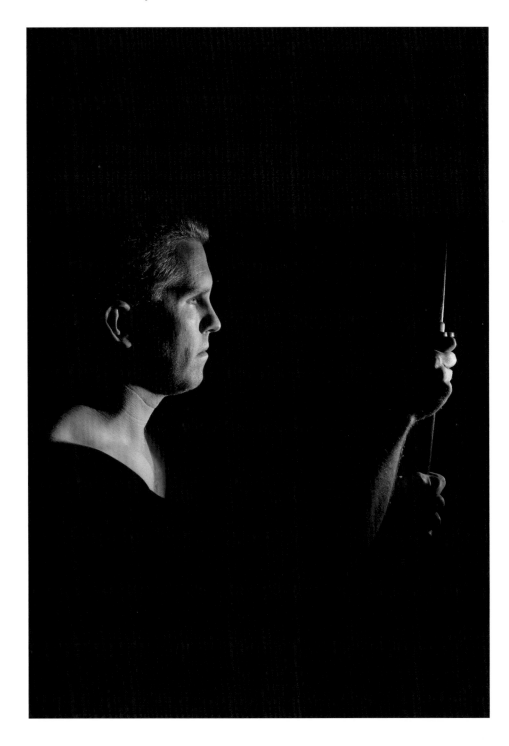

Understanding flash theory can be very beneficial to your photography, even though it can be tedious and difficult to learn. I will publically state that lack of knowledge is almost always to blame for my bad shots. Therefore, I endeavor to learn as much as possible about flash photography so I can solve problems in the field. I encourage you to do the same.

I will go into some limited technical details in this chapter and also give some simple rules of thumb for those who want to skip the math lessons!

Light

As you know, photography is all about capturing light. When you don't use flashes in your exposure, then you simply capture ambient light. In other words, you capture the light already in the scene—the sun, a roomful of fluorescent lights, or even a single candle (figure 3.1).

You control the amount of ambient light that enters your camera by setting the shutter speed and the lens aperture. A longer shutter speed and a bigger aperture let in more light. The combination of the two determine how much ambient light makes it into your final exposure.

When you take a picture that includes flash, you must account for the brightness of the flash as well as the brightness of the ambient light. In effect, you are balancing two exposures: one for the ambient light and one for the flash output. Control the flash output by dialing the power up or down with the flash's + and - buttons (figure 3.2).

Figure 3.1 - Photos like this one are a combination of ambient light (background) and light from the flash (usually the foreground). Shutter speed determines the amount of background light, and flash output sets the foreground light. D2X, SB-800 mounted on SC-17 cord.

Figure 3.2: Frequently, you must work carefully to balance flash output with ambient light. You can do this with the +/- buttons on the flash unit.

How a Flash Fires

When broken down to its simplest elements, the flash consists of the following three systems:
- Batteries
- Capacitor
- Flash Tube

When you turn the flash on, the batteries fill the capacitor with energy (figure 3.3). Think of the capacitor as a water tank. When the capacitor is filled to the top, the batteries stop adding more energy. When you take a photograph, the flash uses energy from the capacitor and sends it to the flash tube (also called the flash head) where it makes a pulse of light. The camera's TTL system controls the amount of power sent to the flash tube, and the matrix meter determines how much power the flash puts into the scene.

Controlling the Power

Fundamentally, there are three methods of controlling flash output:
- TTL and TTL BL (camera controls the power)
- Automatic (flash controls the power)
- Manual (you control the power)

The first method, TTL, uses the camera's light meter to figure out how much energy is dumped from the capacitor and how much is needed to expose the subject at medium brightness (18% gray). In TTL terms, this is called 0.0. Figure 3.4 shows what 0.0 looks like in an exposure.

If you press the +/- buttons on the back of the flash when you are in TTL mode, you can change the amount of energy your flash will output. For example, if you dial in +1.0, then your flash will put out one stop more power than 0.0 (see the next section called "Stops"). Also, note that the SB-600, SB-800,

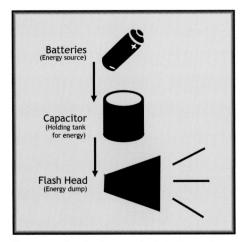

Figure 3.3 - Simple diagram of a flash. Energy from the batteries fills the capacitor. When you take a picture, the capacitor dumps the correct amount of power to the flash tube to provide a good flash exposure.

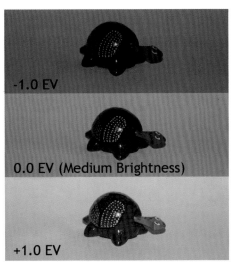

Figure 3.4 - These three images show the results of changing the +/- settings on the flash between -1.0, 0.0, and +1.0. They were taken with a D70 pop-up flash against a white piece of paper. Notice that 0.0 is indeed medium brightness, also known as 18% gray (middle gray).

and SB-900 have two TTL modes: TTL BL and TTL. TTL BL (Automatic Balanced Fill Flash), a newer flash mode for Nikon, works to balance the light between the background and the subject. TTL (without the BL) is similar to Nikon's older flash mode which only puts out enough light for the subject. In other words, regular TTL doesn't try as hard to balance the flash with the background. These modes are discussed in detail in chapters 4, 5, and 6.

The second method of controlling flash power is Automatic Flash mode. Access this mode by pressing the flash's MODE button until you see the icon A or AA. The SB-600 does not have Automatic Flash mode; only the SB-800 and SB-900 have it (figure 3.5).

When you operate in Automatic Flash mode, the camera does not have a say in the final flash exposure because the flash operates independently. In other words, the flash calculates how much light it needs without using the camera's TTL system (figure 3.6).

The SB-900 has two automatic flash modes, Auto and Auto Aperture (figure 3.6), which are covered in detail in chapters 5 and 6. In

Figure 3.5 - Here is the MODE button on the SB-900

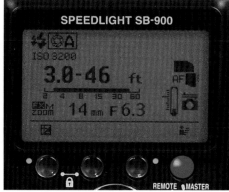

Figure 3.6 - AA mode on the SB-800 (left) and A mode on the SB-900 (right)

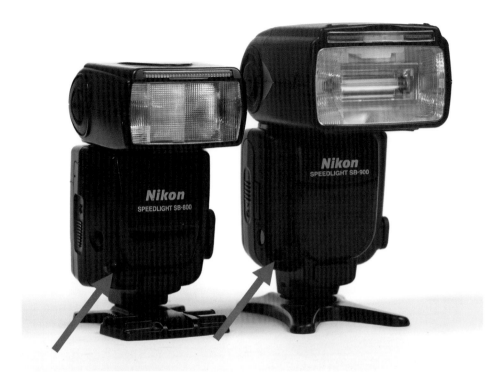

Figure 3.7 - Auto Flash Light Sensor on the SB-800 and SB-900 (arrows)

both modes, the flash uses its own built-in photocell (figure 3.7) to figure out when it has received the appropriate amount of light for the scene (i.e., medium brightness or 18% gray). Once the photocell is happy, it shuts off power from the capacitor and stops the flash output.

Based on this information, you can still vary the flash output from 0.0 by pressing the +/- buttons. The flash will put out more light or less light depending on what you choose.

The third method of controlling flash power is Manual mode. Select it by pressing the MODE button until you see the letter M in the upper left corner. When shooting in Manual mode, you basically tell the flash what fraction of the full capacitor to use by pressing the +/- buttons. For example, if you set the flash to 1/1, it means that the flash will dump 100% of the capacitor for the

shot. Another term for 1/1 is "full power". If you have the flash set to 1/16 (figure 3.8), it will use 1/16 of full power during the photograph.

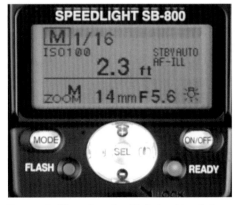

Figure 3.8 - Manual mode with flash set to 1/16 power

Stops

All photographic exposures are set up in terms of stops. When photographers say "open up a stop" or "stop it down a bit", what we really mean is "add more light" or "take away some light". One of the more confusing aspects of flash photography is learning what it means to program +1 or -1.7 into your exposure system.

In photography, one stop equals either double or half the amount of light. For example, if you set the flash to +1.0, you increase its flash output by one stop. Stated another way, you double the amount of light it emits onto the scene. On the other hand, if you set the flash to -2.0, then you cut its output by two stops. In other words, you reduce the amount of light onto the scene to 1/4 (25%).

In general, all automatic camera systems strive to create exposures at medium brightness. For example, if you set your flash at 0.0, then your exposure system works to make the scene medium brightness (like the middle turtle in figure 3.4). However, in most of your flash work, you will frequently want to change flash output in response to scene brightness when using TTL and TTL BL.

For example, if your subject is mostly dark like figure 3.9, then you will probably have to dial down your flash output. For a brighter subject like figure 3.10, you will probably have to dial up your flash output.

Figure 3.9 has mostly dark tones (hat and shirt), while figure 3.10 has mostly light tones (wall, dress, and floor). The camera's TTL system works by looking at the entire scene, not just the face of the person. So when I talk about brightness, I refer to the total scene.

Now, back to stops. While stops are a quick and easy way to change the brightness

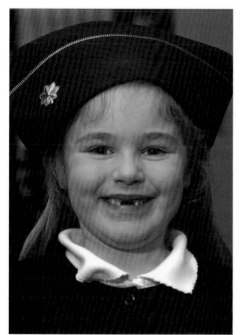

Figure 3.9 - I dialed down the flash power to -0.7 to make sure the TTL system would not expose this scene at medium brightness. D2X, SB-800 on SC-17 cord bounced off ceiling.

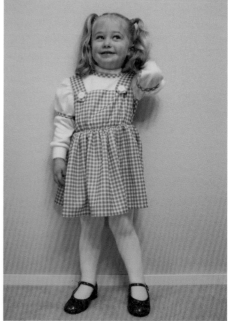

Figure 3.10 - I dialed up the flash power to +0.7 to make sure the TTL system would not expose this scene at medium brightness. D70, SB-600 mounted on camera and bounced off ceiling.

of your exposures, the change is not linear but rather exponential. +1.0 gives you twice the light, +2.0 four times the light, and +3.0 eight times the light.

Always remember that the plus and minus values are based on what the camera's exposure system judges as medium brightness. So if you dial in +1.0, you are telling the exposure system to put out twice as much light from the flash as 0.0. If you dial in -1.0, then you are telling it to put out half the light.

Thirds of a Stop

All Nikon flash units have the ability to change flash power in third-of-a-stop increments. The SB-600 and SB-900 show this by decimal points on the flash's LCD panel (figure 3.11). For example, it will say -0.7. The SB-800 shows the fraction rather than the decimal on the LCD panel (figure 3.12). For example, it will say -2/3. The values -0.7 and -2/3 are exactly the same.

The ability to fine tune exposures to within a third of a stop is very important, especially in digital photography. Since digital capture does not permit a wide exposure range, overexposing or underexposing your shots will result in photos that can't be printed with full tonality.

So try to nail the exposure within -0.5 stops to +0.3 stops. Anything outside of that range, and you will get noise artifacts or highlight clipping when you attempt to adjust the photo later. Even the magic of Photoshop can't fix blown highlights if they were captured that way. Therefore, I encourage you to nail the exposure when you take the photo. Get it right in the camera!

Guide Number

Your flash has a power rating called a Guide Number that describes how powerful it is and how far it will shoot. As with all good things in photography, you can use a mathematical formula to figure out how your camera's aperture should be set. Back in the good old days, we used to do manual flash calculations based on the power of the flash and the distance Aunt Sally was standing from it. Using this calculation, we could

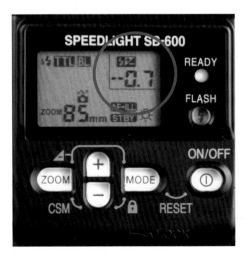

Figure 3.11 - The SB-600 shows thirds of a stop in decimal format

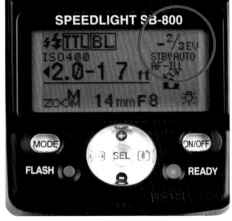

Figure 3.12 - The SB-800 shows thirds of a stop in fraction format

figure out how to set lens aperture with this simple equation:

$$Aperture = \frac{GN}{Distance}$$

To put this equation into practice, you would need to follow these steps:

1. Select your flash's Guide Number
 - SB-600 = 98
 - SB-800 = 125
 - SB-900 = 112
2. Set flash to Manual mode and 1/1 power (full power)
3. Set camera to ISO 100
4. Set camera to Manual Exposure
5. Measure distance from flash to subject

Now use the above equation to set the aperture in your camera for a good exposure.

Here's a typical example using Guide Number calculations. Let's say you are taking a portrait and your model is 10 feet away from the flash. Using the SB-800, you would divide the Guide Number (125) by the distance (10 feet) to get an aperture of about f/12.5. You then set f/12.5 in the camera and take the shot. (This assumes you are shooting at ISO 100.)

Notice there is no mention of shutter speed in the Guide Number calculation. This is because shutter speed controls the brightness of ambient light. We use the Guide Number calculation to help control the *flash exposure*. It bears repeating: shutter speed controls the amount of ambient light, and aperture controls the amount of light from the flash.

Camera Sync Modes

Nikon camera systems typically have five shutter sync modes on the camera body. Officially, they are called "Shutter Synchronization Modes". Unofficially, they are called "kinda confusing".

These five sync modes are:

1. Front Curtain (Normal)
2. Front Curtain + Red-eye (Normal + Red-eye)
3. Slow
4. Slow + Red-eye
5. Slow + Rear

The shutter sync mode determines when the flash fires during the exposure. More specifically, it tells the flash whether to fire at the beginning of the exposure or at the end of the exposure. It also tells the flash whether or not to help reduce red-eye. The beginning of the exposure is defined as the moment when the camera's front curtain first moves entirely out of the way of the CCD. The end of the exposure is defined as the moment when the camera's rear curtain begins to close over the CCD.

Each of these modes is used in different circumstances and is largely independent of the flash mode settings such as TTL BL, TTL, Manual, AA, etc. Shutter sync mode is also independent of the quantity of flashes you use. For example, if you set your camera for Normal Sync, it will behave the same way whether you are using the pop-up flash, an SB-600 mounted on the camera, or 15 flashes in a wireless setup.

To select the modes, press and hold the Flash button on your camera body and then rotate the main command dial on the back of the camera. Figures 3.13 and 3.14 show how

Figure 3.13 - The Flash mode button is generally found on the lefthand side of most Nikon SLRs

to make the selection. When you do this, you will see a flash icon on the camera's LCD panel with a little lightning bolt. Inside the box, you will see different designations such as SLOW, REAR, and a red-eye symbol (figure 3.15).

Let's talk about each of these modes and when to use them.

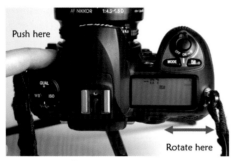

Figure 3.14 - While pressing the Flash mode button with your left finger, rotate the command dial with your right thumb to see the different sync modes

Front Curtain Sync (Normal Sync)

Front Curtain Sync, or Normal Sync, instructs the flash to fire as soon as the front shutter curtain of the camera has been fully raised. This is another way of saying that the flash fires at the beginning of the exposure. You can see what the symbol looks like in figure 3.16.

Using Normal Sync signifies that the camera's shutter speed will probably default to 1/60 second. Most of the newer cameras have a custom setting so you can choose what the default shutter speed will be. For example, on the D300, you can go into the custom menu called Flash Shutter Speed (CSM e2) and choose 1/60 second, 1/15 second, 2 seconds, or whatever you want. This is commonly referred to as your "sync speed".

Remember, the shutter speed in Normal Sync mode is the *minimum* (slowest) speed that the camera will use for its exposures. So if

Icon/Symbol	Sync Mode
	Front Curtain (Normal)
	Front Curtain + Red-eye
SLOW	Slow
SLOW	Slow + Red-eye
SLOW REAR	Slow + Rear

Figure 3.15 - Shutter Sync Modes

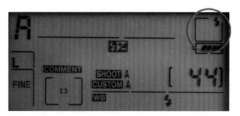

Figure 3.16 - Front Curtain Sync, also referred to as Normal Sync. The icon for this setting is a box with a flash symbol (lightning bolt). Notice that there are no other words or symbols inside the box.

Auto FP High Speed Sync Mode

Most of the higher-end Nikon cameras have a mode called Auto FP High Speed Sync that allows the flash to sync at shutter speeds of up to 1/8000 second. See chapter 13 for more details.

Figure 3.17 - Normal Sync. Two wireless strobes were used for this photograph, and no ambient light was captured. D70, SB-600, SB-800, f/5.6, 1/60 second.

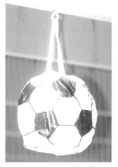

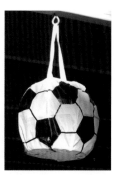

Figure 3.19 - The shot on the left represents what happens when you exceed the camera's maximum shutter sync speed for the flash. In this case, the images were taken with a D70, which has a maximum shutter sync speed of 1/500 second. The soccer ball was a decoration at a birthday party and the sun shone directly on it. The image was taken at f/2.8, and the shutter speed showed "HI". This meant that there was too much ambient light for a 1/500 second shutter speed. The camera still allowed me to take the photo, but you can see that it was dramatically overexposed. The next image was taken at f/14, and the shutter speed was 1/320 second. Now it is a manageable photograph and well exposed to boot! The moral of the story is to watch your shutter speed and make sure that it never goes faster than the camera's maximum sync speed.

Figure 3.18 - This photo was taken in Normal Sync. The camera didn't take the background lighting into account, but it was bright enough for the ambient light to contribute to the photograph. D70, SB-600, f/20, 1/250 second.

your subject is very dark, the flash will be the only light in the final photograph (figure 3.17).

On the other hand, let's say you want to take your photo outside in the middle of the day. In this case, it might be bright enough to require a faster shutter speed than 1/60 second, so your camera's metering system may choose a faster shutter speed. In fact, assuming you are in an auto exposure mode like Aperture Priority, your camera will choose a shutter speed up to its fastest possible sync speed. For example, the D70 sync speed is 1/500 second, the D80 sync speed is 1/250 second, the F6 sync speed is 1/250 second, and the D3 sync speed is 1/250 second. Figure 3.18 shows a good example of this; the photo was taken outdoors in Normal Sync, but the camera chose a faster shutter speed than 1/60 second.

When you choose Normal Sync and an auto exposure mode (e.g., Aperture

Priority), the LCD readout will say "HI" if it wants to use a shutter speed faster than the fastest shutter sync speed (e.g., 1/250 second for a D3). In this scenario, the camera will still allow you to take the shot, but the exposure will be horribly blown out and overexposed. Look at the examples in figure 3.19, and you'll see what I mean!

The Nikon literature says that Normal Sync should be used for "most situations"; however, I disagree. As with most generic camera settings, the standard setting is not the best for everything. My approach is to understand what happens in a specific mode and then apply that knowledge to a specific shooting situation.

So when should you use Normal Sync? I suggest using it when you photograph people or subjects in very dark locations where you don't care about the background, such as

Figure 3.20 - This photo was taken in Normal Sync. Notice the background is very dark since the camera shot the photo at 1/60 second shutter speed. D70, SB-600, bounced off reflector on the left.

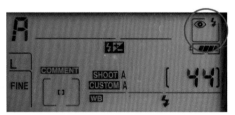

Figure 3.21 - Front Curtain + Red-eye Sync as shown on the D200. This is also referred to as Normal + Red-eye Sync.

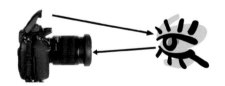

Figure 3.22 - Red-eye is caused when the flash reflects off the rear of your subject's eye and back to the camera. Your camera's pop-up flash causes most red-eye problems. You can eliminate red-eye by shooting with off-camera flash. Thank goodness for wireless flash control!

figure 3.20. In this type of scenario, I set up with a flash bracket and bounce the light off the ceiling, a wall, or a reflector (figure 3.20).

I also use Normal Sync to create a typical studio arrangement with my flashes, like the studio portrait in figure 3.17. Normal Sync typically eliminates the ambient light and allows me to use only the flashes for lighting the scene.

Front Curtain + Red-eye Sync (Normal + Red-eye Sync)

The icon for Red-eye Sync on the camera, shown in figure 3.21, is a box with a lightning bolt and an eyeball inside. Red-eye is usually caused by light from the flash reflecting off the back of your subject's retina (figure 3.22). If your flash is in close alignment with your lens, like a pop-up flash, then many of your flash shots will result in red-eye. Red-eye gets worse when your subject's pupils are very big, e.g., in a dark room or in the shade of a tree.

The Red-eye Reduction mode differs depending on the type of flash you use. If you use the SB-600, SB-800, or SB-900 flashes, then Red-eye Reduction mode results in a series of quick light pulses just before the shutter opens. If you use your camera's pop-up flash, Red-eye Reduction is accomplished by illuminating your camera's Red-eye Reduction Lamp. This lamp is very bright and can be annoying, so I don't recommend using it. Be nice to your subjects and turn off the red-eye lamp (figure 3.23)!

The best way to eliminate red-eye is simply by moving the flash farther away from the camera body. There are a few ways to do this, such as using a TTL cord and a flash bracket or setting up your system in Wireless Remote Mode to completely separate the camera and the flash.

I encourage you to stop using the Red-eye Reduction mode in your camera unless you don't own an accessory flash. Not only is on-camera flash more prone to red-eye, it also rarely produces excellent results. Since

Figure 3.23 - This shot is a good candidate for Red-eye Reduction mode. The subject is in a shadow, and the photo was taken with a pop-up flash.

you aspire to obtain more professional results, do everything you can to get the flash off the camera, and you will never have to worry about red-eye again. Problem solved!

Slow Sync

The Slow Sync icon, shown in figure 3.24, is a box with a lightning bolt and the word SLOW. I like using Slow Sync mode when I want to incorporate ambient light with flash, as in figure 3.25.

The standard Slow mode is a *Front Curtain Sync* mode. This means that the camera fires the flash at the beginning of the exposure and then keeps the shutter open for the ambient light exposure. Perhaps a better name for this mode would be Slow Front.

A great time to use this mode is when the subject is stationary, such as a statue, tree, building, etc. If you aren't careful and the subject is moving, you will get motion blur (figure 3.26). You can use the blur as a

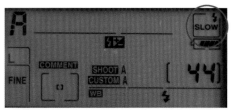

Figure 3.24 - Slow Sync as shown on the camera's LCD panel

Figure 3.25 - Slow Sync balances the subjects in front with the ambient light in the background. D2X, SB-800, f/2.8, 70-200.

creative element, but it takes considerable skill to get the motion blur just right. The blur can quickly become a distraction. For example, if you photograph someone dancing at a wedding and use Slow Sync, then the dancer will probably have some motion blur due to the long exposure. Since this mode is also a Front Curtain Sync mode, the flash fires at the beginning of the exposure. This results in the dancer being frozen in place by the flash at the beginning of the movement. Then, the shutter stays open and the person continues to move. The resulting

Figure 3.26 - This is a Slow Sync photo. The car is moving from right to left, but notice the blur in front of the car. D70, SB-800 Remote, f/2.8, 1/30 second. Compare this to the car shot in figure 3.29.

photograph looks like the person is moving backwards with the motion blur in front of them. This can appear somewhat weird, as shown in figure 3.26.

The neatest thing about Slow Sync mode is the balance between the flash on the subject and the ambient light. It is the classic "fill flash" mode; a great tool that every photographer should master. Remember that since it uses a long shutter speed, the camera will expose for the ambient light which might have a different color than your flash. In that case, use a gel with your flash so the color of the flash matches the color of the ambient light. If you are indoors, then you will probably want to use a tungsten gel or fluorescent gel so that all your colors match (see chapter 11).

Slow + Red-eye Reduction Sync

Use this mode when you photograph people with a pop-up flash to balance the brightness of the flash with the ambient light. I don't

employ this mode in my photography because I don't use on-camera flash for my professional work. Figure 3.27 shows the symbol for Slow + Red-eye.

Since the flash fires at the beginning of the exposure, the Red-eye Reduction works exactly the same as in Normal Sync. However, this mode can be very confusing to your subjects because they see a bunch of flashes and assume the photograph is over. They end up turning their heads or closing their eyes before the camera opens the shutter, and you completely miss the shot. I think you will generally find this sync mode more trouble than it's worth.

Slow + Rear Sync

Slow + Rear Sync is my all-time favorite flash sync mode because it accomplishes so much with one setting. I use this mode for almost all of my travel and outdoor photography when I want to incorporate ambient light with a flash. Figure 3.28 shows the camera icon for this mode. Notice the words SLOW and REAR inside the box.

The principle is exactly the same as Slow Sync except that the flash fires at the end of the exposure rather than at the beginning. First, the front curtain opens and starts exposing the sensor; then, just before the rear curtain begins to shut, the flash fires. The Slow portion of the setting refers to the long exposure required to register the ambient light. The Rear portion of the setting refers to the flash firing before the rear curtain closes.

Figure 3.27 - Slow + Red-eye Reduction Sync as shown on the camera's LCD panel

Figure 3.28 - Slow + Rear Sync as shown on the camera's LCD panel

Figure 3.29 - Slow + Rear puts the motion blur behind the movement, where it should be! This happens because the flash fires at the end of the exposure. Since the car is moving from right to left, you can see the blur behind it. The flash pulse freezes the motion at the end. SB-800 Remote, f/2.8, 1/30 second.

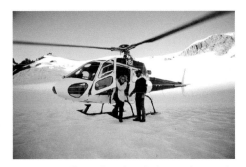

Figure 3.31 - Slow + Rear Sync balances the subjects in front with the ambient light in the background. "Rear" means that the flash fires at the end of the exposure, thereby allowing motion blur to show behind the movement. D2X, SB-800.

Figure 3.30 - Slow + Rear Sync balances the people and helicopter in the foreground with the bright snow in the background. I dialed down the flash power to about -1.7 for this shot.

This mode is excellent when you want to include motion in a shot. Using the dancer example again, the motion blur would appear behind the dancer rather than in front of the dancer. I set my camera to Slow + Rear anytime I expect motion blur in the image, just so the photo looks natural (figure 3.29).

When in Slow + Rear mode, get into the habit of dialing down your flash power so it blends better (is better balanced) with the ambient light. If you shoot the flash at 0.0 power, then most likely your subject will be too bright. Most of my travel photos start out at approximately -1.0 for the flash. Then, if my test shots come out too dark, I readjust to -0.7

or -0.3. If my test shots come out too bright, I readjust to -1.3 or -1.7. Each situation is different, so I'm not afraid to change my flash power to get the look I'm after (figure 3.30).

The Slow + Rear mode can only be accessed when your camera is in Aperture Priority mode (A) or in Program mode (P). The reason for this is the camera can automatically make a "slow" exposure to expose for the ambient light when it is in A or P modes. In A mode, you set the aperture yourself (e.g., f/5.6), and the camera sets the shutter speed automatically. In P mode, the camera is responsible for setting both shutter speed and aperture.

In Manual mode (M), you set the shutter speed yourself so the camera can't adjust it independently to make it "slow". The same holds true for Shutter Priority mode (S). You set the shutter speed, so the camera can't make

a long exposure for the ambient light. It is important to note that if you set Rear Sync when you are in M or S mode, the flash will still fire at the end (rear curtain) of the exposure to get the trailing light effect (figure 3.31).

Often, there is confusion over the word "Slow". In the vernacular, it implies lethargic or long. Many of us assume that when we set the flash sync for Slow + Rear, it automatically results in a long exposure. This assumption is true if the location is dark, as in figure 3.31. On the other hand, what if you take a

My Own Use of Sync Modes

I typically use just two sync modes:
• Normal
• Slow + Rear

Sync Modes for Common Flash Scenarios

Situation	Sync Mode
Dark interior room (wedding reception, living room)	Normal
Landscape where it is desirable to light the foreground with flash	Slow + Rear
Studio photography with flashes, umbrellas, soft boxes, etc.	Normal
Environmental portrait next to a window using fill flash	Slow + Rear
Sports where there is a possibility of motion blur	Slow + Rear
Birthday party where the house lights are very low (dark)	Normal

Table 3.1 summarizes flash settings for a variety of common scenarios

photograph on a bright, sunny day and set your flash sync to Slow + Rear, as in figure 3.30? You will probably notice the shutter speed is "fast", around 1/500 second or even faster. Remember, in Slow mode, the camera chooses a shutter speed for the ambient light exposure and then fires the flash as a fill light at the end of the exposure.

Which Sync Mode Should You Use?

Almost all of my flash photographs are taken in either Normal (Front Curtain) or Slow + Rear. The other modes—Normal + Red-eye, Slow, and Slow + Red-eye—do not provide any benefit for my photography.

Most often, I have a scene that fits one of these two descriptions:
1. I want to incorporate ambient light and flash, so I choose Slow + Rear.
2. I don't want to use any ambient light (or there isn't any), so I choose Normal.

Many photographers have uses for the other sync modes, but in my photography, I choose to use just two. Life is easier when you simplify.

Making Good Use of Flash Power

If the world were a perfect place, we would always have enough power from our flashes to get any shot, at any time, in any light. At some point, though, reality sets in and we must face the fact that flashes like the SB-600, SB-800, and SB-900 don't have much power in comparison to large studio strobes. Do keep in mind that Nikon Speedlight flashes have a different purpose in life than full-fledged studio strobes. Speedlights are made so they can hit the road and produce excellent results in a small package. They aren't made to illuminate the interior of a warehouse or the entire flight line at LAX International.

Once you understand the Speedlights' place in photography, then you can

understand how to work within their limitations. There are four simple ways to influence flash power that I like to teach. You will probably use all of them at some point:

1. Distance from subject
2. Flash zoom setting
3. Camera ISO
4. Aperture

Let me go through them one by one and explain how to put them into practice.

Distance from Subject

A fundamental and frustrating property of light is that its intensity falls off very rapidly with distance. For example, have you ever stood just one foot away from a standard 100-watt light bulb? Pretty bright, isn't it? If you read a book next to it, it gives off plenty of light. However, what if you move the light bulb to the other end of your living room? The light hitting your book dramatically drops off. This is because light intensity (brightness) falls off as the inverse square of distance. If we were to state this in an equation, it would look like this (D = distance):

$$\text{Light Intensity} = \frac{1}{D^2}$$

In real life, if you had 100% power right at the flash head and moved two feet away, your subject would receive only 1/4 the original amount of light. How about if you moved three feet away? Now the subject would receive 1/9 the amount. If you moved 10 feet away, then the subject would receive only 1/100 the amount (figure 3.32).

When I take photographs, I always consider how close my flashes are to the subject. In general, the closer your flashes are to the subject, the more control you have over them and the more power you have available. For example, in a wedding environment, your flashes can't be at the other end of the church because they just don't have enough oomph (energy) to light up the altar.

Since Speedlights aren't very powerful, Nikon has a warning system in place to tell you when the flash can't put out enough power for the scene: the blinking READY light. Let's say you are taking photos at an outdoor concert and your flash's READY light is blinking at you. In Nikon's world, those blinks mean the flash is underexposing the shot.

In fact, the flash will actually tell you how far underexposed the shot is by placing a minus sign in the upper right corner of the LCD panel (figure 3.33). You have to be fast to catch it, but it will show something like -0.3 or – 3/4. This means the flash dumped

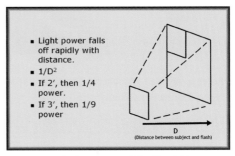

Figure 3.32 - Light intensity falls off quickly as you move the subject away from the flash

Figure 3.33 - If you take a photo and the flash is not able to expose properly, it shows the underexposure amount on the LCD screen. In this example, it underexposed by -0.3 stops.

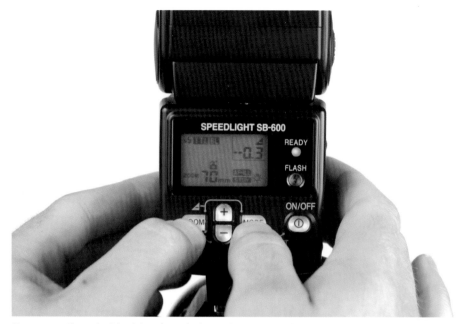

Figure 3.34 - If you don't look fast enough, the underexposure value will disappear. When this happens, you can push the ZOOM + MODE buttons on the SB-600 (shown here), the MODE + SEL buttons on the SB-800, or Function Button 2 on the SB-900.

100% of its energy from the capacitor, but it still wasn't enough to do the job.

One way to fix this problem and get enough light onto the scene is simply to move the flash(es) closer to the subject. Cutting the distance between the flash and the subject in half will result in a four-fold (4x) increase in available power! The inverse square equation shown in figure 3.32 can be a friend or an enemy depending on which way you move your flashes.

If you aren't fast enough to see the underexposed value on the back of the flash, then you can recall the value by pressing these buttons (figure 3.34) on each of the flashes:

- SB-600: ZOOM + MODE (simultaneously)
- SB-800: MODE + SEL (simultaneously)
- SB-900: Function Button 2

Figure 3.35 - When you zoom your lens, the flash head zooms along with it. This ensures that the angle of view from your lens is the same as the angle of coverage from your flash.

Flash Zoom Setting

Another way to get more power out of your flash is to change the zoom setting on the flash head. Think of the light that leaves your flash like a stream of water coming out of a garden hose. When you set the nozzle to mist, it covers a wide area but won't shoot very far. The opposite is true when you set the nozzle to stream; it covers a small area but will shoot quite a distance. You use the stream setting when you want to soak your grumpy neighbor across the street, and you use the mist setting when you want to soak the side of your muddy pickup truck a few feet away.

Your flash has the same ability to focus light so that it covers a small area or a wide area. This is important because as you zoom your lens, your flash also zooms to cover the same angle of view. Most of the time, you leave the flash so it automatically zooms the head along with the lens (figure 3.35). This makes sense because you want everything your lens sees to be covered by the flash.

I use my flash zoom frequently to extend its useful working distance. You already know that when you zoom the lens on your camera, the flash head zooms with it. While you are doing this, though, look at the back of your SB-800 or SB-900 flash and watch the "usable distance" scale change with the zoom setting. You'll notice that when your flash is zoomed to 24 mm, the usable distance may only be 36 feet (figure 3.36). However, when you zoom the flash to 105 mm, it now extends to 66 feet. You've extended the usefulness of the flash by focusing the light into a tighter column.

There are many reasons why you might want to change the zoom setting of the flash so it is different from the focal length of your lens. For example, say you are photographing a speaking engagement where the master of ceremonies is standing at the left side of the stage. You want to get a photograph of her speaking and retain the ambient light in the theater. Your solution is to take the flash head and aim it at the speaker. Then, zoom the flash head so it only covers the master of ceremonies and not the rest of the stage. Voila!

In general, the zoom setting on your flash should match the zoom setting on your lens. The reason is that most of the time, you want full coverage of the scene. If you have a wide angle lens such as a 12 mm, then you are out of the normal zoom range of your flash (which is 24 mm on the wide end) and you will get light fall-off at the corners of the image (figure 3.37). It isn't until the lens and the flash are set for the same focal length that you will get even coverage.

At the other end of the zoom range, sometimes you run out of zoom on your flash. Say, for instance, you have a 400 mm telephoto lens mounted to your camera and you want to use fill flash. In this scenario, the flash only zooms to 85 mm on the SB-600, 105 mm on the SB-800, or 200 mm on the SB-900, so the angle of coverage is bigger than the lens can see. This isn't a big deal, but you are wasting light and the flash sometimes won't focus enough light to effectively illuminate

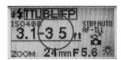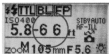

Figure 3.36 - When you zoom your flash head, it changes the usable distance. Notice that at 24 mm zoom, the flash is usable only to 35 feet. When you zoom to 105 mm, the flash is usable to 66 feet.

Figure 3.37 - The left photo shows an angle of flash coverage less than the lens zoom setting. Note the light fall-off in the corners. The right photo shows the angle of coverage equal to the lens zoom setting. Note the even, overall coverage.

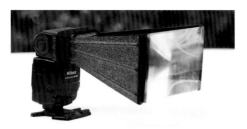

Figure 3.38 - I want to plug a fantastic product for wildlife photographers called the Better Beamer Flash X-Tender (fX-4 model). The X-Tender increases your flash output two to three stops by focusing the light into a tight beam. This product is generally used for wildlife and bird photography (www.photoproshop.com).

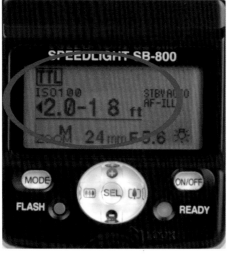

Figure 3.39 - Notice that when you change the ISO on your camera body, the ISO also changes on your flash. Additionally, as you increase your ISO, your effective distance increases. To get more usable distance, increase your ISO.

the subject. To remedy this problem, some companies have created flash extenders that help focus the light beam to enable telephoto photography with flash. See figure 3.38 for an example.

Camera ISO

The third most common way to get more power out of your flash is to change your camera's ISO. If you make the camera more sensitive to light, then your flashes don't have to work as hard to illuminate the subject. If you increase your camera's ISO, your flashes can work from a greater distance (figure 3.39).

How does this work in a real world application? Let's say I'm taking photographs in an area where the ambient light is fairly low and my subject is far away, like a concert or an evening soccer match. If I want to use fill flash, then the Speedlight might not have enough power to reach the action. In this situation, I would bump up the camera's ISO to the sensitivity required to get the shot.

Notice that when you change the ISO on your camera, the SB-800 and SB-900 display the new ISO on their LCDs. Also, as you change ISO, the flashes displays the new usable distance values on their LCDs (figure 3.39). You get the same effect with the SB-600, but it doesn't show the distance value on the LCD.

The usable distance information on the back of the flash helps me determine whether my flashes will work for the scene.

Aperture

The fourth way to influence flash power is to change the lens aperture. In the past, all flash photographers worth their salt spoke strictly in terms of apertures. A photographer would commonly tell her assistant to "brighten it up a stop". What that meant was to make the aperture one stop larger than the current setting. If the photographer shot the first photo at f/8, then the next photo's settings would be shot at f/5.6, which lets in twice as much light.

Alternatively, the smaller your aperture, the less light you allow into your camera (figure 3.40). For example, assuming that your flash puts out a constant amount of power, then changing your camera's aperture from f/5.6 to f/8 will darken the photo by one stop.

In the real world, it is imperative to understand the relationship between aperture and the amount of light, especially if your flash photos tend to look too dark. If you are struggling to light a scene and your flashes aren't putting out enough power, then choose a larger aperture like f/4 or f/2.8 rather than f/16 or f/13. Many people incorrectly try to make their shutter speeds longer, hoping their flash shots will get brighter. While this allows more ambient light into the photograph, it doesn't do anything to let more light from the flash into the photograph. It bears repeating: in flash photography, aperture affects light from the flash and shutter speed affects ambient light.

So there you have it, four ways to influence flash power: distance, zoom, ISO, and aperture. I use all of these methods extensively in the field, and I encourage you to practice them as well.

Effects of Aperture & Shutter Speed

- Aperture affects light from the flash
- Shutter speed affects ambient light

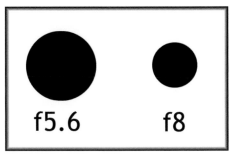

Figure 3.40 - f/5.6 lets in twice as much light as f/8 because the aperture is exactly twice as large. Shooting at f/8 takes twice as much flash power as shooting at f/5.6.

SB-600 Buttons, Modes, Menus, and Operation

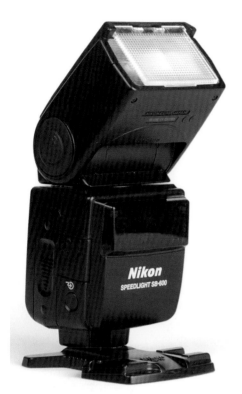

Figure 4.1 - The SB-600 is a very capable Dedicated flash or wireless Remote flash

The SB-600 flash can be used in two basic ways with your Nikon CLS compatible camera. First, it can be used as a Dedicated TTL flash, connected to the camera's hot shoe like any other flash unit. Second, it can be used as a Remote (Slave) flash which is controlled by a Commander (Master) flash like the SB-800, SB-900, or SU-900.

The SB-600 is a very capable flash in and of itself. In fact, if you are only going to buy one flash unit, I would suggest the SB-600. It can be purchased at a much lower cost than the SB-800 or SB-900 and will do almost everything for a "one flash photographer". It has a respectable guide number of 98 and a flash recycle time of about 3.5 seconds from a full power discharge.

SB-600 Buttons and Controls

Flash Head

To point the SB-600's flash head in different directions, press the Tilt button (figure 4.2) with your finger and rotate the head. The flash head will rotate 270 degrees side-to-side and 90 degrees vertically. You need to press the button to begin movement, but you don't need to keep pressing it to continue.

If you look closely at the back of the flash head, you will notice that it has angle scales. However, they are not really useful unless you are telling someone else how to set up your flash.

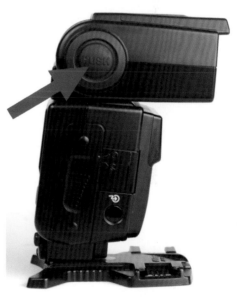

Figure 4.2 - Push the Tilt button to rotate or tilt the flash head

Wide Angle Adapter

If your lens has a wider angle than 24 mm, then it makes good sense to pull out the Wide Angle Adapter to improve your flash coverage (figures 4.3 and 4.4). Notice that when you deploy it, the flash automatically zooms to 17 mm. This means the Wide Angle Adapter allows an angle of coverage the same as a 17 mm lens. You can also use this adapter as a diffusion panel for close-ups to take some harshness away from the flash.

Auxiliary Ready Light

There are two LEDs that blink when the SB-600 is configured as a wireless Remote flash unit (figure 4.5). These two lights tell you that the flash is listening and waiting for a signal from the Commander flash. That is their only purpose. Note: the SB-800 does not have these lights when it is configured as a Remote flash unit, but the SB-900 does.

Figure 4.3 - Here the Wide Angle Adapter is pulled out from the top of the flash head

Figure 4.5 - These two LEDs blink when the SB-600 is configured as a wireless Remote flash

Figure 4.4 - This is what the Wide Angle Adapter looks like when fully deployed. It is very useful when you use a lens wider than 24 mm.

Wide Area AF Assist Illuminator

This is a fantastic feature. It activates automatically in dark rooms to assist your camera's autofocus sensors. This feature overrides the camera body's AF Assist Illuminator (found on the D50, D200, D700, etc.) (figure 4.6).

The Wide Area AF Assist pattern also activates when the flash is used with a TTL extension cord such as the SC-17, SC-28, or SC-29 (figure 4.7).

Figure 4.6 - The Wide Area AF Assist pattern is generated behind the red window in the front of the flash

Figure 4.7 - This is what the pattern looks like against a wall in a dark room

IMPORTANT!

You must set up the following things properly in your camera for the Wide Angle AF Assist Illuminator to work:

1. Turn on the autofocus (the switch on the camera body down by the lens mount)
2. Set your camera to AF-S (not AF-C)
3. Position the autofocus sensor so it can "see" the flash's red pattern–for example, in the center position of your camera's viewfinder
4. Make sure the ambient light is dark enough for the camera to activate the red pattern
5. Turn on your flash and your camera
6. Turn on your flash's Custom Settings Menus for AF-ILL

Once these conditions are met, the Wide Angle AF Assist Illuminator will work from the flash head.

Light Sensor Window

This is where all wireless communication takes place between the SB-600 and the Commander unit. When you have the flash configured as a Remote, be sure to point this window towards the Commander flash (figure 4.8).

Figure 4.8 - The Light Sensor Window for wireless TTL flash control is located beside the battery chamber. Point this sensor towards the Commander flash.

The window works best when it is in the shade or in a dark room not affected by bright ambient light. I've had some problems making the system work in direct sun and assume the reason is that Remote flashes have a hard time distinguishing between flash pulses and direct sun.

Many times I have an assistant point the remote flash at the subject for extra fill. In this situation, make sure the assistant's thumb doesn't cover the window (figures 4.9 and 4.10). Unfortunately, Nikon placed it at the perfect location for a thumb grip!

Battery Chamber Lid

The Battery Chamber Lid on the SB-600 is not designed to be removed like the SB-800 lid. Its operation is very simple: slide the cover down to the "unlocked" position and then open the chamber (figure 4.11).

I find that over time the battery contacts can corrode (figure 4.12), causing a poor connection between the batteries and the flash. To remedy the problem, I clean them with a pencil eraser or lightly scrape them with a pocket knife. Also, the tabs deep inside the battery chamber can form light corrosion, so I clean those off as well.

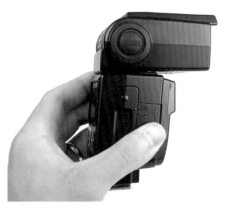

Figure 4.9 - When the SB-600 is set up as a Remote, don't cover the Light Sensor Window with your thumb

Figure 4.11 - Open the Battery Chamber Lid by sliding the cover down

Figure 4.10 - This is the correct way to hand hold the flash in Remote mode, with the Light Sensor Window fully visible

Figure 4.12 - Clean these metal contacts periodically to prevent corrosion

ON/OFF Button

The ON/OFF button is, of course, used to turn the flash on and off, but it also serves several additional functions:

- To bring the flash out of Standby mode, push the ON/OFF button, and the flash will wake up
- To exit from Custom Settings Menus, push the ON/OFF button to return to the regular screen
- To perform a system reset, push the MODE and ON/OFF buttons together for two seconds, and you will reset the flash (including the custom settings) to the factory default settings

Be sure to turn the flash off before you attach or remove it from the camera body. This prevents any short circuits as well as preventing the flash from firing. If you forget to turn the flash off before putting it back into the camera case, it automatically goes into standby mode and stops consuming battery power (figure 4.13).

MODE Button

Like most of the controls on the SB-600, this button performs a number of functions depending on how the flash is configured. When the flash is set up as a Dedicated flash (i.e., not as a Remote flash), the MODE button switches between three flash modes: TTL BL, TTL, and M. All of these modes are covered in detail below.

Notice that when the flash is not attached to the camera (or when the camera is turned off), you can only choose TTL or M. When the flash is attached to the camera, you can also choose TTL BL (figures 4.14 and 4.15).

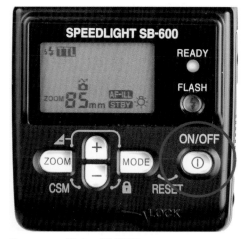

Figure 4.13 - SB-600 ON/OFF button

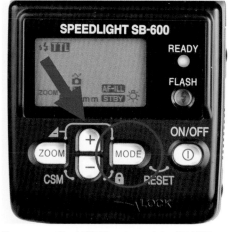

Figure 4.14 - The MODE button and the ON/OFF button are linked by a white line and the word RESET

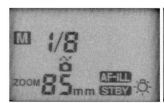

Figure 4.15 - SB-600 flash modes: M, TTL, and TTL BL

TTL BL Mode

If your camera is a newer Nikon SLR such as the D40, D50, D60, D70, D80, D90, D200, D300, D700, D2, D3, F6, etc., then it will operate your flashes using TTL BL mode (figure 4.16). TTL stands for "Through The Lens" metering and BL stands for "Balanced" fill flash.

Nikon refers to this mode as "Automatic Balanced Fill Flash". Its goal is to balance the ambient light (background) with the subject (foreground). I use TTL BL for the vast majority of my photography.

In TTL BL mode, the SB-600 puts out a preflash that is reflected back to the camera's Matrix light metering system. The camera then quickly calculates the correct amount of light for the scene. You can sometimes see this preflash sequence if you pay close attention when the flash fires.

The preflash delay is definitely visible on slower cameras like the Nikon D70, but very short (almost imperceptible) on fast systems like the D3. Unfortunately, on the slower cameras like the D50 and D70, the preflashes can cause people to close their eyes during the shot. Sometimes, the only way to get around this is to tell your subjects to try to keep their eyes open until the sequence is finished. Obviously, this is easier said than done.

Another way to get around the preflash is to turn your flash to Manual mode. You can use a function called FV Lock. See chapter 13 for more information on how to cure this problem using FV Lock.

TTL Mode

This mode is often called Standard TTL. Its purpose is to expose only for the subject, not for the background light. TTL mode goes back a long way in Nikon camera systems and is truly the legacy mode. It does a good job, but I have found that TTL BL seems more accurate and consistent (figure 4.17).

The best places to use TTL mode are situations where you only want the subject exposed, such as:

- Weddings and other events in dark reception halls
- Parties in dark living rooms
- Macro photography where the surrounding environment is a nonissue

M Mode

In M or Manual mode (figure 4.18), you are responsible for determining flash output. To do this, you have three options:

- Trial and error
- Guide Number calculation
- Hand-held light meter

Figure 4.17 - SB-600 in TTL mode

Figure 4.16 - SB-600 in TTL BL mode

Figure 4.18 - SB-600 in M mode

The first method of determining flash power is trial and error. Simply take a picture and review the results on your camera's histogram and/or highlights screen. If it looks too bright, then dial the flash power down. If it looks too dark, then increase the power.

The second method is to use a Guide Number calculation, which is contingent on knowing the flash's guide number. Although we know that the SB-600 has a guide number of 98, it gets more complicated when you zoom the flash head or choose different ISO values. For example, if you zoom the flash head to 24 mm, then the Guide Number is 85. If you zoom the flash head to 85 mm, then the Guide Number is 131. Table 4.1 provides a quick summary of SB-600 Guide Number values depending on different power and zoom settings.

Once you know what the Guide Number is, you can run a calculation based on the following Guide Number formula to set the aperture for your camera:

Guide Number (GN) = Shooting Distance (in feet) x Aperture ÷ ISO Sensitivity Factor

The formula doesn't mean much to most people, but we can change it around to solve that problem. The formula now looks like this:

$$\text{Aperture} = \frac{GN}{\text{Distance}}$$

Let's assume you know your subject is 10 feet away and your Guide Number is 70 (table 4.1). According to this calculation, set your lens aperture to f/7.0 and take the photograph. Easy! But honestly, this is an old way to calculate flash power, and it isn't a very fast way to do flash photography.

The third and best choice for determining flash power in Manual mode is to use a handheld flash meter such as the Sekonic L-358. Here is the process for using it:

1. Set the flash power to a specific output value, such as ¼ power
2. Set your camera and flash meter to the same ISO value

SB-600 Guide Numbers at ISO 100 (Calculated Using Feet)

Flash Output Level	Flash Head Zoom Position (mm)						
	14	24	28	35	50	70	85
1/1	46	85	92	98	118	125	131
1/2	33	60	65	70	84	88	93
1/4	23	43	46	49	59	62	66
1/8	16	30	33	35	42	44	46
1/16	12	21	23	25	30	31	33
1/32	8	15	16	17	21	22	23
1/64	6	11	12	13	15	16	16

Table 4.1

3. Place the meter in front of your subject with the dome pointed towards the camera lens
4. Fire the flash in Manual mode
5. Read the flash meter values, such as shutter speed and aperture
6. Set those values into your camera (e.g., f/8 at 1/60 second)

Using a hand-held light meter is truly the best and most accurate way to calculate Manual flash exposure. This is how most studio photographers set up their flash exposures. But you may ask, "If it's so good, then why does Nikon create all those other flash modes?" The answer is because this method is s-l-o-w and takes patience. It is impossible to capture candid shots if you always have to stop and take a flash meter reading. Nikon keeps innovating new and exciting flash modes like TTL BL to help us capture serendipitous scenes that would otherwise be lost.

Other Uses of the MODE Button

The next function of the MODE button is to lock all the buttons (figure 4.19). If you press the MODE and the - buttons together for one second, you lock out control from the other buttons. This function prevents you or someone else from inadvertently changing the flash settings. I sometimes lock the buttons when photographing an event in order to prevent people from changing my settings. You'd be surprised at what an errant button push can do to your photography! Note that you can still turn the flash on or off when the buttons are locked. To unlock the buttons, push the MODE and - buttons together again for about one second.

Another function of the MODE button is to show the amount of underexposure in your last photograph (figure 4.20). For example, if the flash's READY light is blinking, that tells you the last shot was underexposed. This situation is most common when you photograph something far away from the camera or when you use a small aperture (e.g., f/22).

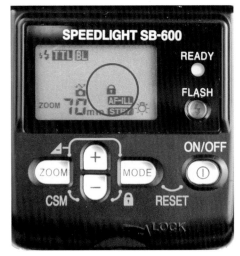

Figure 4.19 - Use the MODE and - buttons to lock the flash. Notice the lock symbol on the flash's LCD panel.

Figure 4.20 - Press the MODE and ZOOM buttons to recall the amount of underexposure

If you see the READY light blinking after you take the shot, you can display the under-exposed value on the LCD panel by simul-taneously pressing the MODE and ZOOM buttons (figure 4.20). To fix the underexpo-sure, choose a larger aperture, move closer to your subject, increase the ISO, or increase your flash's zoom.

Finally, the MODE button is used to select settings in the Custom Settings Menus. For

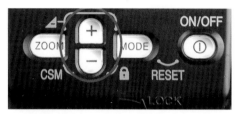

Figure 4.21 - The +/- buttons (Flash Compensation buttons) are mainly used to change flash power output

example, press the MODE button to activate wireless flash or turn off the Standby func-tion. The Custom Settings Menus are covered later in this chapter.

+/- Buttons

The +/- buttons, or Flash Compensation but-tons, are generally used to control the output, or power, of the flash (figure 4.21). Depend-ing on what mode the flash is in, the output is shown in terms of stops or fractions.

In TTL mode or TTL BL mode, the +/- buttons control flash output compensation in stops. They are independent from the Exposure Compensation button found on top of your camera body (figure 4.22).

The default setting for the flash is 0.0. This means the flash will put out enough light to capture the scene at medium brightness. Stated another way, if your flash is set up for

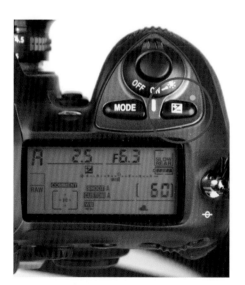
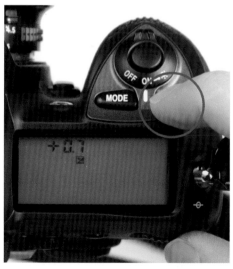

Figure 4.22 - The Exposure Compensation button on your camera is different from the Flash Compensa-tion buttons (figure 4.21). Exposure Compensation changes the amount of ambient light in the exposure.

Figure 4.23 - The Flash Compensation button on your camera will change flash output for the pop-up flash or the SB-600

0.0, then it will expose the subject as bright as an 18% gray card (figure 4.23).

If you press the + button four times in TTL mode, the flash will display +1.3 on the LCD readout (figure 4.24). The +1.3 symbol will blink for a few seconds and then stop blinking to indicate the new setting. When you take a picture with +1.3, the exposure will be brighter by 1.3 stops than the same photo with 0.0.

On the other hand, if you press the - button, you decrease the amount of flash compensation. For example, a value of -1.7 will reduce flash output by 1.7 stops from 0.0. Stated another way, the flash will put out -1.7 stops from what would be required to illuminate your subject at 18% gray.

When you set the flash mode to Manual, the +/- buttons still control flash output but the readout changes to fractions (figure 4.25). Remember that in TTL and TTL BL modes, the camera automatically controls the flash output to what it thinks is correct. However, in Manual mode, you are the brains behind the output. You must figure out how much light to add to the scene by using a Guide Number calculation, light meter, or trial and error.

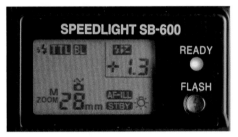

Figure 4.24 - In TTL mode, the power output is displayed in terms of stops. For example, +1.3 means 1.3 stops more light than medium brightness.

Figure 4.25 - In Manual mode, the power output is shown in terms of fractions. This example represents 1/8 of full power.

Zoom Button

One of the great features of modern flashes is their ability to focus the beam of light from the flash head. This is a good thing because you generally want the entire scene to be evenly lit by the flash. As you zoom the lens to a wider angle, the flash must illuminate a larger area. So, at the same time the lens zooms, the flash head must also zoom.

On Nikon camera systems, the lens sends zoom information to the camera body, which then forwards it to the flash. Say, for example, you set your lens to 24 mm; then your flash will also zoom to 24 mm to provide the same angle of coverage. This is called Auto Zoom on the flash. You can override the Auto Zoom function and zoom manually by pressing the ZOOM button. When you do this, you will see M ZOOM displayed on the flash's LCD (figure 4.26).

Figure 4.26 - When you press the ZOOM button, you override the Auto Zoom function and go into manual, or M ZOOM mode

Figure 4.27 - The Wide Angle Adapter is extended, so the flash automatically defaults to the 14 mm zoom setting

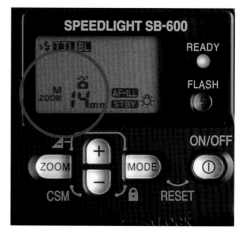

Figure 4.28 - When the Wide Angle Adapter is extended, the flash head defaults to the 14 mm zoom setting and M ZOOM shows on the LCD

SB-600 Two-Button Controls

Press These Two Buttons Together	Function Name	What it Does
ZOOM and MODE	Underexposed Value	Recalls the last underexposed value when the flash sounded eight beeps in a row. If it shows -1.3, increase the ISO by 1.3 stops or open the aperture by 1.3 stops.
MODE and -	Button Lock	Locks the buttons so you (or your assistant) won't mistakenly change the settings during a photo shoot. You must unlock the buttons before making changes to power, zoom, mode, etc.
ZOOM and -	CSM Access	Takes you in and out of the Custom Settings Menus.
MODE and ON/OFF	Flash Reset	Resets all flash settings, including the custom settings, back to their default values. Handy if you forget how to get out of Wireless Remote mode.

Table 4.2 - SB-600 Two-Button Controls

Two-Button Controls

You can access four different settings from the back of the flash by pressing two buttons together. Figure 4.29 shows the SB-600 button panel. Table 4.2 shows the button combinations and what they do.

FLASH Button

For years, people have pressed the FLASH button to make sure a flash will fire properly. However, in TTL BL or TTL mode, it serves no purpose other than to confirm the flash is on and ready to fire. Also, in TTL BL mode, pressing the FLASH button will cause the flash to put out about 1/16 power.

The real use of this button is in Manual mode (figure 4.30). In this case, the flash will put out exactly the amount of power you program into it. If you use a flash meter in a traditional studio environment, you can take a meter reading without tripping the shutter on your camera to fire the flash.

Figure 4.29 - The white lines show the two-button control combinations. For example, pressing the ZOOM and - buttons together brings you to the Custom Settings Menus (CSM).

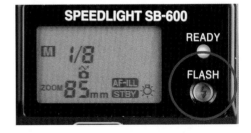

Figure 4.30 - In TTL BL mode, pressing the FLASH button will make the flash fire at about 1/16 power. In Manual mode, the FLASH button makes the flash fire at whatever value you set. This is useful in setting up studio shots when you measure actual output with a hand-held light meter.

Mounting Foot Lock Lever

Obviously, this lever locks the flash on top of the camera (figures 4.31 and 4.32). I highly recommend using it. It is especially important when you mount the flash to accessory platforms like light stands or other tripods. You don't want the flash to fall on the ground; that can ruin your day pretty quickly.

Hot Shoe Contacts

There are four metal contacts on the bottom of the flash (figure 4.33) and four round circular contacts on the camera's accessory shoe (figure 4.34). This is going to sound obvious, but all four contacts on the bottom of the flash must match up perfectly with all four contacts on the camera. If not, the flash and camera cannot communicate.

I have had this happen many times when I moved too quickly and didn't fully secure the flash to the camera body. Nothing is more embarrassing than staring at your flash and wondering why it won't fire! Well, there are probably some more embarrassing things, but I won't mention them here.

Figure 4.31 - Lever is unlocked (arrow). Notice that the locking pin does not protrude from the base (red circle).

Figure 4.33 - The flash has four conical electrical contacts that need to match up with the four contacts on the camera

Figure 4.32 - Lever is locked (arrow). Here, the locking pin does protrude from the base (red circle). When the flash is mounted, the pin will lock into the hot shoe and prevent the flash from falling off.

Figure 4.34 - The camera has four hot shoe points that need to match up with the four contact pins on the flash

External AF Assist Illuminator Contacts

If you have the SC-29 flash TTL extension cable, then the two metal contacts shown in figure 4.35 enable the cable to function with the Wide Area AF Assist Illuminator. Basically, these two contacts connect with the SC-29 cable so you can activate or deactivate the AF Assist function. The SC-29 has a lever switch on the front that allows you to turn off the SB-600 AF Assist lamp and use only the AF Assist lamp at the other end of the cable, mounted on the camera body.

Why would you do this? Let's say you have the flash mounted to the TTL cable so it is off-camera. In this situation, you are probably bouncing the flash off the ceiling or aiming through an umbrella. Therefore, the flash will emit the AF Assist pattern onto the ceiling or umbrella, not the subject. But if you purchase the SC-29 cable, you can still use the AF Assist pattern function because there is an additional AF box that mounts on the camera body. Problem solved!

READY Light

When the READY light is on, it means the flash's capacitor is fully charged and ready to take the next picture (figure 4.36). After you take a photo, the READY light turns off while the flash recharges its capacitor. Once the capacitor is recharged, it turns on again. The READY light also coincides with the beep of the flash in wireless mode.

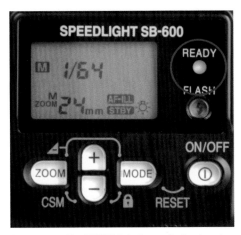

Figure 4.36 - The READY light is your indication that the flash's capacitor is fully charged and the flash is ready to fire. If it takes a long time for the light to come back on after you shoot a photograph, then change your batteries for fully charged ones.

Figure 4.35 - The AF Assist contacts allow you to use the SC-29 cable for autofocusing in dark rooms

Figure 4.37 - Notice that the READY light is not illuminated when the flash is in Standby (STBY) mode

When you are waiting between photos, the flash will periodically go into Standby mode. At this point, the READY light turns off until you wake up the flash by pressing the ON/OFF button or the camera's shutter release button (figure 4.37).

Also, because your flash doesn't have a battery level indicator, the READY light is the only way to really tell how much power remains in your batteries. Specifically, the longer it takes for the READY light to illuminate, the lower your battery life. If you find it takes four to six seconds after each shot to recharge the flash, then it is time to change your batteries.

Finally, the READY light blinks rapidly if you take a photograph and the flash does not have enough power to light the scene. In this situation, the flash indicates underexposure by a minus sign in the upper right corner of the LCD (figure 4.38). The rapid blinking is your cue to check out the underexposed value and then change aperture, ISO, distance, or zoom in order to take the shot.

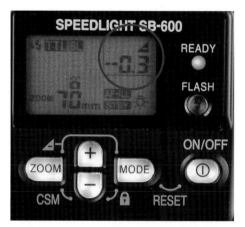

Figure 4.38 - If the READY light blinks rapidly after your photo, it means the flash didn't have enough power to light the scene. Press the MODE and ZOOM buttons simultaneously to recall the underexposed value.

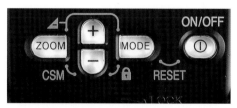

Figure 4.39 - To get into the SB-600 Custom Settings Menus (CSM), press the ZOOM and - buttons simultaneously for two seconds. Notice that these buttons are linked by the CSM label.

SB-600 Custom Settings Menus

The Custom Settings Menus (CSM) on the SB-600 are frustratingly difficult to understand and follow. It isn't always clear what menu you are in or what item you actually select. Unfortunately, you need to memorize some simple hieroglyphics to make heads or tails of CSM.

To get into CSM, hold down the ZOOM and - buttons simultaneously for two seconds (figure 4.39). You will know you are in CSM when all other data disappears from the LCD panel.

To navigate between menu screens, press the + and - buttons. The number of custom settings varies depending on how you configure the flash. For example, when you set up the flash as a Remote unit, the menus will be different from the ones you see when you configure the flash as a Dedicated TTL unit.

Once you select the item you want to change, press the MODE button to change it. Here is a breakdown of what the CSM settings mean:

Standby (STBY)

Standby mode on the SB-600 helps conserve battery power. You have two Standby choices in CSM (figure 4.40). Press the MODE button to select either AUTO or OFF.

- **AUTO-** In this mode, the flash automatically goes into Standby after the camera body meter system turns off. To wake up the flash, press the ON/OFF button or the camera's shutter release. The flash will not go into Standby mode when it is configured as a Remote unit.
- **OFF-** This mode is represented by a line of dashes on the LCD panel: - - - -. When configured like this, the flash will never go into Standby mode.

M ZOOM

M ZOOM means Manual Zoom. Use this function to disable the Auto Zoom feature of the flash when it is mounted on your camera(figure 4.41).

- **ON-** When set to ON, the flash will not zoom as the lens zooms. If you want to set the flash head for a different zoom value, you can still manually press the ZOOM button on the back of the flash to change the setting.
- **OFF-** When s et to OFF, the flash automatically zooms with the lens. I know, selecting OFF to allow Auto Zoom doesn't make sense to me, either.

LCD Panel Illuminator

This setting allows you to turn off the green backlight function on the flash. Typically, when you push a button on the flash, the green backlight comes on for a few seconds to help you read the screen (figure 4.42).

- **ON-** Allows the green backlight to turn on any time you press control buttons on the flash.
- **OFF-** Turns off the green backlight function.

Wireless Remote Flash Mode

Turning this function ON activates the wireless flash functionality of the SB-600. This function is illustrated by a squiggly arrow throughout the Nikon literature (figure 4.43).

- **ON-** Turns on Wireless Remote Flash mode so the SB-600 works only as a Remote flash unit.
- **OFF-** Turns off Wireless Remote Flash mode so the SB-600 works as a Dedicated flash unit.

NOTE

If you turn the backlight function off, the backlight button on the camera body will still cause the flash backlight to turn on.

Figure 4.40 - Standby CSM showing AUTO and OFF (- - -)

Figure 4.41 - CSM for M ZOOM. ON means the flash is in M ZOOM mode only.

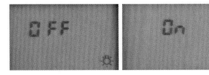

Figure 4.42 - CSM for the LCD Panel Illuminator. ON means that the backlight function will activate when you push any button on the flash.

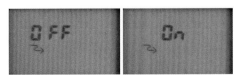

Figure 4.43 - CSM for Wireless Remote Flash mode. The squiggly arrow represents wireless mode.

Figure 4.44 - CSM for AF Illumination

Figure 4.45 - CSM for turning the beep on or off

Figure 4.46 - CSM for the READY Light LEDs

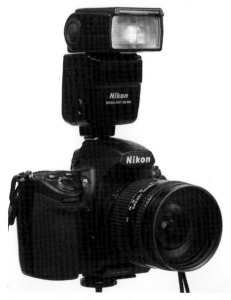

Figure 4.47 - The SB-600 makes a great Dedicated flash as shown here on the D700

AF Illumination

Use this setting to disable autofocus illumination on the flash (figure 4.44).

- NO AF-ILL- Turns off the AF Illumination feature.
- AF-ILL- Turns on the AF Illumination feature.

Beep On/Off

This item is available only after you turn on Wireless Remote Flash mode (figure 4.45).

- ON- Turning the beep on activates the flash's beeps during normal operation.
- OFF- Turning the beep off keeps the flash silent.

READY Light

This setting activates or deactivates the blinking LEDs on the front of the flash when you are in Wireless Remote Flash mode (figure 4.46).

- ON- Activates the blinking LEDs.
- OFF- Deactivates the blinking LEDs.

Using the SB-600 as a Dedicated Flash

Most people use the SB-600 as a Dedicated flash attached to the camera's hot shoe (figure 4.47). In this configuration, you can use the flash in any of these standard modes:

- TTL BL
- TTL
- Manual

A fully Dedicated flash means that all of the flash's capabilities can be used by the camera body. Also, the flash and the camera body communicate back and forth to relay information such as zoom settings, aperture, shutter speed, and power.

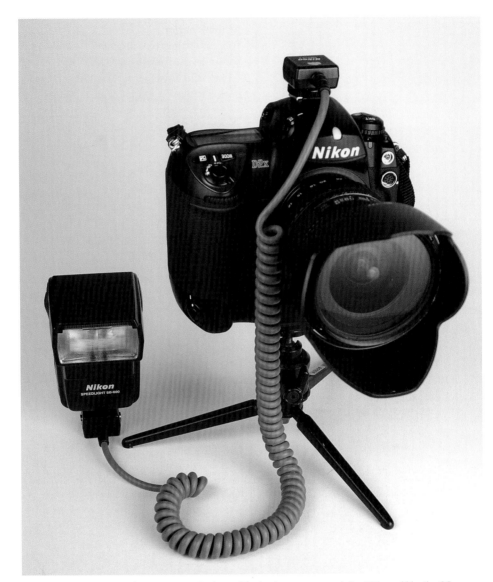

Figure 4.48 - The SB-600 also serves as a Dedicated flash when connected via a TTL cord like the SC-17, SC-28, or SC-29

System Setup for Common Shooting Scenarios

Shooting Scenario	Camera Sync Mode	Flash Mode	Flash Power	Comments
Outdoor & Travel	Slow + Rear	TTL BL	-0.7	Goal is to use subtle fill flash balanced with ambient light
Window Portraits	Slow + Rear	TTL BL	-0.7	Goal is to combine fill flash with ambient light or window light
Formal Lighting (umbrellas and stands with flash on TTL cable)	Normal (Front Curtain)	TTL BL or Manual	Variable	Goal is for flashes to provide 100% of light with no ambient light to speak of. Change power as needed for each subject and scene.
Wedding Reception in Dark Room	Normal (Front Curtain)	TTL BL or AA	0.0 (but change as necessary)	Goal is for flash to provide 100% of light. Mount flash on bracket and use diffusion dome.

Table 4.3

The SB-600 also functions as a Dedicated flash when attached via a TTL remote cord such as the SC-17, SC-28, or SC-29 (figure 4.48). These cables provide full TTL operation as if the flash were mounted on top of the camera.

In shooting scenarios where you want to operate quickly, I suggest setting the flash mode to TTL BL. Table 4.3 shows some general settings for the camera and flash in various scenarios.

Using the SB-600 as a Remote Flash

As you know, the SB-600 can operate in two configurations. The first is Dedicated mode where the flash takes its directions directly from the camera body. The second is Wireless Remote mode where the flash takes its directions from a Commander flash through pulses of light.

The power and flexibility of the Nikon CLS (Creative Lighting System) truly exists in Wireless Remote mode. To set up the SB-600 as a Remote flash, you must go into CSM and turn on Wireless Remote mode. Here are the steps:

1. Turn on flash
2. Simultaneously press ZOOM and - buttons for two seconds
3. Press + button until you see the squiggly arrow
4. Press MODE button until you see ON
5. Press ON/OFF button
6. Press MODE button to navigate to Channel
7. Press + or - button to change Channel
8. Press MODE button to navigate to Group
9. Press + or - button to change Group
10. Make sure the Commander flash is set to same Channel and Group
11. Take picture

Figure 4.49 - The SB-600's Light Sensor "sees" the light pulses from the Commander flash

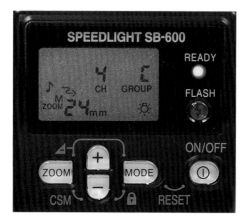

Figure 4.50 - When the SB-600 is in Wireless Remote mode, make sure that the Channel and Group are the same as the Commander unit. This flash is set to Channel 4, Group C; therefore, the Commander needs to be programmed to send data on Channel 4, Group C.

Once you configure the flash as a Remote unit, the SB-600 gets its instructions from the Commander flash unit. These instructions are broadcast via light pulses (chapter 1, figure 1.6), and the SB-600 "sees" these pulses from the Light Sensor (figure 4.49).

Make sure you point the Light Sensor towards the Commander flash. Even though it is sensitive, sometimes communication fails because the sensor literally can't see the light.

The SB-600 cannot be used as a Commander flash unit. This is different from the SB-800 and SB-900, which can be used as a Commander, Remote, or Dedicated flashes.

When you configure the SB-600 as a Remote flash, you must program it to the correct Channel and Group (figure 4.50). Most of the time, you can choose for yourself which Channel and Group you want. The CLS flashes have a total of four Channels and three Groups per Channel.

Sometimes people get confused about the hierarchy of Channels and Groups, so I made some simple tables to explain it further (tables 4.4 and 4.5). Some Commander units, such as the D70 pop-up flash, cannot be configured for different Channels and Groups. The D70 sends out flash data only on Channel 3, Group A. Other Commander units like the D80/D90 pop-ups, SB-800, SB-900, and SU-800 can work with multiple Channels and Groups.

The following tables summarize how Channels and Groups are organized.

Wireless Flash Channels and Groups

Channel	Groups Available
1	A, B, C
2	A, B, C
3	A, B, C
4	A, B, C

Commander Unit Channels and Groups

Commander	Available Channels and Groups
SB-800	CH 1, 2, 3, 4 Groups A, B, C
SU-800	CH 1, 2, 3, 4 Groups A, B, C
SB-900	CH 1, 2, 3, 4 Groups A, B, C
D70	CH 3 Group A
D80, D90, D200, D300, D700	CH 1, 2, 3, 4 Groups A, B

SB-800 Buttons, Modes, Menus, and Operation

Prior to the SB-900, the SB-800 was Nikon's flagship Speedlight, and it still deserves its reputation as an extremely capable strobe. The SB-800 is a great all-around, very rugged flash. It will serve you well for many years.

The SB-800 is typically used in three ways:

- Dedicated flash mounted directly to your camera
- Commander flash to control other wireless remotes
- Wireless Remote flash

SB-800 Buttons and Controls

Flash Head

To point the flash head in different directions, press the Tilt button (figures 5.1 and 5.2) with your finger and rotate the head. The flash head on the SB-800 rotates 270 degrees side to side and 90 degrees vertically. You need to press the button to begin movement, but you don't need to keep pressing it to continue.

If you look closely at the back of the flash head, you will notice it has angle scales on it. However, they are not really useful unless you are telling someone else how to set up your flash.

The SB-800 also has a -7 degree position (figure 5.3) that is used for doing macro work when mounted on top of your camera. Pay close attention to this setting, because many functions of the flash are not accessible when the head is at -7 degrees (e.g., GN).

Figure 5.1 - SB-800 Tilt button. Push this button to rotate or tilt the flash head. In this example, the flash head is at the horizontal front position.

Figure 5.2 - SB-800 flash head at 45 degrees, front position

Figure 5.3 - SB-800 flash head at -7 degrees, front position. This position is used for macro photography.

Wide Angle Adapter

If you use a lens with an angle wider than 24 mm, it makes good sense to pull out the Wide Angle Adapter (figure 5.4). Notice that when you deploy it, the flash automatically zooms to 17 mm (figure 5.5). This means that the Wide Angle Adapter allows an angle of coverage the same as a 17 mm lens. If you don't deploy it in this situation, you run the risk of light fall-off in the corners of the photograph (figures 5.6 and 5.7).

You can also zoom the flash to 14 mm by pressing the ZOOM button on the SB-800. When the Wide Angle Adapter is deployed, only two zoom settings available: 14 mm and 17 mm.

Figure 5.4 - Wide Angle Adapter is deployed

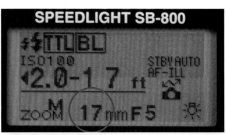

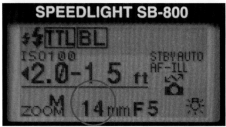

Figure 5.5 - When the Wide Angle Adapter is out, the zoom setting automatically changes to 17 mm as the default. You can also choose 14 mm by pressing the ZOOM button.

Figure 5.6 - This shot was taken with a 12 mm lens pointed at a white wall. The flash was set to 24 mm. Notice the strong light fall-off in the corners.

Figure 5.7 - This shot was also taken with a 12 mm lens but with the Wide Angle Adapter deployed. There is still light fall-off in the lower corners, but the coverage is much improved.

Bounce Card

Nikon includes a small built-in bounce card on the SB-800. The card automatically extends when you pull out the Wide Angle Adapter (figure 5.8). The purpose of the bounce card is to reflect light forward to the subject while allowing some of it to bounce off the ceiling. Doing this hopefully creates a nice catch light in the subject's eyes. It also serves to lighten up the dark shadows that frequently appear under the eyes.

In reality, the built-in 1.5" x 1.75" bounce card is too small to be very effective. A real bounce card should be at least 4" x 6" or larger (figure 5.9). Bigger is better when it comes to light diffusion, and bounce cards are no different. Most photographers who use bounce cards end up taping or rubber-banding a larger card to the back of the SB-800. These provide much better results.

If you do want to use the built-in bounce card, point the flash head upwards about 45 degrees. At this setting, some light will bounce off the ceiling (assuming you are inside), and some light will reflect off the card towards the subject. I like to extend the Wide Angle Adapter when using the bounce card, but if you want, you can push it back into the flash head.

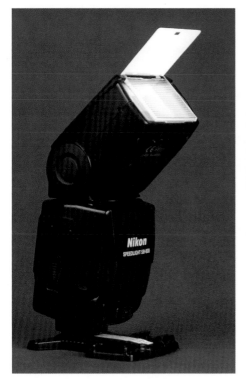

Figure 5.8 - When using the bounce card, deploy the Wide Angle Adapter for best results. Also, point the flash head upwards at 45 degrees.

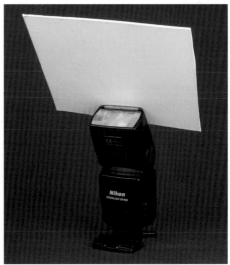

Figure 5.9 - This is a "real" bounce card that actually has some usable surface area. It is 5" x 8". The bigger your bounce card, the better your flash results! Attach it with Velcro or gaffer tape.

Figure 5.10 - Cheat sheet on the back of the SB-800 bounce card

Notice that the back of the SB-800 bounce card has a "cheat sheet" that shows the most-used buttons on the flash (figure 5.10). This is helpful if you forget how to get into your Custom Settings Menus or how to lock the button pad (figure 5.11).

Wide Area AF Assist Illuminator

The Wide Area AF Assist Illuminator is a fantastic feature that automatically activates in dark rooms to assist your camera's autofocus sensors. This feature normally overrides the camera body's AF Assist Illuminator (found on cameras like the D60, D90, and D700). This pattern also activates when the flash is used with a TTL extension cord such as the SC-17, SC-28, or SC-29 (figures 5.12 and 5.13).

Figure 5.12 - The Wide Area AF Assist pattern is generated behind the red window in the front of the flash

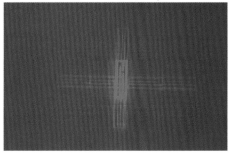

Figure 5.13 - This is what the pattern looks like against a wall in a dark room

Figure 5.11 - A good substitute for a bounce card is to use your hand instead. Your hand will add a nice warming effect to the light and produce excellent results. Try it, you'll like it!

You must set up the following things properly for the Wide Area AF Assist Illuminator to work:

1. Turn on the autofocus (the switch on the camera body down by the lens mount)
2. Set your camera to AF-S (not AF-C)
3. Position the autofocus sensor so it can "see" the flash's red pattern—for example, in the center position of your camera's viewfinder
4. Make sure the ambient light is dark enough for the camera to activate the red pattern
5. Turn on your flash and your camera
6. Turn on your flash's Custom Settings Menus for AF-ILL

Once these conditions are met, the AF Illumination pattern will work from the flash head. (Why can't they make this stuff easier?)

Light Sensor for Auto Flash

The SB-800 has the special ability to work as an automatic flash unit. What this means is that it can determine the appropriate exposure automatically by using its own built-in light sensor (figure 5.14), rather than by using the camera's TTL exposure system. More information on how this works appears later in this chapter.

External Power Source Terminal

The External Power Source Terminal is located on the front of the flash behind the plastic Nikon insignia (figure 5.15). Pull off the little plastic cap to access the terminal. If you use accessory flash power such as the Nikon SD-8A, SD-9, or an alternative product such as a Sunpak, Quantum Turbo, or Al Jacob's Black Box (see chapter 12), plug the unit into this part of the flash.

Figure 5.14 - The Light Sensor for Auto Flash mode (A or AA)

Figure 5.15 - The External Power Source Terminal. Remove the plastic Nikon cap to access these pins.

Note that this sensor is different from the wireless TTL sensor shown in figure 5.16.

Light Sensor Window

When the SB-800 is configured as a Remote flash, this is where all the communication takes place between it and the Commander flash (figure 5.16). Be sure to point this window towards the Commander flash.

The window works best in the shade or in a dark room away from bright ambient light. I've had some problems making the system work in direct sun and assume the reason is because the Remote flashes have a hard time distinguishing between flash pulses and direct sun.

Many times I have an assistant hold the Remote flash and aim it at the subject. In this scenario, make sure the assistant's thumb does not cover the window. Unfortunately, Nikon placed it at the perfect location for a thumb grip! (Figures 5.17 and 5.18.)

Figure 5.17 - Be sure not to cover the Light Sensor Window with your thumb

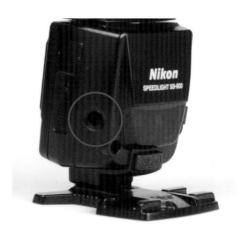

Figure 5.16 - The Light Sensor Window for wireless TTL flash control is located beside the battery chamber. Point this sensor towards the Commander flash.

Figure 5.18 - This is the correct way to hand hold the flash without covering the Light Sensor Window

Battery Chamber Lid

The Battery Chamber Lid is simple to operate: just slide the cover down to the "unlocked" position and then open up the chamber (figure 5.19). The lid is designed to be removed so you can add the Extra Battery Holder (details in next section).

I find over time that the battery contacts can corrode, causing a poor connection between the batteries and the flash. To remedy the problem, I clean them with a pencil eraser or lightly scrape them with a pocket knife. Also, the tabs deep inside the battery chamber can form light corrosion, so I clean those off as well.

Extra Battery Holder

If you need extra battery life and faster recycle times, consider attaching the Extra Battery Holder. This is a good accessory, and I recommend using it if you need the capacity. In order to attach it to the flash, you must remove the SB-800 battery door by following these steps:

1. Open door
2. Rotate door to the side (figure 5.20)
3. Place fifth battery in battery holder
4. Slide battery holder into place (figure 5.21)

In most of my photography, I choose to use the four-battery setup rather than the five-battery setup. This is because most of my battery chargers have four positions and also because my plastic battery cases hold four batteries. Since my workflow is very easy with four batteries, I don't attach the Extra Battery Holder.

Figure 5.19 - SB-800 Battery Chamber Lid

Figure 5.20 - Removing the battery door is very easy. Just open it up and rotate it to the side as shown in the second photo. It will pop off the hinge quickly.

Figure 5.21 - Add the Extra Battery Holder to the flash by pushing it onto the door slot and clicking it into place

ON/OFF Button

The ON/OFF button is, of course, used to turn the flash on and off, but it also serves several additional functions:

- Press ON/OFF to bring the flash out of Standby mode
- Press ON/OFF to exit from the Custom Settings Menus
- Press ON/OFF and SEL simultaneously to lock the flash's buttons
- Press ON/OFF and MODE simultaneously to reset the flash to defaults

Be sure to turn the flash off before you attach or remove it from the camera body (figure 5.22). This prevents any short circuits as well as preventing the flash from firing.

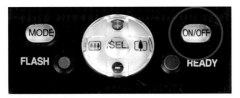

Figure 5.22 - SB-800 ON/OFF button

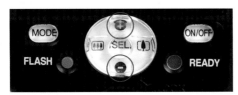

Figure 5.23 - The +/- buttons, or Flash Compensation buttons, control flash power

+/- Buttons

The + and – buttons, or Flash Compensation buttons, are generally used to control the power output of the flash (figure 5.23). Depending on what mode the flash is in, the output is shown in terms of stops or fractions.

The default setting for the flash is 0.0. This means the flash will put out enough light to capture the scene at medium brightness. Stated another way, if your flash is set up for 0.0, then it will expose the subject as bright as an 18% gray card (figure 5.24).

In TTL mode or TTL BL mode, the +/- buttons control flash output compensation in stops. They are independent from the Exposure Compensation button found on top of your camera body (figure 5.25).

If you press the + button one time in TTL mode, the flash will display +1/3 on the LCD readout. The +1/3 symbol will blink for a few seconds and then stop blinking to indicate the new setting. When you take a picture with +1/3, the exposure will be brighter by 0.3 stops than the same photo with 0.0.

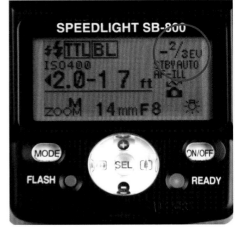

Figure 5.24 - Flash Compensation on the SB-800 is shown in terms of stops. In this case, -2/3 means two-thirds of a stop less light than 0.0.

On the other hand, if you press the - button, you decrease the amount of flash compensation. For example, a value of -2/3 will decrease flash output by 0.7 stops from 0.0. Stated another way, the flash will put out -2/3 stops from what would be required to illuminate your subject at 18% gray (figure 5.26).

When you set the flash mode to Manual, the +/- buttons still control flash output but the readout changes to fractions. Remember that in TTL and TTL BL modes, the camera automatically controls the flash output to what it thinks is correct. However, in Manual mode, you are the brains behind the output. You must figure out how much light to add to the scene by using a Guide Number calculation, hand-held light meter, or trial and error.

Figure 5.25 - The Exposure Compensation button on your camera is different from the Flash Compensation buttons. Exposure Compensation changes the amount of ambient light in the exposure.

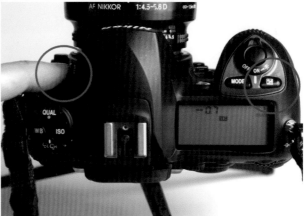

Figure 5.26 - The Flash Compensation buttons only change flash output. Exposure Compensation only changes shutter speed or aperture.

ZOOM Button

One of the great features of the SB-800 is its ability to focus the beam of light from the flash head. This is a good thing because you generally want the entire scene to be evenly lit by the flash. As you zoom the lens to a wider angle, the flash must illuminate a larger area. So, at the same time the lens zooms, the flash head will also zoom.

On Nikon camera systems, the lens sends zoom information to the camera body, which then forwards it to the flash. Say, for example, you set your lens to 24 mm; then your flash will also zoom to 24 mm to provide the same angle of coverage. This is called Auto Zoom on the flash. You can override the Auto Zoom function and zoom manually by pressing the ZOOM button, which displays on the flash's LCD as M ZOOM (figure 5.27).

Figure 5.28 - When the Wide Angle Adapter is extended, the flash automatically sets the zoom to 14 mm or 17 mm

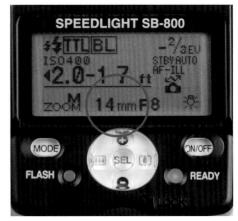

Figure 5.29 - Pressing the ZOOM button allows you to choose between 14 mm and 17 mm

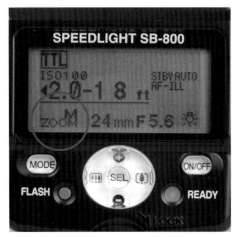

Figure 5.27 - When you press the ZOOM button, you override the Auto Zoom function and go into M ZOOM mode

IMPORTANT!

On Nikon camera systems, the lens sends zoom information to the camera body, which then forwards it to the flash. Say, for example, you set your lens to 24 mm; then your flash will also zoom to 24 mm to provide the same angle of coverage. This is called Auto Zoom on the flash. You can override the Auto Zoom function and zoom manually by pressing the ZOOM button, which displays on the flash's LCD as M ZOOM (figure 5.27).

Following are three other details you need to know about:

1. Let's say you zoom the flash to 105 mm and the LCD shows M ZOOM. If you want the flash to re-synchronize with the lens, then you need to follow these simple steps:

Turn lens barrel to 24 mm

then

Press "Zoom" button on flash until it is set to 24 mm

OR

Turn lens barrel to any zoom setting

then

Press "Zoom" button on flash until it is set to same zoom setting

2. When you have the Wide Angle Adapter extended, the SB-800 will only zoom between 14 mm and 17 mm. You can change from one to the other by pressing the ZOOM button as shown in figures 5.28 and 5.29.

3. When you mount a diffusion dome on the SB-800 (figure 5.30), a micro switch on the bottom of the flash head (figure 5.31) detects the dome and defaults the zoom to 14 mm. There is no way to override this unless you cut away the plastic on the dome, but there is no reason to do so. Just leave it at 14 mm and be happy.

Figure 5.30 - When you use a diffusion dome, the flash defaults to 14 mm zoom

Figure 5.31 - The flash knows a diffusion dome is mounted because of the micro switch on the outside of the flash head (inside the red circle)

Diffusion Dome

This little piece of plastic is one of the greatest inventions ever made for flash photography (figures 5.32 and 5.33). Its purpose is to diffuse the light from the flash and force it to spread all around the scene and subject. I use a diffusion dome when I photograph events and don't have time to set up elaborate lighting equipment. I also use it for macro photography, portraits, and just about everything else under the sun.

The proper way to use a diffusion dome is to place it on the flash and then point the flash head upwards about 45 degrees (figures 5.32 and 5.33). This allows the dome to do its job by sending light all around the room. I frequently use it in conjunction with a flash bracket (figure 5.34) to minimize the effect of the shadow.

Remember, when a diffusion dome is placed on the SB-800, it defeats the zoom function of the flash. It does this by depressing a micro switch on the bottom of the flash head.

Some SB-800 owners wonder whether to use the Wide Angle Flash Adapter along with the diffusion dome. The answer is no. There is no need to diffuse *behind* the diffusion dome. That's straight from the Department of Redundancy Department.

Figure 5.32 - Diffusion dome in use when the camera is horizontal. Point the flash head upwards at 45 degrees for best results.

Figure 5.33 - Diffusion dome in use when the camera is vertical. Point the flash head upwards at 45 degrees for best results.

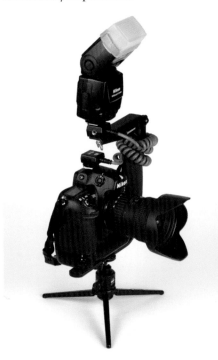

Figure 5.34 - Diffusion dome with Stroboframe Quick Flip flash bracket. A flash bracket is the best option for event photography.

If you ever lose a diffusion dome, you can buy a replacement through Nikon or buy off-brand models from companies like Sto-Fen. Sto-Fen makes great replacement domes, and I highly recommend them (www.stofen.com). In addition, there are plenty of other products that do a great job of diffusing the flash, such as Harbor Digital Design's Ultimate Light Box (www.harbordigitaldesign.com).

MODE Button

Like most of the controls on the SB-800, the MODE button (figure 5.37) performs a number of functions depending on how the flash is configured.

When the flash is set up as a Dedicated Speedlight (i.e., not a Remote flash or a Commander flash), the MODE button switches between seven flash modes: TTL BL, TTL, A, AA, GN, M, and RPT (figure 5.38). When the flash is not attached to the camera (or the camera is powered off), you can only choose from five modes: TTL, A, GN, M, and RPT.

Figure 5.37 - SB-800 MODE button

NOTE

In order to choose between A and AA, you need to make a change in the Custom Settings Menus. Starting from the top left, select the following: TTL BL, TTL, Auto Aperture, Auto Flash, Guide Number, Manual, Repeat.

Figure 5.35 - Wedding photo taken with diffusion dome and flash bracket. Notice the soft light and the shadow hidden behind the young girl. D70, SB-800, diffusion dome, Stroboframe bracket, SC-17 cable. Camera set up for SLOW REAR sync and flash set for TTL BL -1.7.

Figure 5.36 - The diffusion dome on the left is an SB-800 model from Nikon. The diffusion dome on the right is a Sto-Fen model for an SB-600.

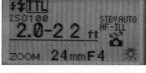
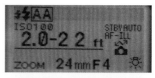
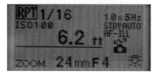

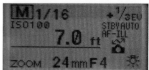
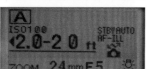

Figure 5.38 - The SB-800 has seven modes when used as a regular Dedicated flash. To select them, press the MODE button on the back of the flash.

TTL BL Mode

TTL stands for "Through The Lens" metering and BL stands for "Balanced" fill flash (figure 5.39). Nikon refers to this mode as "Automatic Balanced Fill Flash". Its goal is to balance the ambient light (background) with the subject (foreground). I use TTL BL for the vast majority of my photography and find it to be reliable for fast shooting.

In TTL BL mode, the SB-800 puts out a preflash that is reflected back to the camera's flash metering system (the Matrix meter). The camera then quickly calculates the correct amount of light for the scene. You can watch this preflash sequence happen if you pay close attention to the flash when it fires.

The preflash delay is fairly long on slower cameras like the Nikon D70, but very short (almost imperceptible) on fast systems like the D2X and D200. Unfortunately, the preflashes can cause people to close their eyes during the shot, which can be very frustrating for the photographer. Sometimes the only way to get around this is to tell your subjects to try to keep their eyes open until the sequence is finished. Obviously, this is easier said than done.

Another way to get around the preflash is to turn your flash to Manual mode; or, you can use a function called FV Lock. See chapter 13 for more information on how to cure this problem with FV Lock.

TTL Mode

This mode is often called Standard TTL. Its purpose is to expose only for the subject and not for the background light. TTL mode goes back a long way in Nikon camera systems and is truly the legacy mode. It does a good job, but I have found that TTL BL seems more accurate and consistent (figure 5.40).

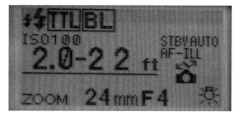

Figure 5.39 - SB-800 in TTL BL mode

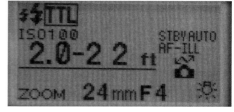

Figure 5.40 - SB-800 in TTL mode

The best places to use TTL mode are situations where you only want the subject exposed, such as:

- Weddings and other events in dark reception halls
- Parties in dark living rooms
- Macro photography where the surrounding environment is a nonissue

AA Mode

AA stands for Auto Aperture. In this mode, the flash makes the exposure decision automatically without using the camera's TTL Matrix Meter system.

This mode is typically used when you need more shot-to-shot consistency than TTL BL can provide. Unfortunately, TTL BL doesn't always provide consistent exposures when you take a large number of shots of a variety of subjects. For example, at a wedding, TTL BL might slightly underexpose photographs that include the bride's white dress while slightly overexposing photos that include black tuxedos.

This variation from shot to shot can be very frustrating for a professional photographer who plans to present wedding photos to a client in one showing. If you show a photo of the bride by itself, it would look OK; but if you show a number of photos side by side, the TTL BL variation quickly becomes apparent. The reason is that TTL takes every scene and modifies the exposure based on its overall reflectance (brightness).

AA mode takes the camera's TTL meter out of the flash calculation and instead uses the SB-800's built-in light sensor. Exposures using AA tend to have less brightness variation from shot to shot, but they take a little more effort to pull off.

This mode uses lots of information to determine the flash exposure, including:

- Lens Aperture
- Camera ISO
- Exposure Compensation Setting
- Lens Focal Length (zoom)

Even though this mode tries to automate the flash exposure, it does not use the camera's TTL Matrix Meter system: hence the name Auto Aperture Flash. AA means that the flash makes the exposure decision automatically.

You can use this setting in one of two ways:

1. Set the aperture and then work within a general shooting distance range. This allows the flash's sensor to take up the slack. Your shooting range is shown on the back of the flash in either feet or meters (figure 5.41). For example, the flash might state 2.0-22 feet, which means it will operate well at any distance between those two values.

2. From your known distance, adjust the aperture on the camera until the flash is within range. Say, for example, you are 12 feet from the bride and want to get a well-exposed image of her in AA mode. Adjust the aperture (on the camera) until the distance range on the back of the flash includes 12 feet and take the picture. It will look something like the example below.

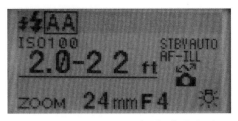

Figure 5.41 - SB-800 in AA mode. The flash displays an operating range (2.0-22 feet) which is the subject-to-flash distance.

Figure 5.42 - AA mode, direct flash

Figure 5.43 - TTL BL mode, direct flash

Figure 5.44 - AA mode, bounced off ceiling

Figure 5.45 - TTL BL mode, bounced off ceiling

NOTE

In figures 5.44 and 5.45, both flash modes did a nice job with the exposure when the flash was bounced off the ceiling.

Figures 5.42 through 5.45 compare shots taken in AA and TTL BL modes. The photos on the top row were taken with the flash head pointed directly at the subject with no diffusion. The photos on the bottom row were taken with the flash head pointed at the ceiling to diffuse the light. The left photos are AA mode, and the right photos are TTL BL mode.

In general, I find that AA mode tends to expose the subject about 1/3 to 2/3 of a stop brighter than TTL mode. This isn't necessarily a bad thing, just a reality of the system. Once you get a handle on the exposure, you can change the power by pressing the flash's + and - buttons until you are happy with it.

A Mode

A stands for Auto Flash. This mode uses *only* the SB-800's built-in sensor to measure the light reflected from the subject. This is different from AA mode where the camera communicates aperture, lens, ISO, and exposure compensation data to the lens. When the flash's sensor decides enough light is reflected back, it shuts down power to the flash head and stops outputting light (figure 5.46).

The neat thing about A mode is that the flash works "automatically" on most of the cameras you own, including your older Nikon film cameras and even off-brand cameras like the Pentax K1000. There is no back-and-forth communication between the flash and the camera body, so you have to trust the flash to do everything.

If your camera is a newer Nikon SLR like the D40, D50, D60, D70, D200, D300, D700, D2, or D3, you actually have to configure the flash to operate in plain old A mode rather than AA mode. To do this, go to Custom Settings Menus and change the settings for A/AA (figure 5.47). Here are the steps:

1. Press and hold the SEL button for two seconds
2. Press the + or - and ZOOM buttons until you see the A/AA box
3. Press SEL button
4. Choose A by pressing - button
5. Press SEL button
6. Press ON/OFF button

In A mode, you generally set the camera's exposure mode to Aperture Priority or Manual. The next step is to press the + or - button until the aperture on the flash equals the aperture on the camera body, or until the shooting distance on the back of the flash matches the shooting distance of your subject. Now, take the picture. Simple, right?

Kind of. These instructions need to take more into account than just making the setting and pressing the shutter release button. Many photographers, like wedding and event photographers, also put their hand-held light meters into the equation for

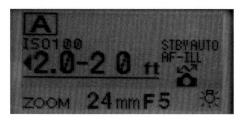

Figure 5.46 - SB-800 in A mode

Figure 5.47 - Change the A/AA custom setting if you want the flash to operate only in A mode rather than AA mode

these shots. If your goal is to get more consistency than TTL BL will give you, it's going to take some effort.

Here is the process for effective (consistent) Auto Flash usage at an event:
1. Set flash for A (Auto Flash) mode
2. Set camera's ISO between 200 and 800
3. Set camera for Manual exposure
4. Set shutter speed to 1/60 second
5. Set aperture to f/8 on your camera
6. Set aperture to f/8 on your flash
7. Place hand-held light meter five feet away from flash
8. Take a photograph of subject five feet away and note hand-held meter aperture reading
9. Repeat this process for subjects at 10 feet, 15 feet, and 20 feet
10. Write down the hand-held meter values for the flash readings (e.g., 5 feet = f/10, 10 feet = f/8, etc.)
11. These are the aperture settings for your event
12. To take photos with these values at the event, mentally estimate how far away your subjects are and set the corresponding aperture into the camera body

For example, let's say you want to photograph people at the local square dance on Saturday night and get great flash photos using A mode. I suggest you get there early and start testing using the steps outlined above. When you are done testing, you will have some information like this:

- 5 feet = f/10
- 10 feet = f/8
- 15 feet = f/6.5
- 20 feet = f/5.6

When it comes time to snap a photograph of the square dancers at 15 feet away, set f/6.5 (f/6.3) on the *camera* and take the shot. Notice that the settings on your *flash* haven't changed from your initial values of f/8 and ISO 200 (or 400).

Now it's simple, right? Right. Go ahead, roll your eyes.

GN

GN stands for Guide Number. This manual flash mode utilizes the SB-800's published Guide Number to help you calculate a flash photograph (figure 5.48). This mode might actually be called a "distance priority" method for determining flash exposure. You arrange your photograph so that you know the *exact* distance from the flash to the subject, and then you program that number into your flash. Figure 5.48 shows a value of 7.4 feet (the big number in the screen). This means if your subject is 7.4 feet away from the flash, then the photograph will be properly exposed.

Here's how it works:
1. Set the flash mode to GN
2. Set the camera to Aperture Priority or Manual mode
3. Measure the distance between the flash and the subject (e.g., 7.4 feet)
4. Set the aperture on your camera (e.g., f/5.6)
5. Press the flash's + and - buttons until the large distance number on the back matches the distance to the subject (7.4 feet)
6. Take the photograph

Note also that you can adjust the flash output by changing the flash compensation. To do this, press the SEL button until EV is highlighted. Then, press the + and - buttons to change flash power (figure 5.49).

GN mode is pretty picky and requires a number of items to be configured properly on your flash. Most important, the flash head

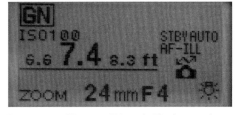

Figure 5.48 - SB-800 in GN mode. The big number (7.4) shows how far away your subject should be for a proper exposure.

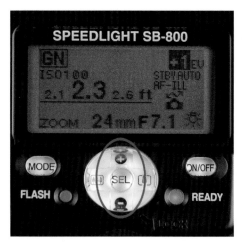

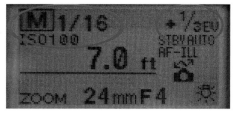

Figure 5.50 - SB-800 in Manual mode. Here, the flash is set up to put out 1/16 power plus 1/3 of a stop.

Figure 5.49 - Change the flash compensation by pressing the SEL button until EV is highlighted. Then press the + and - buttons.

needs to be set at the horizontal (front) position. However, there are many other reasons why this mode may not work properly. Some of them are:

1. Flash head is pointed down at the -7 degree setting
2. Flash head is pointed up at an angle
3. Wide Angle Diffusion Panel is deployed
4. Diffusion dome is mounted on the flash
5. Camera is turned off (hey, it happens!)

M Mode

In Manual flash mode (figure 5.50), you are responsible for determining flash output. To do this, you basically have three choices:

• Trial and error
• Guide Number calculation
• Hand-held light meter

The first method of determining flash power is trial and error. Simply take a picture and review the results on your camera's histogram screen. If it looks too bright, dial the flash power down. If it looks too dark, then increase the power.

The second method is to use a Guide Number calculation, which is contingent on knowing the flash's Guide Number. Although

the SB-800 has a published Guide Number of 125, it gets more complicated when you zoom the flash head. For example, if you zoom the flash head to 24 mm, then the Guide Number is 98. If you zoom the flash head to 105 mm, then the Guide Number is 184. Table 5.2 will help you determine what the Guide Number is depending on your zoom and flash power settings.

Once you know what the Guide Number is, you can run a calculation based on the Guide Number formula to set the aperture for your camera.

Guide Number (GN) = Shooting Distance (in feet) x Aperture ÷ ISO Sensitivity Factor

The preceding formula doesn't mean much to most people, but we can change it around to solve that problem. The formula now looks like this:

$$Aperture = \frac{GN}{Distance}$$

Let's assume you know your subject is 10 feet away and your Guide Number is 58. According to this calculation, set your lens aperture to f/5.8 and take the photograph. Easy!

But honestly, that is the old way to calculate flash power. These days, TTL systems can do all of this for us—except when we're in Manual mode, where there is no automated flash calculation.

SB-800 Guide Numbers at ISO 100 (Calculated Using Feet)

Flash Output Level	Flash Head Zoom Position (mm)							
	14	24	28	35	50	70	85	105
1/1	56	98	105	125	144	164	174	184
1/2	39	70	74	88	102	116	123	131
1/4	28	49	52	62	72	82	87	92
1/8	20	35	37	44	51	58	61	65
1/16	14	25	26	31	36	41	44	46
1/32	10	17	20	22	26	29	31	32
1/64	7	12	13	16	18	21	22	23
1/128	5	9	9	11	13	14	15	16

Table 5.2

The third and most accurate method for setting flash power in Manual mode is to use a hand-held light meter. You basically place the meter in front of your subject, fire the flash, read the light meter values, and set them into your camera (e.g., f/8 at 1/60 second).

Here is the process for using a hand-held light meter:

1. Set the flash power to a specific value, such as ¼ power
2. Set your camera and flash meter to the same ISO value
3. Place the meter in front of your subject with the dome pointed towards the camera
4. Fire the flash in Manual mode
5. Read the light meter values, such as shutter speed and aperture
6. Set those values into your camera (e.g., f/8 at 1/60 second)

This is the best way to calculate flash exposure and is really the most accurate method you can use. It is how many professional photography studios set up flash exposures.

You may ask, "Well, if this way is so good, then why does Nikon create all those other flash modes?" The answer is because the light meter method is slow and takes patience. It is impossible to capture candid shots if you always have to stop and take a flash meter reading. Nikon keeps innovating new and exciting flash modes like TTL BL to help us capture serendipitous scenes that would otherwise be lost.

RPT Mode

This mode is a lot of fun. RPT stands for Repeating Flash Mode, which is used when you want the flash to fire repeatedly during a single exposure. Say you want to take a photograph of a bouncing ping-pong ball (figure 5.52). You can use RPT mode to put out multiple pulses of light while the ball bounces through the scene.

There are myriads of applications for this technique—for example, a dancer going through her routine, a mountain biker jump-

Figure 5.51 - SB-800 in RPT mode. This screen shows that the flash is set at 1/16 power and will fire 10 times at 5 flashes per second.

Figure 5.52 - This photo of a bouncing ping-pong ball was taken in RPT mode. The settings for this shot were 1/32 power, 10 pulses, 5 Hz.

ing off a log, a bird flying by, or a baseball player throwing a pitch.

Here is the process:

1. Set flash mode to RPT
2. Push SEL button once to highlight the flash output level
3. Push + or - buttons to adjust power output
4. Push SEL button again to highlight frequency
5. Push + or - buttons to adjust frequency
6. Push SEL button again to highlight quantity of flashes
7. Push + or - buttons to adjust quantity
8. Set camera to Manual exposure
9. Calculate shutter speed (Shutter Speed = Qty/Hz)
10. Set Aperture on the camera body until you get a usable working distance

Here is more detail on each step:

- Output Level: This is set in fractions of full power (1/1)
- Frequency (Hz): This is how many flashes fire per second. For example, 5 Hz means the flash fires five times per second.
- Quantity: This is how many times the flash fires until it stops. For example, a value of 10 means the flash will fire 10 times and then stop.
- Calculating Shutter Speed: To calculate shutter speed, divide Quantity by Frequency. For example, if the flash fires a total of 10 times and the frequency is five flashes per second, then the duration of the sequence is two seconds (10 flashes divided by five flashes per second is two seconds). Another example: if the flash fires 20 times and the frequency is two flashes per second, then the duration of the sequence is 10 seconds (20 flashes divided by two flashes per second is 10 seconds). You then set that value as the shutter speed into your camera.
- Figuring Out Aperture: Look at the back of the flash, and you will see a distance value like 6.2 feet (figure 5.51). This means the subject needs to be exactly 6.2 feet away in order to be properly exposed. The smaller the aperture, the closer you must be to the subject. For example, f/11 might require you to be two feet away (kinda close!) whereas f/4 would allow you to be eight feet away. Keep adjusting the aperture on the camera body until you are happy with the working distance between flash and subject. You can also increase the ISO to get some additional working distance.

When it comes time to finally take the photograph, make sure the ambient light is very low or nonexistent. Also, try to make the background very dark—in other words, make your studio almost completely black. You typically want the entire scene to be

Figure 5.53 - This image represents each pulse of the flash, starting from pulse #1 and ending at pulse #10. The ball was bouncing from right to left. The settings for this image were: Frequency: 5 Hz. Total Pulses: 10. Shutter Speed: two seconds. Aperture: f/8. Background: black sheet.

lit only by the flash. Finally, position your subject far away from the background. This will keep the flash's reflected light from lighting up the background (figure 5.53).

OK, that's it for the flash modes on the SB-800. Let's continue on with the buttons and controls.

SEL Button

Use this button to select different settings on the flash (figure 5.54). Here are some general uses for the SEL button:

- Push SEL button for two seconds to access the Custom Settings Menus
- Push SEL and ON/OFF buttons simultaneously to lock the flash buttons
- Push SEL and MODE buttons simultaneously to recall the underexposure amount from your last (failed) flash shot
- Push SEL button to choose power, frequency, and quantity in RPT mode

Figure 5.54 - SB-800 SEL button. "One button, so many uses!"

Figure 5.55 - The READY light is illuminated when the flash's capacitor is fully charged

- Push SEL button to choose Channel and Group in Remote mode
- Push SEL button to choose Channel, Group, Mode, and Power in Commander mode

READY Light

When the READY light is on, it means that the flash's capacitor is fully charged and ready to take the next picture (figure 5.55). After you take a photo, the READY light turns off while the flash recharges its capacitor. Once the capacitor is recharged, the Ready light turns on again. The READY light also coincides directly with the beep of the flash in wireless mode.

When you are waiting between photos, the flash will periodically go into Standby mode. At that point, the READY light turns off until you wake up the flash by pressing the ON/OFF button or the camera's shutter release button (figure 5.56).

Figure 5.56 - When the flash goes into Standby, the READY light turns off

Because the flash does not have a battery level indicator, the READY light is the only way to really tell how much power remains in your batteries. Specifically, the longer it takes for the READY light to illuminate, the lower your battery life. If you find that it takes four to five seconds after each shot to recharge the flash, then it is probably time to change your batteries (figure 5.57).

Finally, the READY light blinks rapidly if you take a photograph and the flash does not have enough power to light the scene. In this situation, the flash indicates underexposure by a minus sign in the upper right corner of the LCD. The rapid blinking is your cue to check out the underexposed value and then change aperture, ISO, distance, or zoom in order to take the shot (figure 5.58).

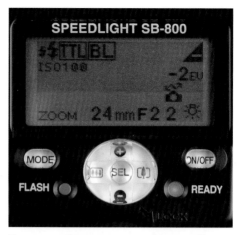

Figure 5.57 - This picture was underexposed by two stops. You can see the readout on the upper right corner of the LCD.

FLASH Button

Since the beginning of time (or flash time at least), flashes have had this button (figure 5.59) so people can press it and watch the flash fire. However, in TTL BL or TTL mode, it serves no purpose other than to confirm that the flash is on and working properly. Also, in TTL BL or TTL mode, pressing the FLASH button will cause the flash to put out only about 1/16 power.

The real use of this button is in Manual mode. In this case, the flash will put out exactly the amount of power you dial into it. If you use a hand-held flash meter in a traditional studio environment, you can take a meter reading without tripping the shutter on your camera to fire the flash.

Figure 5.58 - To see how underexposed the last photo was, press the MODE and SEL buttons together

A neat feature of the SB-800 is that it can use the FLASH button to "speak" to the other flashes in a wireless system. If you set up the SB-800 as a Commander flash, then pushing the FLASH button activates all the flashes listening to it. It pings the other flashes, causing them to ping back—a valuable feature when you need to make sure all the flashes are set to the same Channel and Group. Plus, it's just plain fun to push the button and watch the other flashes respond!

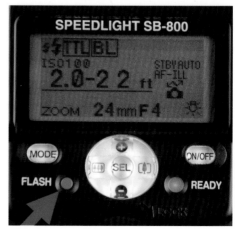

Figure 5.59 - SB-800 FLASH button

Mounting Foot Lock Lever

Obviously, this lever locks the flash on top of the camera. I highly recommend using it. It is especially important when you mount the flash to accessory platforms like light stands or other tripods. You don't want the flash to fall off and smack on the ground (figures 5.60 and 5.61).

Figure 5.60 - Lever is unlocked. Notice that the locking pin does not protrude from the base (red circle).

Figure 5.61 - Lever is locked. Here, the locking pin does protrude from the base (red circle). When the flash is mounted, the pin will lock into the hot shoe and prevent the flash from falling off the camera.

Hot Shoe Contacts

There are four metal contacts on the bottom of the flash and four round circular contacts on the camera's hot shoe. Obviously, all four pins on the bottom of the flash must match up properly with all four contacts on the camera. If not, then the flash and camera cannot communicate.

I have had this happen many times when I moved too quickly and didn't fully secure the flash to the camera body. Nothing says "amateur" like staring at your flash and wondering why it won't fire (figures 5.62 and 5.63)!

Figure 5.62 - The flash has four conical electrical contacts that need to match up with the four contacts on the camera

Figure 5.63 - The camera has four hot shoe points that need to match up with the four contact pins on the flash

External AF Assist Illuminator Contacts

If you have the SC-29 flash TTL extension cable, then two metal contacts on the SB-800 enable the unit to function with the Wide Area AF Assist Illuminator. Basically, these two contacts match up with the SC-29 cable so you can activate or deactivate the AF Assist function. The SC-29 has a lever switch on the front that allows you to turn off the SB-800 AF Assist lamp and use only the AF assist lamp at the other end of the cable, mounted on the camera body (figure 5.64).

Why would you do this? Let's say you have the flash mounted to the TTL cable, but you are bouncing the flash off the ceiling or a wall. In this situation, the flash will emit the AF Assist pattern onto the ceiling or wall, not at the subject. But if you purchase the SC-29 cable, you can still use the AF Assist pattern function because there is an additional AF box that mounts on the camera body. Problem solved!

Modeling Light Button

One of the neatest features of the SB-800 is the Modeling Light, which gives you the opportunity to see where the shadows are going to fall before you take a photo. To activate the Modeling Light, press the button (figure 5.65). It's that simple.

Figure 5.64 - The AF Assist contacts allow you to use the SC-29 cable for auto focusing in dark rooms

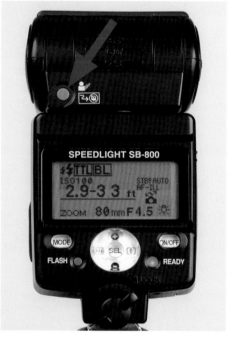

Figure 5.65 - Press the Modeling Light button to activate the flash's own Modeling Light or the Remote flashes' Modeling Lights

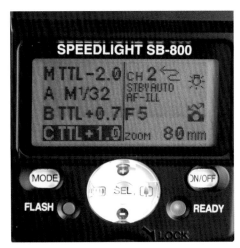

Figure 5.66 - In Commander mode, you can activate the Remote flashes' Modeling Lights from this screen. Press SEL until you hover over each group (e.g., Group C), then press the Modeling Light button. The Group C flashes' Modeling Lights will be activated.

I use the Modeling Light whenever I am worried about a shadow behind the subject. If I find a shadow, then I move the subject or myself until there is no longer a shadow. In addition, I might press the Modeling Light when bouncing the flash off the ceiling or a wall to see the effect on the subject's face or under their eyes.

There's another cool thing about the Modeling Light: when the SB-800 is in Commander mode, you can trigger the Remote flashes with the Modeling Light button and make them respond (figure 5.66). Follow these steps:

1. Set up SB-800 as a Commander flash
2. Set up Remote flashes to correct Channel and Groups
3. Press SEL button on Commander SB-800 until you hover over Group A
4. Press Modeling Light button (Group A flash triggers)
5. Press SEL button on Commander SB-800 until you hover over Group B

6. Press Modeling Light button (Group B flash triggers)
7. Press SEL button on Commander SB-800 until you hover over Group C
8. Press Modeling Light button (Group C flash triggers)

TTL Multiple Flash Terminal

Use this terminal (figure 5.67) when you want to synchronize multiple flashes on a camera that is not CLS compatible (like the Nikon F100). The CLS cameras (D40, D90, D3, etc.) use a monitor pre-flash that would normally cause older camera/flash combinations to fire during the pre-flash. Older Nikon TTL systems don't incorporate a pre-flash into the TTL calculation.

When you use this setup, your other remote flashes can be older standard TTL flashes like the SB-26 or SB-28, and you can even add newer flashes like the SB-800. You can sync approximately five flashes together using the correct cords (SC-18, SC-19, SC-26, or SC-27). Remember, all the flashes must be in TTL mode, not TTL BL mode.

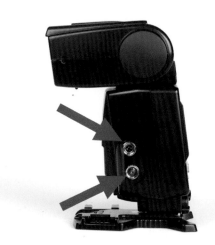

Figure 5.67 - The top terminal is the TTL Multiple Flash Terminal. The bottom terminal is the Sync Terminal.

To set up the flashes in this manner, follow these steps:

1. Set camera to Aperture Priority or Manual
2. Attach the SB-800 to the camera (must be a non-CLS compatible camera like the F100 or N90s)
3. Set flash mode to TTL
4. Attach sync cord to Commander flash
5. Attach sync cord to Remote flash
6. Set Remote flash to TTL
7. Take picture

Sync Terminal

If you use standard studio lighting equipment, then you will use the Sync Terminal (figure 5.68). Back in the day, we called this the PC cable, which stood for Positive Connection. All of the old cameras had built-in PC ports, so you just hooked the PC cable to the lights and the studio flash power pack, and voila, you were ready to go.

Nowadays, some cameras have built-in PC ports and others do not. For example, the Nikon D40, D50, D60, D70, D80, and D90 do not have PC ports, but the D200, D300, D700, D2, D3, and F6 do. Nikon provides a PC port on the SB-800 so it can be used as a studio light trigger even with cameras that don't have a PC port. Nikon sells PC sync cords such as the SC-11 and SC-15, but you can buy these types of cables from any camera store on the planet.

Here are the steps for using the PC terminal on the SB-800:

1. Turn off flash
2. Mount flash on camera
3. Turn on flash and set it for Manual mode
4. Connect sync cord to flash PC terminal
5. Connect sync cord to studio flash power pack
6. Turn on flash and power pack
7. Take picture

Two-Button Controls

The SB-800 has some hidden functions that are only accessible when you press two buttons together. Unfortunately, you need a really good memory because the combinations aren't shown with white lines on the back of the flash like the SB-600. But if you do forget them, you are in luck because Nikon printed them on the back of the SB-800's bounce card (see figure 5.69).

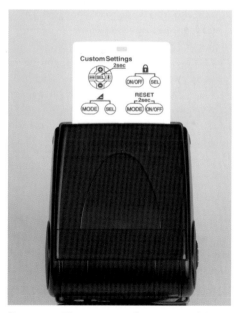

Figure 5.69 - This is your two-button control cheat sheet, located on the back side of the SB-800's bounce card

Figure 5.68 - PC cable terminal on the D700

Here are the hidden functions you can access when you push two buttons together:

- ON/OFF and SEL = Button Lock. Use this combination when you want to prevent someone from changing the settings on your flash. This is useful when you have the SB-800 configured as a Remote and someone finds it; you'd be surprised at how many people are tempted to push the buttons. Push the ON/OFF and SEL buttons together again to unlock the flash.

- MODE and SEL = Underexposure Amount. Sometimes after you take a shot, the READY light on the flash will blink for three seconds, which indicates it fired at maximum output. What this really means is that it needed more power but ran out of energy before the shot was properly exposed. If you missed the display, press MODE and SEL together and the flash will show the underexposed amount from the last shot. You can then increase your ISO, walk closer to the subject, zoom the flash head, or open up the aperture to get the proper exposure.

- MODE and ON/OFF = Reset. If you ever set up your flash and can't figure out how to get the system back to its defaults, press these two buttons together for a system reset. This will return all of your custom settings to the factory defaults.

SB-800 Custom Settings Menus

Getting into and out of the SB-800 Custom Settings Menus (CSM) is the secret to being proficient with the flash system. Most of the neat stuff you can do with the flash is accomplished by selecting from CSM. You need to know what the menus mean as well as how to set them up properly.

To access CSM, press the SEL button for two seconds. To exit from CSM, press the SEL button again for two seconds or press the ON/OFF button. Figure 5.70 shows this as a graphic.

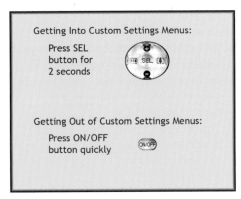

Figure 5.70 - Getting into and out of the SB-800 Custom Settings Menus (CSM) is very easy

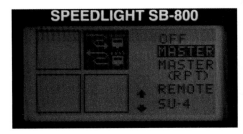

Figure 5.71 - In CSM, each menu item has its own box. There are 12 boxes total.

Once you access CSM, the screen changes to a 2 x 2 grid of square boxes (figure 5.71). Each box represents an individual menu item. To access a specific item, press the +, -, and ZOOM buttons until the box you want turns black.

To access the blackened CSM item, press the SEL button. This moves the cursor to the right-hand side of the screen. Next, press the + or - button to move the cursor over your choice. Then press the SEL button to activate your choice. Finally, press the ON/OFF button to exit CSM.

Here is the same sequence in a list:
1. Press SEL for two seconds
2. Press +, –, or ZOOM buttons to choose menu item
3. Press SEL button to activate menu item
4. Press + or – buttons to make choice
5. Press SEL button to activate choice
6. Press ON/OFF button to exit CSM

There are quite a few choices in CSM, and most people don't push the - button enough times to notice the boxes down below. You should have 12 CSM boxes, but not all of them will have something inside. Some boxes are only available when you configure flash a certain way. For example, the Standby (STBY) custom setting is not accessible when the flash is configured as a Remote. You wouldn't want the flash to go into Standby just as you were taking a Pulitzer Prize-winning photo of your Irish setter!

Now that you can access CSM, let's cover what each menu item does and how to use it.

SB-800 Custom Settings Menus (CSM) Summary

Screen Symbol	Title and Description
	ISO Use this setting when mounting your flash on an older camera like the FM3, FA, N50, or FM10. Nikon calls these cameras Group III to Group VII cameras. These camera bodies can't speak to the flash, so set the ISO manually. The range of ISOs you can set is between 3 and 8000, in 1/3 step increments. When you use the SB-800 on a newer SLR, the camera communicates the ISO directly to the flash, so there is no need to enter the ISO data manually.
	Wireless Flash Mode Use this menu to set up the SB-800 in wireless flash mode. Specific configurations and set-up directions appear later in this chapter. **OFF:** Returns flash to normal operation **MASTER:** Turns the flash into a Master (Commander) unit **MASTER (RPT):** Turns the flash into a Master (Commander) repeating unit **REMOTE:** Turns the flash into a Remote (Slave) unit **SU-4:** Turns the flash into an SU-4 type wireless unit
	Sound Monitor Turn this setting on or off to activate or cancel the beeps when the flash is used as a Remote. I generally like to keep the beeps on so I can hear if every thing worked properly. The proper sequence is "Beep Beep …. Beeeeeep". **ON:** Beep On **OFF:** Beep Off
	Non-TTL Auto Flash Mode Choose either A or AA when setting up your flash in Auto Flash mode. See previous section on Auto Flash for instructions on how to use these flash modes. **A:** Auto Flash (non-TTL Auto) **AA:** Auto Aperture mode

Table 5.3 SB-800 CSM descriptions

SB-800 Custom Settings Menus (CSM) Summary

Screen Symbol	Title and Description
	Standby Function (STBY) This setting determines how the flash goes into STBY mode. I typically leave my flash set to AUTO because it saves battery power by turning off whenever the camera is inactive. To get the flash out of STBY mode, press the camera's shutter release button or the flash's ON/OFF button. **AUTO:** SB-800 turns off when camera's exposure meter turns off **40:** 40-second delay until STBY **80:** 80-second delay until STBY **160:** 160-second delay until STBY **300:** 300-second delay until STBY **- - -:** Cancels STBY function
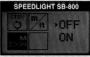	**m/ft Distance Unit of Measure** The setting allows you to choose the unit of measure you see on the LCD panel: meters or feet. **m:** Meters **ft:** Feet
	Power Zoom Function This setting activates or cancels the flash's automatic power zoom function. Normally, you want the flash head to zoom as you zoom the lens so the angle of view (lens) is matched by the angle of coverage (flash). For example, if you zoom your lens to 35 mm, you would typically want the flash zoomed to the same value. Nikon's terminology here is confusing, so let me explain it better: **OFF:** Automatic zoom will work **ON:** Automatic zoom won't work When you choose ON, the symbol on the LCD panel during normal operation has an "x" next to it (see photo on left). That "x" means you have deactivated the automatic zoom. Deactivate the automatic zoom when you place any diffusion device over the flash head (like a Gary Fong Light Sphere or Lumiquest soft box) or when you want to bounce the flash off a wall or ceiling.

Table 5.3 SB-800 CSM descriptions (continued)

SB-800 Custom Settings Menus (CSM) Summary

Screen Symbol	Title and Description

Screen Symbol **Title and Description**

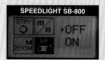

Broken Wide Angle Adapter

If you ever break off the built-in Wide Angle Adapter, then you can use this setting to allow the flash head to zoom. Normally, when the Wide Angle Adapter is deployed, the flash sets the head at 14 mm and then stops zooming. If you break off the adapter (which happens more often than you might guess), go here and turn the setting to ON. Then you can manually zoom the flash by pressing the ZOOM buttons. Note that the ON setting does not activate the automatic zoom if you've broken the adapter. Bummer.

ON: Manual setting activated (you can zoom flash manually)
OFF: Manual setting canceled (you can't zoom flash at all)

LCD Panel Illuminator

This setting turns off the LCD backlight function. Normally, when you press any button on the flash, the backlight comes on. I consider this to be a good thing and keep it on all the time. Maybe you would turn it off to keep from attracting moths to your flash at night.

ON: Allows backlight to turn on
OFF: Prevents backlight from turning on

LCD Panel Brightness

This setting allows you to change the brightness and contrast of the LCD panel. Adjust the brightness by pressing the ZOOM buttons (tree-shaped icons) on the flash. You have nine brightness steps to choose from. I keep it at the default setting which is halfway (shown at left).

Wide Area AF Assist Setting

This setting activates or cancels the Wide Area AF Assist Illuminator on the flash. I like to keep mine active so when I photograph in dark places like dungeons and caves I can still use the autofocus system (it also works really well for wedding receptions and nighttime outdoor photography). Turn it off if you don't want the flash to send out the autofocus assist pattern.

When the setting is turned on, AF-ILL appears on the LCD panel. This means AF Illumination is active and will turn on in a dark room. When the setting is turned off, NO AF-ILL appears on the LCD panel. This means AF Illumination is canceled for all situations.

ON: Activated
OFF: Canceled

Table 5.3 SB-800 CSM descriptions (continued)

SB-800 Custom Settings Menus (CSM) Summary

Screen Symbol	Title and Description
	Canceling Flash Firing Lots of people wonder why you would want to use this setting because it stops the flash from firing when you take a picture. Normally, if you turn the flash on, you want the flash to fire. There are times, though, when you want to use the flash's Wide Area AF Assist lamp to help the lens focus, but you don't want to pop the flash. For example, if you are composing a photograph by a window and don't want to add fill-flash, turn this custom setting to OFF. That will allow you to focus accurately by using the AF Assist pattern but won't fire the flash during the exposure. **ON:** Flash fires normally **OFF:** Flash is canceled during the exposure **Note:** Some Nikons like the D200, D300, D700, D3, and D2X have a programmable button on the camera body called the FUNC button. You can program this button to cancel the flash when you press it. See chapter 11 for details.

Table 5.3 SB-800 CSM descriptions (continued)

Using the SB-800 as a Dedicated Flash

Most people use the SB-800 as a Dedicated flash attached to the camera's hot shoe (figure 5.72). In this configuration, you can use the flash in any of these standard modes:

- TTL BL
- TTL
- Manual
- Auto
- Auto Aperture
- Guide Number
- RPT

A fully Dedicated flash means that all of the flash's capabilities can be used by the camera body. Also, the flash and the camera body communicate back and forth to relay information such as zoom settings, aperture, shutter speed, and power (figure 5.73).

The SB-800 also functions as a fully Dedicated flash when it is attached via a TTL remote cord such as the SC-17, SC-28,

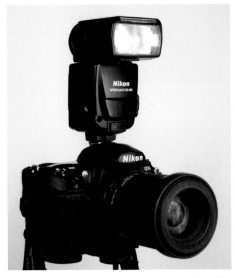

Figure 5.72 - The SB-800 makes a great Dedicated flash as shown here on the D200

System Setup for Common Shooting Scenarios

Shooting Scenario	Camera Sync Mode	Flash Mode	Flash Power	Comments
Outdoor & Travel	Slow + Rear	TTL BL	-0.7	Goal is to use subtle fill flash balanced with ambient light
Window Portraits	Slow + Rear	TTL BL	-0.7	Goal is to use subtle fill flash balanced with ambient light
Formal Studio Lighting (umbrellas, reflectors, etc.)	Normal (Front Curtain)	TTL BL or Manual	Variable	Goal is for flash to provide 100% of light, with no ambient light to speak of
Wedding Reception in Dark Room	Normal (Front Curtain)	TTL BL or AA	0.0 (but change as necessary)	Goal is for flash to provide 100% of light. Mount flash on bracket and use diffusion dome.

Table 5.4

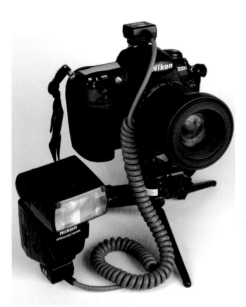

Figure 5.73 - The SB-800 also functions as a Dedicated flash when connected via a TTL cord like the SC-17, SC-28, or SC-29

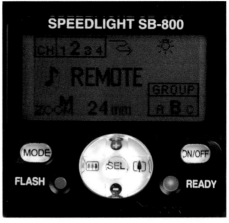

Figure 5.74 - REMOTE screen on the SB-800. This flash is set up to be a Remote for Channel 2, Group B. In order for it to fire, the Commander unit needs to send out information on Channel 2, Group B as well.

or SC-29 (figure 5.74). These cables provide full TTL operation just as if the flash were mounted on top of the camera.

In general shooting scenarios where you want to operate quickly, I suggest setting the flash mode to TTL BL. Table 5.4 shows some general settings for the camera and flash in various scenarios.

Using the SB-800 as a Remote Flash

The SB-800 works exceedingly well as a Remote flash unit (figure 5.76). In this scenario, you need some type of Commander flash to send instructions to the Remote SB-800. The Commander can be another SB-800 (see the next section for how to set this up), an SB-900, an SU-800, or the pop-up flash from a D70, D80, D90, D200, D300, or D700. See chapter 2 for a quick guide to configuring your SLR as a Commander unit. Chapter 6 shows how to set up the SB-900 as a Commander, and chapter 7 shows how to set up the SU-800 as a Commander.

Setting up the SB-800 as a Remote flash requires you to go into the Custom Settings Menus and set the Wireless Remote mode to REMOTE.

Here are the steps to configure the SB-800 as a Remote:

1. Turn on flash
2. Press SEL button for two seconds
3. Press ZOOM buttons along with + and - buttons to navigate to the squiggly arrow box
4. Press SEL button
5. Press - button to navigate to REMOTE
6. Press SEL button
7. Press ON/OFF button
8. Press SEL button to navigate to Channel
9. Press + or - button to change Channel
10. Press SEL button to navigate to Group
11. Press + or - button to change Group
12. Make sure Commander flash is set to same Channel and Group
13. Take picture

A number of things must be set up properly between the Commander unit and the Remote unit. For example, both the Commander and Remote need to be set to the same Channel (e.g., CH 1) and Group (e.g., Group C).

Figure 5.75 - The Light Sensor for Wireless TTL flash control is located beside the battery chamber. Point this sensor towards the Commander flash.

Once you configure the flash as a Remote unit, it takes all of its firing instructions from the Commander unit. These instructions are broadcast via light pulses which the Remote receives through the Light Sensor on the side of the flash (figure 5.75).

Make sure you point this sensor towards the Commander flash. It is pretty sensitive, but there are times when communication fails because it literally can't see the light.

When people first learn this system, one of the most common problems is forgetting to turn on the Commander flash unit. I know it sounds obvious, but to first-time users, it is not intuitive. Remember, the Commander unit might be another SB-800, an SB-900, an SU-800, or a pop-up flash on your camera.

Note: If the Commander is a pop-up flash, be sure to pop it up!

Using the SB-800 as a Commander Unit

The SB-800 can be configured as a Commander flash to control a host of Remote flashes (figure 5.76). I get very consistent results when using the SB-800 as a Commander as opposed to using a pop-up flash as a Commander. One reason is that the SB-800 packs a lot of punch, and its light pulses can be seen far and wide. In contrast, the camera's pop-up flash has a relatively small amount of power.

I typically see a 10-15% failure rate when I use the pop-up flash as a Commander, but I hardly ever get failed flash photos when I use the SB-800 as a Commander. This isn't because pop-up flashes are "bad"; the SB-800 simply has much more broadcast power. By the way, the SB-900 and the SU-800 are also very good Commander units with lots of broadcast power.

Setting up the SB-800 as a Commander is a fairly straightforward process once you get the hang of it (figure 5.77). Unfortunately, Nikon hides the settings behind a few menus,

so you need to access them from the Custom Settings group. Here are the steps:

1. Turn on flash
2. Press SEL button for two seconds
3. Press the ZOOM buttons along with the + and - buttons until you navigate to the squiggly arrow box
4. Press SEL button
5. Press - button until you navigate to MASTER
6. Press SEL button
7. Press ON/OFF button
8. Press SEL button to navigate to Master, Group A, Group B, Group C, and CH settings
9. Press + and - buttons to change power
10. Press MODE button to change Group flash mode
11. Make sure Remote flashes are set to same Channel and Group
12. Take picture

Let's talk more about each of these settings on the back of the flash (figure 5.77).

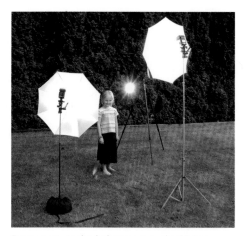

Figure 5.76 - In this lighting setup, the SB-800 is configured as a Commander to control three groups of flashes. Group A is on the left, Group B is on the right, and Group C is behind the subject.

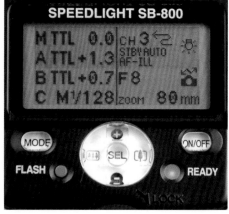

Figure 5.77 - SB-800 Commander Mode screen. The Group icons are on the left (M, A, B, C). Mode is the second column (TTL, M, AA, - -). Output is the third column (0.0, +1.3, +0.7, 1/128). Channel is on the right (CH 3).

Group

The left column of letters on the flash's LCD represents the different Group designations. You can't change the letters themselves, but it is helpful to know what they stand for:

- **M** = Master Flash Settings
- **A** = Group A Settings
- **B** = Group B Settings
- **C** = Group C Settings

Each Group can consist of one flash or multiple flashes. The Master flash (M) is the flash positioned on top of the camera—in this case, the SB-800.

Mode

Each Group can operate in a different flash mode. For example, the flashes in Group A can operate as TTL flashes while those in Group B can operate as Manual flashes. Pressing the MODE button changes the flash mode for a particular group. Here is what each designation means:

- **TTL = Through The Lens mode.** This mode behaves just like the normal TTL mode described earlier. I use this mode for flashes that are set up in front of the subject.
- **AA = Auto Aperture mode.** This mode behaves like normal AA in that it uses the flash's sensor to judge flash output. If you set up a flash group as AA, then all the flashes must be capable of being AA flashes. In other words, you can't have SB-600 Remote flashes in a Group set for AA. Also, make sure the SB-800 or SB-900 Remote flashes have their light sensors pointed at the subject. That's the only way the system can properly judge exposure.
- **M = Manual mode.** This mode sets up the flashes as full Manual strobes. The Commander SB-800 sends out instructions to each flash in the group and tells them all what power level to shoot at. For example, all of the flashes in Group A will fire at 1/128 power if you set the Group value to 1/128.

- **- - - = Off mode.** You can turn off Groups from the Commander unit by selecting - - - as the flash mode. This will deactivate the entire group for the photograph. Sometimes this is useful when you want to see each flash group's individual impact. Note that if you turn off the Group M (Master flash), it won't fire during the actual exposure. This can be confusing because the Master flash still sends out pre-flashes when you push the shutter release, even though the unit itself doesn't fire.

Output

The neat thing about using the Nikon wireless system is the ability to change flash output from the back of the Commander unit. This means you don't have to walk over to each Remote flash unit to change the power. How cool is that?!

To change the flash power for a specific Channel, press the + and – buttons when that Channel is selected. In TTL mode, the readout is in terms of stops. For example, +1.3 means one-and-a-third stops brighter than 0.0. In Manual mode, the readout is in terms of fractions. For example, 1/64 means one-sixty-fourth power.

Channel

Nikon's wireless system allows you to choose from Channels 1, 2, 3, and 4 (figure 5.78). This is helpful when two or more photographers in the same vicinity want to use Nikon CLS wireless flashes. Here are a couple of

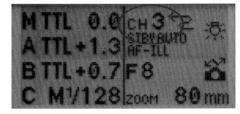

Figure 5.78 - There are four channels to choose from: 1, 2, 3, and 4. This flash is set up for CH 3.

situations where it makes sense to use different Channels:

1. At a press conference where there are multiple Nikon shooters and each one has a wireless setup. Before the event, meet with the other photographers to determine who will be on what channel.

2. At a high school dance with your photo assistant. You take formal photographs along a wall with a wireless studio setup on Channel 1. Your assistant takes informal photographs on the dance floor on Channel 2 with lights set up at each corner to provide ample coverage.

You may be wondering whether any other manufacturer's flashes will set off the Nikon wireless system. The answer is no, for the most part. For example, if you are at a wedding and Aunt Matilda takes a photo with her Olympus point-and-shoot, it won't affect your wireless setup. There are some manufacturers such as Metz and Radio Popper who design their equipment to interface with the Nikon wireless flash system.

Other SB-800 Commander Functions
Modeling Light
If you want to preview your lighting setup, you can use the SB-800 to activate each light in your system by pressing the Modeling Light button on the back of the flash. More specifically, you can activate each Group together by selecting that Group and then pressing the Modeling Light button. Here are the specific steps:

1. Set up SB-800 as a Commander flash
2. Press SEL button until Group A is highlighted
3. Press Modeling Light button

You can continue through this process to activate the Modeling Lights of each Group by simply highlighting Group B and then Group C.

Also, if you have a D200, D300, D700, D2, or D3 (figure 5.80), you can activate all the flashes together by pressing the Depth of Field (DOF) Preview button on the camera body (see chapter 13 for more information).

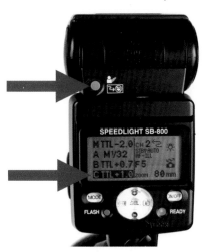

Figure 5.79 - The Modeling Light is a great feature in wireless Commander mode because you can activate each of the Remote flash's Modeling Lights while standing behind your camera. In this image, the Modeling Lights on the Group C flashes will fire when the Modeling Light button is pressed.

Figure 5.80 - Pressing the Depth of Field (DOF) Preview button on your D200, D300, D700, D2, or D3 will activate all the Modeling Lights in your entire wireless system

Flash Button

Sometimes it is beneficial to see if each of the Remote flashes is "listening" before you trip the shutter. You can use the SB-800 to ping all of the Remote flashes by simply pressing the FLASH button (figure 5.81). When you do this, each Channel will ping back in sequence. If a Remote flash is tuned to the wrong Channel, it won't ping in response to the Commander flash. By the way, the ping I'm referring to is a single pulse of light.

Here are the steps to do this:

1. Set up SB-800 as a Commander flash
2. Set up Remote flashes for correct Channel and Groups
3. Press FLASH button
4. Watch the remote flashes ping back

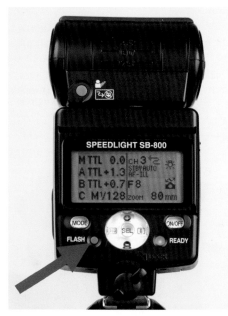

Figure 5.81 - Pushing the FLASH button in Commander mode will ping all of the Remote flashes. Each flash in Group A, B, and C will ping back in sequence if set to the correct Channel and Group. This is a great way to check your system setup before actually taking photos.

Using the SB-800 as *a Repeat* Commander Unit

This mode is different from the standard SB-800 Commander mode. Use this mode when the regular Repeat (RPT) mode on the flash doesn't have enough power to illuminate the scene by itself. In this scenario, you can configure the SB-800 as a Repeat Commander unit (figure 5.82) and instruct a bank of Remote flashes to fire in sync.

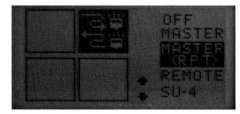

Figure 5.82 - Access the Master REPEAT mode from the Wireless CSM (Custom Settings Menus)

Here is how to set up the SB-800 as a Repeat Commander unit:

1. Turn on flash
2. Press SEL button for two seconds
3. Press the ZOOM buttons along with the + and - buttons until you navigate to the squiggly arrow box
4. Press SEL button
5. Press - button until you navigate to MASTER (RPT)
6. Press SEL button
7. Press ON/OFF button
8. Press SEL button to navigate to Master, Group A, Group B, Group C, Power, Frequency, Qty, and CH settings
9. Press + and - buttons to change values
10. Press MODE button to change Group flash mode
11. Make sure Remote flashes are set to same Channel and Groups
12. Take picture

To navigate around this new screen, press the SEL button to skip from setting to setting.

Let's talk about each of the settings shown in figure 5.83.

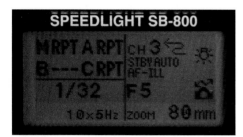

Figure 5.83 - This is the main control screen for Repeat Commander mode. Push the SEL button to jump from setting to setting.
M = Master Flash
A = Channel A
B = Channel B.
C = Channel C
RPT = Flash will Repeat
- - - = Flash is off.
1/32 = Output for each pulse
10 = 10 total pulses
5 Hz = 5 pulses per second
CH 3 = Channel 3

Group

The letters M, A, B, and C on the flash's LCD represent the different Group designations. You can't change the letters themselves, but it is helpful to know what they stand for:

• **M** = Master Flash Settings
• **A** = Group A Settings
• **B** = Group B Settings
• **C** = Group C Settings

Each Group can consist of one flash or multiple flashes. The Master flash (M) is the flash that is positioned on top of the camera—in this case, the SB-800.

Mode

Each Group can operate in one of two flash modes: RPT or - - -. For example, Group A can operate as RPT while Group B is turned off (- - -). Pressing the MODE button changes the flash mode for the Group. Here is what each designation means:

• **RPT = Repeat Flash mode.** This activates the group as a Repeat flash.
• **- - - = Off mode.** You can turn off Groups from the Commander unit by selecting - - - as the flash mode. This will deactivate the entire Group for the photograph. Sometimes this is useful when you want to see each flash Group's individual impact. Note that if you turn off the M group (Master flash), it won't fire during the actual exposure. This can be confusing because the Master flash still sends out pre-flashes when you push the shutter release, even though the unit itself doesn't fire.

Output

Just like in a normal wireless setup, you can change flash output from the back of the Commander unit. This means you don't have to go over to each Remote flash unit to change the power. To change the flash power, press the + and - buttons. In this mode, the readout is in terms of fractions. For example, 1/64 means one sixty-fourth power.

Frequency

This is how many pulses per second the flash will fire. For example, 5 Hz means the flash fires five times per second.

Quantity of Pulses

This is how many times the flash fires until it stops. For example, a value of 10 means the flash fires 10 times and then stops firing.

Channel

You still have four Channels to choose from in Wireless Repeat mode: Channels 1, 2, 3, and 4. Generally, you work alone in a studio when using Repeat Commander mode, so there is less need for all four Channels than when photographing in a group of other photographers.

When it comes time to take the photograph, set the camera's exposure mode to Manual. You then need to figure out the shutter speed and aperture. Here's how:

- Calculating Shutter Speed: Divide the Quantity of flashes by the Frequency. For example, if the flash fires a total of 10 times and the Frequency is five flashes per second, then the duration of the sequence is two seconds (10 flashes divided by five flashes per second is two seconds). Another example: if your flash fires at two flashes per second and you fire a total of 20 times, then the duration of the sequence is 10 seconds (20 flashes divided by two flashes per second is 10 seconds). You then set that value as the shutter speed.

- Figuring Out Aperture: The smaller the aperture you use, the closer you must be to your subject. For example, f/11 might require you to be two feet away, whereas f/4 would allow you to be eight feet away. Keep adjusting the aperture on the camera body until you are happy with the working distance between the flash and the subject.

Some Other Tips

Make sure the ambient light is very low or even nonexistent so your subject is only exposed by the flash. Also, try to make your backgrounds very dark in color. In other words, make your studio almost completely black. The reason is that you typically want the entire scene to be lit up just by the flash and not by any ambient light. Finally, position your subject far away from the background. This will keep the flash's reflected light from lighting up the background.

Using the SB-800 as an SU-4 Unit (Commander or Remote)

A few years ago, Nikon introduced a simple system aimed at allowing wireless TTL flash control. This system was introduced in the era of the N90s and the F5 film cameras and was actually pretty ingenious. It required the use of an SU-4 unit (figure 5.84) attached to a normal TTL flash such as an SB-26 or SB-28.

If you have older flashes and SU-4 units lying around, you might like to use them in a wireless setup. As you know, though, they will not work with the Nikon CLS wireless setup. Fortunately, Nikon installed a function in the SB-800 that allows it to operate like older TTL flash systems that didn't have pre-flash technology.

When you set up the SB-800 in this mode (figure 5.85), the flash emits only one pulse of light (rather than the two you would normally get with the iTTL pre-flash). When the SB-800 stops putting out light, all of the SU-4 Remote flashes also stop putting out light. Simple.

Figure 5.84 - The SU-4 unit, Nikon's original wireless remote module. The SB-800 still supports this unit and SU-4 flash mode via the Custom Settings Menus and the SB-800's built-in Light Sensor.

Figure 5.85 - This is the Custom Settings Menu screen to set up SU-4 mode on the SB-800

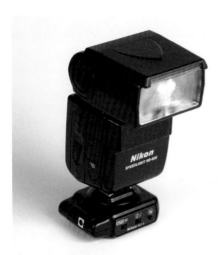

This next part is a little bit confusing. The SU-4 shown in figure 5.84 operates in SU-4 flash mode when mounted on another Nikon flash like the SB-26. Many times people refer to an SU-4 when they talk about the actual unit (figure 5.84). They also refer to SU-4 *mode*, which references the setting in the SB-800 flash that simulates the operation of the SU-4 unit.

Figure 5.86 shows an SB-600 attached to an SU-4 Remote module. This allows the flash to listen to SU-4 instructions from the SB-800. When the SB-600 is attached to an SU-4, it needs to be set for Manual output (figure 5.87). Also, the switch on the SU-4 module needs to be set for Manual.

You can also use your older Nikon flashes such as the SB-26, SB-80, etc. with the SU-4 Remote module (figure 5.90) as long as they receive instructions from the SB-800 that is set up in SU-4 mode.

Figure 5.86 - The SB-600 can be attached to an SU-4 and will work just fine as a Remote unit

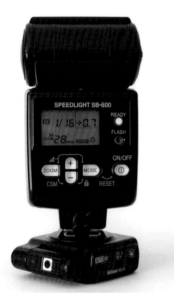

Figure 5.87 - Note that when the SB-600 is mounted on an SU-4 unit, the flash must be set up in Manual mode

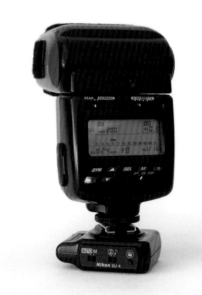

Figure 5.88 - Older flashes like the Nikon SB-26 work great in SU-4 mode. You can also use it with flashes from Metz, Vivitar, Canon, etc. if they are set up in Manual mode.

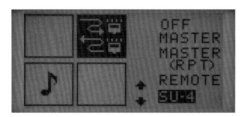

Figure 5.89 - Here is the SB-800 Custom Settings Menu for SU-4 mode

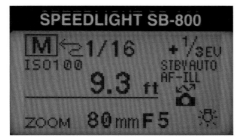

Figure 5.90 - This is what the SB-800 screen looks like in SU-4 Manual mode. Notice that the squiggly arrow points to the left. That is Nikon secret code speak for "Commander" in SU-4 mode.

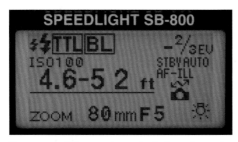

Figure 5.91 - When you have the flash configured as an SU-4 Commander, TTL BL mode behaves exactly as before. ***Do not do this.***

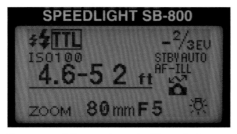

Figure 5.92 - When you have the SB-800 flash configured as an SU-4 Commander, TTL mode behaves exactly as before. ***Do not do this.***

Here's how to set up SU-4 mode on the SB-800:

1. Mount the SB-800 on your camera
2. Turn on the SB-800 and camera
3. Press SEL button for two seconds
4. Press the ZOOM buttons along with the + and - buttons until you navigate to the squiggly arrow box
5. Press SEL button
6. Press - button until you navigate to SU-4
7. Press SEL button
8. Press ON/OFF button
9. Press MODE button to choose flash mode
10. Press + and - buttons to change power
11. Press SEL button to navigate to different settings
12. Attach SU-4 to Remote flash units (e.g., SB-26)
13. Turn SU-4 switch to Auto or Manual
14. Take picture

Now that the Commander flash is set up as an SU-4 unit, it behaves a bit differently than you are used to in *most* of the flash modes. I say "most" because TTL BL and TTL operate exactly as before. In other words, the flash works as a regular TTL BL flash, not an SU-4 Commander unit. I wish Nikon had eliminated TTL and TTL BL from the choices once you select SU-4 to eliminate confusion. The other modes, such as AA, GN, M, and RPT, are different than before. Let's review each flash mode here to understand what is happening. Press the MODE button to toggle between each of these modes.

TTL BL (SU-4)

This is the same as the standard TTL BL flash (figure 5.91). When the Custom Settings Menu is set for SU-4 and the flash mode is set for TTL BL, then the flash will fire preflashes and cause the SU-4 Remotes to fire prematurely. This mode is not designed for use with SU-4 Remotes. **Do not use TTL BL in SU-4 mode.**

TTL (SU-4)

This is the same as the standard TTL flash (figure 5.92). When the Customs Settings Menu is set for SU-4 and the flash mode is set for TTL, then the flash will fire pre-flashes and cause the SU-4 Remotes to fire prematurely. This mode is not designed for use with SU-4 Remotes. **Do not use TTL in SU-4 mode.**

AA (SU-4)

AA SU-4 mode is shown in figure 5.93. Here, you can use the SU-4 Remote flash's own light sensor to judge flash output. This mode is not a TTL mode and relies heavily on the Remote flash's ability to judge exposure. Therefore, the Remote flash needs to be capable of Auto Flash operation by itself. For example, an SB-600 cannot be an SU-4 Remote AA flash, but the SB-26 can be an SU-4 Remote flash in AA mode *if* you have the SB-800 Commander configured for AA mode.

Make sure the Remote flash's Light Sensor is aimed squarely at the subject with nothing in the way. For example, if you place

the Remote flash behind an umbrella in AA mode, the flash will judge exposure off the back of the umbrella!

When in AA mode, be sure the SU-4 Remotes are in the same mode. This means they must be set up as Auto Flashes in SU-4 mode. Here's how to do this on three flash models:

- **SB-26:** Mount the SB-26 to the SU-4 controller. Set the SU-4 to AUTO. Set the SB-26 to A (Auto).

- **SB-800:** Turn the SB-800 to SU-4 mode from the Custom Settings Menus. Press the MODE button until you see A (figure 5.96). Notice that the SB-800 does not require mounting an additional SU-4 unit. The SB-800 is its own SU-4 controller.

- **SB-900:** Turn the SB-900 to SU-4 mode from the Custom Settings Menus. Rotate the power switch to Remote. Press the MODE button until you see A. Like the SB-800, the SB-900 does not require mounting an additional SU-4 unit, since the SB-900 is its own SU-4 controller (figue 5.94).

Figure 5.93 - Here is SU-4 AA mode on the SB-800. This mode works just great. Be sure to configure your Remote flash as an AA flash, too.

Figure 5.94 - This is what the SB-800 screen looks like in SU-4 AA mode as a Remote flash. It is not connected to the SU-4 control module because the SB-800 has its own built-in SU-4 controller. Notice also that the squiggly arrow points to the right, which is Nikon secret code speak for "REMOTE" in SU-4 mode.

GN (SU-4)

When you have the SB-800 mounted as an SU-4 Commander (figure 5.95), you can still use GN mode. This mode only configures the SU-4 Commander as a GN flash. The SU-4 Remote flashes operate as either M (Manual) or A (Auto) flashes, depending on how you set them. For more information on GN usage, read the GN mode section earlier in this chapter.

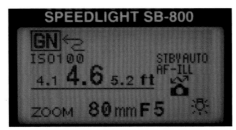

Figure 5.95 - When you configure the SB-800 as an SU-4 GN flash, only it works using the GN calculation. The Remote SU-4 flashes work as regular Manual or Auto flashes, depending on how you configure them.

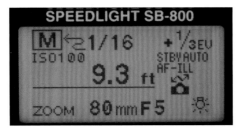

Figure 5.96 - Manual is the most practical method to use in SU-4 mode because you have full control over the lighting in your scene. This SB-800 is configured as an SU-4 Commander. You can tell because the squiggly arrow is pointing to the left.

Figure 5.97 - Set the switch on the SU-4 controller module to M when your flash system is in Manual mode

M (SU-4)

M (Manual) mode is probably the most practical of the SU-4 modes because it gives you the most control (figure 5.96). You also need some method to determine your exposures, so I recommend using a hand-held light meter when you set up your lighting arrangement.

The first step in using SU-4 Manual mode is to set up your Commander SB-800 as an SU-4 unit as previously explained and mount it on your camera. Next, press the MODE button until it displays M (manual). Next, press the + and - buttons until you set the appropriate power.

Now, set up your Remote flashes as SU-4 remotes:

- **Old Flash Models:** Mount the older flash (e.g., SB-26 or other manufacturer's flash unit) to the SU-4 controller module (figure 5.99). Set the SU-4 to M (Manual). Set the flash's mode to M (manual). Press the + and - buttons on the flash to adjust power output.

- **SB-800:** Turn the SB-800 to SU-4 mode from the Custom Settings Menus. Press the MODE button until you see M. Note that the SB-800 does not require mounting an additional SU-4 unit. The SB-800 is its own SU-4 control module. Press the + and - buttons to set the power output (figure 5.100).

- **SB-900:** Turn the SB-900 to SU-4 mode from the Custom Settings Menus. Turn the power switch to Remote. Press the MODE button until you see M. The SB-900 does not require mounting an additional SU-4 unit since it is its own SU-4 controller. Change the power by pressing Custom Settings Button 1 and then rotating the control dial.

- **SB-600:** Set the SB-600 for Manual mode. Press the MODE button until you see M. The SB-600 requires that you mount an SU-4 unit to its base. Set the SU-4 to M (Manual). Press the + and - buttons on the flash to set the power output.

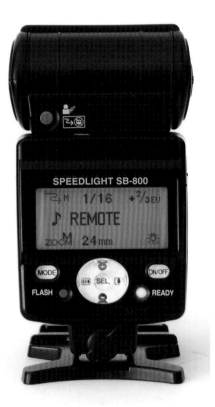

Figure 5.98 - The SB-26 is mounted on an SU-4 control module and will work well as an SU-4 Manual Remote flash unit. Just about any other flash you own will also work fine with the SU-4 control module.

Figure 5.100 - The SB-800 does not need to be attached to anything to work as an SU-4 Remote flash unit. Just set up the CSM menu for SU-4, then press the MODE button until the LCD screen shows M.

Figure 5.99 - The SB-600 is mounted on an SU-4 control module and will also work well as an SU-4 Manual Remote flash unit

RPT (SU-4)

You can also set up an SU-4 system in RPT (Repeat) mode (figure 5.101). Setting up the Commander SB-800 works the same as described earlier in this chapter. Push the MODE button until you see RPT. Next, press the SEL button to toggle between Power, Frequency, and Total Pulses. Press the + and - buttons to change the values.

Set up the Remote flashes as SU-4 Manual Remote strobes. Here's how to do it for each model:

- **Old Flash Models:** Mount the older flash (e.g., SB-26 or other manufacturer's flash unit) to the SU-4 controller. Set the SU-4 to M (Manual). Set the flash's mode to M (Manual). Press the + and - buttons on the flash to adjust power output.
- **SB-800:** Turn the SB-800 to SU-4 mode from the Custom Settings Menus. Press the MODE button until you see M. Notice that the SB-800 does not require mounting an additional SU-4 unit. The SB-800 is its own SU-4 controller. Press the + and - buttons to set the power output (figure 5.103).
- **SB-900:** Turn the SB-900 to SU-4 mode from the Custom Settings Menus. Turn the power switch to Remote. Press the MODE button until you see M. The SB-900 does not require mounting an additional SU-4 unit since it is its own SU-4 controller. Change the power by pressing Custom Settings Button 1 and then rotating the control dial.
- **SB-600:** Turn the SB-600 to Manual mode. Press the MODE button until you see M. The SB-600 does require mounting an SU-4 unit. Set the SU-4 to M (Manual). Press the + and - buttons on the flash to set the power output (figure 5.104).

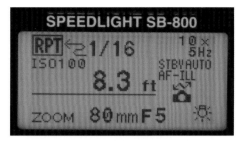

Figure 5.101 - SU-4 Repeat mode works exactly the same as standard Repeat mode. Make sure that each of the Remote flashes is set up in Manual SU-4 mode.

Figure 5.102 - The SB-26 works very well as a Remote SU-4 Repeat flash. Mount it on the SU-4 control module and set it for M. This Remote flash will only fire if the SB-800 mounted to your camera is configured as an SU-4 Commander unit.

Figure 5.103 - The SB-600 also works great as a Re-mote SU-4 Repeat flash. Mount it on the SU-4 control module and set it for M.

Figure 5.104 - If you want to use the SB-800 as a Remote SU-4 Repeat flash, you don't need to mount the SU-4 control module. Just configure the flash's Custom Settings Menu to SU-4 mode, then press the flash's MODE button until you see M on the LCD.

SB-900 Buttons, Modes, Menus, and Operation

The SB-900 is Nikon's newest and most advanced Speedlight. The designers have worked very hard to improve upon the flash's interface, controls, and overall usability.

The SB-900 is typically used in three ways:

- Dedicated flash mounted directly to your camera
- Commander flash to control other wireless remotes
- Wireless Remote flash

SB-900 Buttons and Controls

Flash Head

To point the flash head in different directions, press the Tilt button (figure 6.1) with your finger and rotate the head. The flash head on the SB-900 rotates 180 degrees to each side (360 degrees total) and 90 degrees vertically. You need to press the button to begin movement, but you don't need to keep pressing it to continue.

If you look closely at the back of the flash head, you will notice it has angle scales on it. However, they are not really useful unless you are telling someone else how to set up your flash (figure 6.2).

The SB-900 also has a -7 degree position (figure 6.3) that is used for doing macro work when mounted on top of your camera. Pay close attention to this setting, because many functions of the flash are not accessible when the head is at -7 degrees (e.g., GN).

Figure 6.1 - SB-900 Tilt button. Push this button to rotate or tilt the flash head. In this example, the flash head is at the horizontal front position.

Figure 6.2 - SB-900 flash head at 45 degrees, front position

Figure 6.3 - SB-900 flash head at -7 degrees, front position. This position is used for macro photography.

Wide Angle Adapter

If you use a lens with an angle wider than 12 mm, it makes good sense to pull out the Wide Angle Adapter (figure 6.4). Notice that when you deploy it, the flash automatically zooms to 10 mm (figure 6.5). This means that the Wide Angle Adapter allows an angle of coverage the same as a 10 mm lens. If you don't deploy it in this situation, you run the risk of light fall-off in the corners of the photograph. However, the SB-900 has such a wide range of coverage that this is rarely an issue.

Bounce Card

Nikon includes a small built-in bounce card on the SB-900. The card automatically extends when you pull out the Wide Angle Adapter (figure 6.6). The purpose of the bounce card is to reflect light forward to the subject while allowing some light to bounce off the ceiling. Doing this hopefully creates a nice catch light in the subject's eyes. It also serves to lighten up the dark shadows that frequently appear under the eyes.

In reality, this 1.5" x 2" bounce card is too small to be very effective. A *real* bounce card should be at least 4" x 6" or larger (figure 6.7). Bigger is better when it comes to light diffusion, and bounce cards are no different. Most photographers who use bounce cards end up taping or rubber-banding a larger card to the back of the SB-900. These provide much better results!

Figure 6.4 - Wide Angle Adapter is deployed

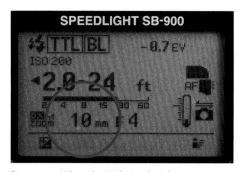

Figure 6.5 - When the Wide Angle Adapter is out, the zoom setting automatically changes to 10 mm as the default

Figure 6.6 - When using the bounce card, deploy the Wide Angle Adapter for best results. Also, point the flash head upwards at 45 degrees.

If you to want to use the built-in bounce card, set up the flash head at about 45 degrees. At this setting, some light will bounce off the ceiling (assuming you are inside), and some light will reflect off the card towards the subject. I like to extend the Wide Angle Adapter when using the bounce card, but if you want, you can push it back into the flash head (figure 6.8).

Figure 6.7 - This is a "real" bounce card that actually has some usable surface area. It is 5" x 8". The bigger your bounce card, the better your flash results! Attach it with Velcro® or gaffer tape.

Figure 6.8 - A good substitute for a bounce card is to use your hand instead. Your hand will add a nice warming effect to the light and produce excellent results. Try it, you'll like it!

Wide Area AF Assist Illuminator

The Wide Area AF Assist Illuminator is a fantastic feature that automatically activates in dark rooms to assist your camera's autofocus sensors. This feature normally overrides the camera body's AF Assist Illuminator (found on cameras like the D60, D90, and D700). This pattern also activates when the flash is used with a TTL extension cord such as the SC-17, SC-28, or SC-29 (figvures 6.9 and 6.10).

Figure 6.9 - The Wide Area AF Assist pattern is generated behind the red window in the front of the flash

IMPORTANT!

You must set up the following things properly for the Wide Area AF Assist Illuminator to work:

1. Turn on the autofocus (the switch on the camera body down by the lens mount)
2. Set your camera to AF-S (not AF-C)
3. Position the autofocus sensor so it can "see" the flash's red pattern–for example, in the center position of your camera's viewfinder
4. Make sure the ambient light is dark enough for the camera to activate the red pattern
5. Turn on your flash and your camera
6. Turn on your flash's Custom Settings Menus for AF-ILL

Once these conditions are met, the AF Illumination pattern will work from the flash head. (Why can't they make this stuff easier?)

Figure 6.10 - This is what the pattern looks like against a wall in a dark room

Light Sensor for Auto Flash

The SB-900 has the special ability to work as an automatic flash unit. What this means is that it can determine the appropriate exposure automatically by using its own built-in light sensor (figure 6.11), rather than by using the camera's TTL exposure system. More information on how this works appears later in this chapter.

External Power Source Terminal

The External Power Terminal is located on the front of the flash behind the plastic Nikon insignia (figure 6.12). Pull off the little plastic cap to access the terminal. If you use accessory flash power such as the Nikon SD-8A, SD-9, or an alternative product such as a Sunpak, Quantum Turbo, or Al Jacob's Black Box (see chapter 12), plug the unit into this part of the flash (figure 6.13).

Figure 6.11 - The Light Sensor for Auto Flash mode (A or AA)

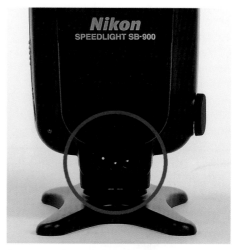

Figure 6.12 - SB-900 External Power Source Terminal. Remove the plastic Nikon cap to access these pins.

> **NOTE**
>
> Note that this sensor is different from the wireless TTL sensor shown in figure 6.14

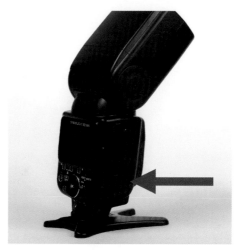

Figure 6.13 - The Light Sensor Window for wireless TTL flash control is located beside the battery chamber. Point this sensor towards the Commander flash.

Light Sensor Window

When the SB-900 is configured as a Remote flash, this is where all the communication takes place between it and the Commander flash (figure 6.14). Be sure to point this window towards the Commander flash.

The window works best when it is in the shade or in a dark room away from bright ambient light. I've had some problems making the system work in direct sun and assume the reason is that the Remote flashes have a hard time distinguishing between flash pulses and direct sun.

Many times I have an assistant hold the Remote flash and aim it at the subject. In this scenario, make sure the assistant's thumb does not cover the window. Unfortunately, Nikon placed it at the perfect location for a thumb grip (figures 6.14 and 6.15)!

Battery Chamber Lid

The Battery Chamber Lid is simple to operate: just slide the cover down to the "unlocked" position and then open up the chamber (figure 6.16).

I find over time that the battery contacts can corrode, causing a poor connection between the batteries and the flash. To remedy the problem, I clean them with a pencil eraser or lightly scrape them with a pocket knife. Also, the tabs deep inside the battery chamber can form light corrosion, so I clean those off as well.

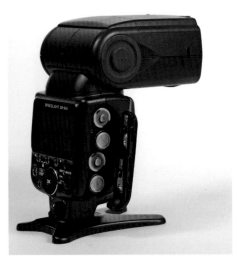

Figure 6.16 - SB-900 Battery Chamber Lid

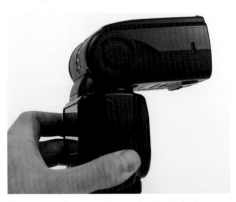

Figure 6.14 - Be sure not to cover the Light Sensor Window with your thumb

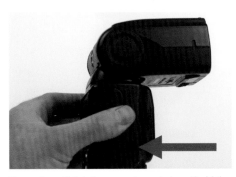

Figure 6.15 - This is the correct way to hand hold the flash without covering the Light Sensor Window

Power Switch

One of the neatest improvements on the SB-900 is that the Power Switch controls access to the three main modes on the flash:

- Dedicated flash
- Master (Commander) flash
- Remote flash

If you have used the SB-600 or SB-800 before, you know that you have to go into the Custom Settings Menus (CSM) to activate the Master or Remote flash modes. Being able do this with a flick of a switch makes all the difference in the world! It is faster, more efficient, and you never have to wonder what mode the flash is in; just look at the switch. Major kudos to Nikon for simplifying this process.

Make sure you turn the flash off before you attach or remove it from the camera body (figure 6.17). This prevents any short circuits as well as preventing the flash from firing.

My only criticism of the Power Switch is that it is very small. When I wear gloves, I have a hard time flipping the switch. In that case, my technique is to press the pad of my thumb onto the switch and then rotate my hand.

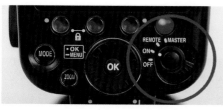

Figure 6.17 - The Power Switch on the SB-900 has four positions that easily allow you to select the flash mode

Selector Dial and OK Button

Another big improvement in the design of the SB-900 is the introduction of the Selector Dial and OK button. Previous versions of Nikon flashes relied on the +/- buttons to increase or decrease settings. Now, you rotate the dial left or right to increase/decrease settings. Once you have dialed in the correct setting, you use the OK button to lock in your selection (figure 6.18).

For example, to make an EV (output) change in TTL BL mode, rotate the Selector Dial to your desired output and press the OK button to lock in the value. The approach is simple and direct.

If you look carefully at the back of the flash, you will see a small icon with the words OK/MENU. The dot icon next to the word OK means that if you press the OK button quickly, the button will behave like an enter button. The line icon next to the word MENU means that if you press and hold the button for two seconds, it will open up the Custom Settings Menus.

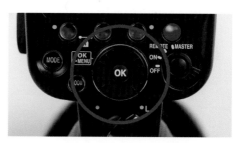

Figure 6.18 - Rotate the Selector Dial to choose your setting, then press the OK button to lock in that value

Function Buttons

You can access most of the menu-driven features on the SB-900 by pressing one of three Function buttons (figure 6.19). For example, in TTL mode, press Function Button 1 (the left button) to activate the +/- EV setting. Then, to make changes to the EV setting, rotate the Selector Dial. To set the value, press the OK button.

Any time there is an icon above a Function button, press the button underneath it to access the setting. If you continue to press the same Function button, you will also change the setting. Using the same example as above, if you press Function Button 1 to activate the

+/- EV setting, then you can keep tapping the button to change the value. If you stop pressing the button, then the last value remains as your new setting.

The Function buttons are generic and don't always have the same purpose. If you are in Remote mode as shown in figure 6.20, Function Button 1 activates the Group setting and Function Button 2 activates the Channel setting. Each flash mode applies different settings for the Function buttons.

ZOOM Button

Another improved feature of the SB-900 is the increased zoom range provided by the flash head. The zoom range now goes from 12 mm to 200 mm! With the ability to zoom the flash head, you are better able to evenly light up your scene with light from the flash. As you zoom the lens to a wider angle, the flash must illuminate a larger area. So, at the same time the lens zooms, the flash head will also zoom.

On Nikon camera systems, the lens sends zoom information to the camera body, which then forwards it to the flash. Say for example, you set your lens to 24 mm; then your flash will also zoom to 24 mm to provide the same angle of coverage. This is called Auto Zoom on the flash. You can override the Auto Zoom function and zoom manually by pressing the ZOOM button, which will display on the flash's LCD as M ZOOM (figure 6.21).

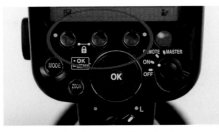

Figure 6.19 - Use these three Function buttons to select different menu items on the SB-900's LCD panel

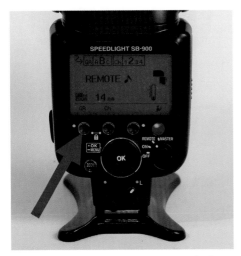

Figure 6.20 - When you are in Remote mode, the Function buttons access different settings such as Group (GR) and Channel (Ch)

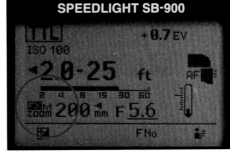

Figure 6.21 - When you press the ZOOM button, you override the auto zoom function and go into M ZOOM mode

If you press the ZOOM button a number of times, it will toggle between different settings like 24 mm, 36 mm, 50 mm, etc. Another way to move between ZOOM settings is to press the ZOOM button one time and then rotate the Selector Dial.

There are three other details you need to know about here:

1. Let's say you manually set the zoom value on the flash to 105 mm, and the LCD shows M ZOOM. If you want the flash to re-synchronize with the lens, turn the flash off and back on again.

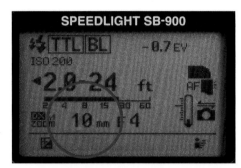

Figure 6.22 - When you use a diffusion dome, the flash defaults to 10 mm zoom

Figure 6.23 - The flash knows a diffusion dome is mounted because of the micro switches on the outside of the flash head (inside the red circles)

2. When you have the wide angle diffusion panel extended, the SB-900 only allows a zoom setting of 10 mm.

3. When you have a diffusion dome mounted on the SB-900 (figure 6.22), the flash will default its zoom to 10 mm. A micro switch on the bottom of the flash head (figure 6.23) detects the diffusion dome and defaults the zoom to 10 mm. There is no way to override this unless you cut away the plastic on the diffusion dome, but there's no reason to do so. Just leave it at 10 mm and be happy.

Diffusion Dome

This little piece of plastic is one of the greatest inventions ever made for flash photography (figures 6.24 and 6.25). Its purpose is to diffuse the light from the flash and force it to spread all around the scene and subject. I use a diffusion dome whenever I photograph events and don't have time to set up more elaborate lighting equipment. I also use it for macro photography, portraits, and just about everything else under the sun.

The proper way to use a diffusion dome is to place it on the flash and then point the flash head upwards about 45 degrees (figures 6.24 and 6.25). This allows the dome to do its job by sending light all around the room. I frequently use it in conjunction with a flash bracket (figure 6.26) to minimize the effect of the shadow.

Figure 6.24 - Diffusion dome in use when the camera is horizontal. Point the flash head upwards at 45 degrees for best results.

Remember, when a diffusion dome is placed on the SB-900, it defeats the zoom function of the flash. It does this by depressing a micro switch on the bottom of the flash head (figure 6.27).

Some SB-900 owners wonder whether to use the Wide Angle Flash Adapter along with the diffusion dome. The answer is no. There is no need to diffuse *behind* the diffusion dome. That's straight from the Department of Redundancy Department.

There are plenty of other products that do a great job of diffusing the flash, such as Harbor Digital Design's Ultimate Light Box (www.harbordigitaldesign.com) or Gary Fong's products (www.garyfong.com).

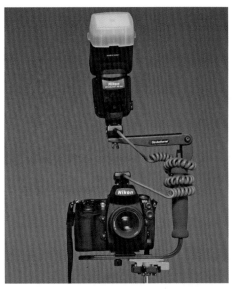

Figure 6.26 - Diffusion dome with Stroboframe Quick Flip flash bracket. A flash bracket is the best option for event photography.

Figure 6.25 - Diffusion dome in use when camera is vertical. Point the flash head upwards at 45 degrees for best results.

Figure 6.27 - Wedding photo taken with diffusion dome and flash bracket. Notice the soft light and the shadow hidden behind the young girl. D70, SB-800, diffusion dome, Stroboframe bracket, SC-17 cable. Camera set up for Slow + Rear sync and flash set for TTL BL -1.7.

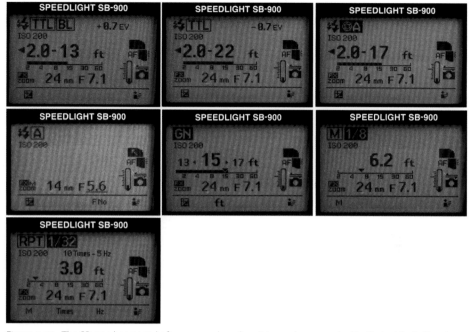

Figure 6.28 - The SB-900 has a total of seven modes when it is used as a regular Dedicated flash. To select these modes, press the MODE button on the back of the SB-900.

MODE Button

When the SB-900 is set up as a regular Dedicated Speedlight (i.e., not a Remote flash or a Commander flash), the MODE button switches between seven flash modes: TTL BL, TTL, A, AA, GN, M, and RPT (figure 6.28). When the flash is not attached to the camera (or the camera is powered off), you can only choose from five modes: TTL, A, GN, M, and RPT.

NOTE

In order to select between A and AA, you need to make a change in the Custom Settings Menus. Starting from the top left: TTL BL, TTL, Auto Aperture, Auto Flash, Guide Number, Manual, Repeat.

TTL BL Mode

TTL stands for "Through The Lens" metering and BL stands for "Balanced" fill flash (figure 6.29). Nikon refers to this mode as "Automatic Balanced Fill Flash". Its goal is to balance the ambient light (background) with the subject (foreground). I use TTL BL for the vast majority of my photography and find it to be reliable for fast shooting.

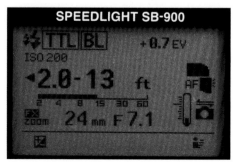

Figure 6.29 - SB-900 in TTL BL mode

In TTL BL mode, the SB-900 puts out a pre-flash that is reflected back to the camera's flash metering system (the Matrix meter). The camera then quickly calculates the correct amount of light for the scene. You can watch this pre-flash sequence happen if you pay close attention to the flash when it fires.

The pre-flash delay is fairly long on slower cameras like the Nikon D70, but very short (almost imperceptible) on fast systems like the D700 or D3.

Unfortunately, the pre-flashes can cause people to close their eyes during the shot, which can be very frustrating for the photographer. Sometimes the only way to get around this is to tell your subjects to try to keep their eyes open until the sequence is finished. Obviously, this is easier said than done.

Another way to get around the pre-flash is to turn your flash to Manual mode; or, you can use a function called FV Lock. See chapter 13 for more information on how to cure this problem with FV Lock.

TTL Mode

This mode is often called Standard TTL. Its purpose is to expose only for the subject and not for the background light. TTL mode goes back a long way in Nikon camera systems and is truly the legacy mode. It does a good job, but I have found that TTL BL seems more accurate and consistent (figure 6.30).

The best places to use TTL mode are situations where you only want the subject exposed, such as:

- Weddings and other events in dark reception halls
- Parties in dark living rooms
- Macro photography where the surrounding environment is a nonissue

AA Mode

AA stands for Auto Aperture. Notice that the symbol for this mode has a circle icon that looks like a lens aperture alongside the letter A (figure 6.31).

This mode is typically used when you need more shot-to-shot consistency than TTL BL can provide. Unfortunately, TTL BL doesn't always provide consistent exposures when you take a large number of shots of a variety of subjects. For example, at a wedding, TTL BL might slightly underexpose photographs that include the bride's white dress while slightly overexposing photos that include black tuxedos.

This variation from shot to shot can be very frustrating for a professional photographer who plans to present wedding photos to a client in one showing. If you show a photo of the bride by itself, it would look OK; but if you show a number of photos side by side, the TTL BL variation quickly becomes apparent. The reason is that TTL takes every

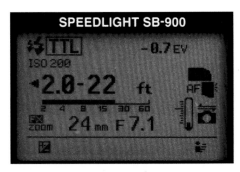

Figure 6.30 - SB-900 in TTL mode

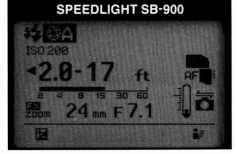

Figure 6.31 - SB-900 in AA mode

scene and modifies the exposure based on its overall reflectance (brightness).

AA mode takes the camera's TTL meter out of the flash calculation and instead uses the SB-900's built-in light sensor. Exposures using AA tend to have less brightness variation from shot to shot, but they take a little more effort to pull off.

This mode uses lots of information to determine the flash exposure, including:

- Lens Aperture
- Camera ISO
- Exposure Compensation Setting
- Lens Focal Length (zoom)

Even though this mode tries to automate the flash exposure, it does not use the camera's TTL Matrix Meter system. Hence the name Auto Aperture flash. AA means that the flash makes the exposure decision automatically.

You can use this setting in one of two ways:

1. Set the aperture and then work within a general shooting distance range. This allows the flash's sensor to take up the slack. Your shooting range is shown on the back of the flash in either feet or meters (figure 6.32). For example, the flash might state 2.8-44 feet, which means it will operate well at any distance between those two values.

2. From your known distance, adjust the aperture on the camera until the flash is within range. Say, for example, you are 12 feet from the bride and want to get a well-exposed image of her in AA mode. Adjust the aperture (on the camera) until the distance range on the back of the flash includes 12 feet and take the picture. It will look something like the example below.

Figures 6.33 through 6.36 compare shots taken in AA and TTL BL modes. The photos on the top row were taken with the flash head pointed directly at the subject with no diffusion. The photos on the bottom row were taken with the flash head pointed at the ceiling to diffuse the light. The left photos are AA mode, and the right photos are TTL BL mode.

In general, I find that AA mode tends to expose the subject about 1/3 to 2/3 of a stop brighter than TTL mode. This isn't necessarily a bad thing, just a reality of the system. Once you get a handle on the exposure, you can change the power by pressing the flash's + and - buttons until you are happy with it.

You can select from two AA flash modes in the Custom Settings Menus. The first is AA with monitor preflashes, and the second is AA without monitor preflashes. Using the preflashes almost always results in a slightly better exposure, since the flash has the benefit of knowing how reflective the subject is. I recommend keeping the monitor preflashes active.

NOTE

In figures 6.35 and 6.36, both flash modes did a nice job with the exposure when the flash was bounced off the ceiling.

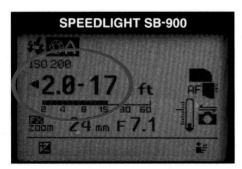

Figure 6.32 - SB-900 in AA mode. The flash displays an operating range (2.0.-17 feet) which is the subject-to-flash distance.

Figure 6.33 - AA mode, direct flash

Figure 6.34 - TTL BL mode, direct flash

Figure 6.35 - AA mode, bounced off ceiling

Figure 6.36 - TTL BL mode, bounced off ceiling

A Mode

A stands for Auto Flash. This mode uses *only* the SB-900's built-in sensor to measure the light reflected from the subject. This is different from AA mode where the camera communicates aperture, lens, ISO, and exposure compensation data to the lens. When the flash's sensor decides enough light is reflected back, it shuts down power to the flash head and stops outputting light (figure 6.37).

The neat thing about this mode is that the flash works "automatically" on most of the cameras you own, including your older Nikon film cameras and even off-brand cameras like the Pentax K1000. There is no back-and-forth communication between the flash and the camera body, so you have to trust the flash to do everything.

If your camera is a newer Nikon Digital SLR like the D40, D50, D60, D70, D200, D300, D700, D2, or D3, you actually have to configure the flash to operate in plain old A mode rather than AA mode. To do this, go to Custom Settings Menus and change the settings for A/AA (figure 6.38). Here are the steps:

1. Push and hold the OK key for two seconds
2. Rotate Selector Dial until the A box is highlighted
3. Press OK button
4. Choose A by rotating Selector Dial
5. Press OK button
6. Press Function Button 1 (EXIT)

In A mode, you generally set the camera's exposure mode to Aperture Priority or Manual. The next step is to change the F No value (f Stop) by rotating the Selector Dial until the aperture on the flash equals the aperture on the camera body, or until the shooting distance on the back of the flash matches the shooting distance of your subject. Now, take the picture. Simple, right?

Kind of. These instructions need to take more into account than just making the setting and pressing the shutter release button. Many photographers, like wedding and event photographers, also put their hand-held light meters into the equation for these shots. If your goal is to get more consistency than TTL BL will give you, it's going to take some effort.

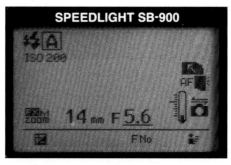

Figure 6.37 - SB-900 in A mode

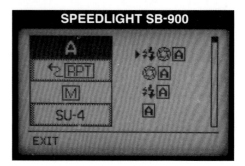

Figure 6.38 - Change the A/AA custom setting if you want the flash to operate only in A mode rather than AA mode

Here is the process for effective (consistent) Auto Flash usage at an event:

1. Set flash for A (Auto Flash) mode
2. Set ISO between 200 and 800 on your camera
3. Set camera for Manual exposure
4. Set shutter speed to 1/60 second
5. Set aperture to f/8 on your camera
6. Set aperture to f/8 on your flash
7. Place hand-held light meter five feet away from flash
8. Take a photograph of subject five feet away and note hand-held meter aperture reading
9. Repeat this process for subjects at 10 feet, 15 feet, and 20 feet
10. Write down the hand-held meter values for the flash readings (e.g., 5 feet = f/10, 10 feet = f/8, etc.)
11. These are the aperture settings for your event
12. To take photos with these values at the event, mentally estimate how far away your subjects are and set the corresponding aperture into the camera body

For example, let's say you want to photograph people at the local square dance on Saturday night and get great flash photos using A mode on your flash. I suggest you get there early and start testing using the steps outlined above. When you are done testing, you will have some information like this:

- 5 feet = f/10
- 10 feet = f/8
- 15 feet = f/6.5
- 20 feet = f/5.6

When it comes time to snap a photograph of the square dancers at 15 feet away, set f/6.5 (f/6.3) on the *camera* and take the shot. Notice that the settings on your *flash* haven't changed from your initial values of f/8 and ISO 200 (or 400).

Now it's simple, right? Right. Go ahead, roll your eyes.

You can select two Auto Flash modes from the Custom Settings Menus. The first is Non-TTL Aperture with monitor pre-flashes, and the second is Non-TTL Aperture without monitor pre-flashes. Using the pre-flashes almost always results in a slightly better exposure since the flash has the benefit of knowing how reflective the subject is. I recommend keeping the monitor pre-flashes active.

GN

GN stands for Guide Number. This manual flash mode utilizes the SB-900's published Guide Number to help you calculate a flash photograph (figure 6.39). This mode might actually be called a "distance priority" method for determining flash exposure. You arrange your photograph so that you know the *exact* distance from the flash to the subject, and then you program that number into your flash. Figure 6.39 shows a value of 15 feet (the big number in the screen). This means if your subject is 15 feet away from the flash, the photograph will be properly exposed.

Here's how it works:

1. Set the flash mode to GN
2. Set the camera to Aperture Priority or Manual mode
3. Measure the distance between the flash and the subject (e.g., 15 feet)
4. Set the aperture on your camera (e.g., f/5.6)
5. Press Function Button 2 to activate the distance and then rotate the Selector Dial until the large distance number on the back matches the distance to the subject (15 feet)
6. Take the photograph

Note also that you can adjust the flash output by changing the flash compensation. To do this, press Function Button 1 until +/- is highlighted. Then, rotate the Selector Dial to change flash power (figure 6.40).

GN mode is pretty picky and requires a number of items to be configured properly on your flash. Most important, the flash head needs to be set at the horizontal (front) position. However, there are many other reasons why this mode may not work properly. Some of them are:

1. Flash head is pointed down at the -7 degree setting
2. Flash head is pointed up at an angle
3. Camera is turned off (hey, it happens!)

Finally, the SB-900 flash *will* work in GN mode if your wide angle diffusion panel is deployed or your diffusion dome is mounted.

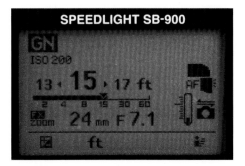

Figure 6.39 - SB-900 in GN mode. The big number shows how far away your subject should be for a proper exposure.

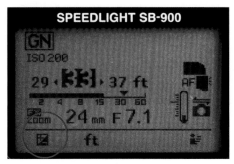

Figure 6.40 - Change the flash compensation by pressing Function Button 1 until +/- is highlighted. Then rotate the Selector Dial.

M Mode

In Manual flash mode (figure 6.41), you are responsible for determining flash output. Change flash output by pressing Function Button 1 and then rotating the Selector Dial to the output you desire. To determine the correct setting, you basically have three choices:

- Trial and error
- Guide Number calculation
- Hand-held light meter

The first method of determining flash power is trial and error. Simply take a picture and review the results on your camera's histogram screen. If it looks too bright, then dial the flash power down. If it looks too dark, increase the power.

The second method is to use a Guide Number calculation, which is contingent on knowing the flash's Guide Number. Although the SB-900 has a published Guide Number of 111, it gets more complicated when you zoom the flash head. For example, if you zoom the flash head to 24 mm, then the Guide Number is 89. If you zoom the flash head to 200 mm, then the Guide Number is 184. Table 6.1 gives more detail on figuring out what the Guide Number is depending on zoom and flash power settings.

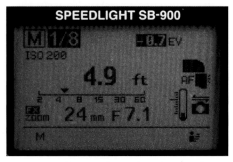

Figure 6.41 - SB-900 in Manual mode. Here, the flash is set up to put out 1/8 power, plus 0.3 (one third) of a stop.

SB-900 Guide Numbers at ISO 100 (Calculated Using Feet)

Flash Output Level	Flash Head Zoom Position for DX Format (mm)							
	17	24	35	50	85	120	135	200
1/1	72	89	111	131	154	167	169	184
1/2	51	62	79	93	109	118	119	130
1/4	36	44	56	66	77	84	84	92
1/8	25	31	39	46	56	59	60	65
1/16	18	22	28	33	38	42	42	46
1/32	13	15	20	23	27	29	30	32
1/64	9	11	14	16	19	21	21	23
1/128	6	8	10	12	14	15	15	16

Table 6.1

Once you know what the Guide Number is, you can run a calculation based on the Guide Number formula to set the aperture for your camera.

Guide Number (GN) = Shooting Distance (in feet) x Aperture ÷ ISO Sensitivity Factor

The preceding formula doesn't mean much to most people, but we can change it around to solve that problem. The formula now looks like this:

$$\text{Aperture} = \frac{GN}{\text{Distance}}$$

Let's assume you know your subject is 10 feet away and your Guide Number is 56. According to this calculation, set your lens aperture to f/5.6 and take the photograph. Easy!

But honestly, that is the old way to calculate flash power. These days, TTL systems do all of this for us except when we're in Manual

mode where there is no automated flash calculation.

The third and most accurate method for setting flash power in Manual mode is to use a hand-held light meter. You basically place the meter in front of your subject, fire the flash, read the light meter values, and set them into your camera (e.g., f/8 @ at 1/60 second).

Here is the process for using a hand-held light meter:

1. Set the flash power to a specific value, such as ¼ power
2. Set your camera and flash meter to the same ISO value
3. Place the meter in front of your subject with the dome pointed towards the camera
4. Fire the flash in Manual mode
5. Read the light meter values, such as shutter speed and aperture
6. Set those values into your camera (e.g., f/8 at 1/60 second)

This is the best way to calculate flash exposure and is really the most accurate method you can use. It is how many professional photography studios set up flash exposures.

You may ask, "Well, if this way is so good, then why does Nikon create all those other flash modes?" The answer is because the light meter method is slow and takes patience. It is impossible to capture candid shots if you always have to stop and take a flash meter reading. Nikon keeps innovating new and exciting flash modes like TTL BL to help us capture serendipitous scenes that would otherwise be lost.

RPT Mode

This mode is a lot of fun. RPT stands for Repeating Flash Mode, which is used when you want the flash to fire repeatedly during a single exposure. Say you want to take a photograph of a bouncing ping-pong ball (figure 6.42). You can use RPT mode to put out multiple pulses of light while the ball bounces through the scene.

There are myriads of other applications for this technique—for example, a dancer going through her routine, a mountain biker jumping off a log, a bird flying by, or a baseball player throwing a pitch (figure 6.43).

Here is the process:

1. Set flash mode to RPT
2. Push Function Button 1 to select M (power output)
3. Rotate Selector Dial to adjust power output
4. Push Function Button 2 to highlight Times (quantity of pulses)
5. Rotate Selector Dial to adjust Times
6. Push Function Button to highlight Hz (frequency of pulses)
7. Rotate Selector Dial to adjust Hz
8. Set camera to Manual exposure
9. Calculate shutter speed (Shutter Speed = Times/Hz)
10. Set Aperture on the camera body until you get a usable working distance

Here is more detail on each step:

- Power Output (M): This is set in fractions of full power (1/1).
- Frequency (Hz): This is how many flashes fire per second. For example, 5 Hz means the flash fires five times per second.
- Times: This is how many times the flash fires until it stops. For example, a value of 10 means the flash will fire 10 times and then stop.

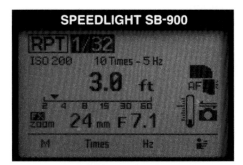

Figure 6.42 - SB-900 in RPT mode. This screen shows that the flash is set at 1/32 power and will fire 10 times at 5 flashes per second.

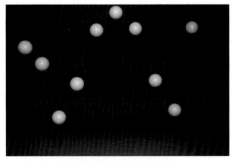

Figure 6.43 - This photo of a bouncing ping-pong ball was taken in RPT mode. The settings for this shot were 1/32 power, 10 pulses, 5 Hz.

- Calculating Shutter Speed: To calculate shutter speed, divide Quantity by Frequency. For example, if the flash fires a total of 10 times and the frequency is five flashes per second, then the duration of the sequence is two seconds (10 flashes divided by five flashes per second is two seconds). Another example: if the flash fires 20 times and the frequency is two flashes per second, then the duration of the sequence is 10 seconds (20 flashes divided by two flashes per second is 10 seconds). You then set that value as the shutter speed into your camera.

- Figuring Out Aperture: Look at the back of the flash, and you will see a distance value such as 7.7 feet (figure 6.42). This means the subject needs to be exactly 7.7 feet away in order to be properly exposed. The smaller the aperture, the closer you must be to the subject. For example, f/11 might require you to be two feet away (kinda close!) whereas f/4 would allow you to be eight feet away. Keep adjusting the aperture on the camera body until you are happy with the working distance between flash and subject. You can also increase the ISO to get some additional working distance.

When it comes time to finally take the photograph, make sure the ambient light is very low or nonexistent. Also, try to make the background very dark—in other words, make your studio almost completely black. You typically want the entire scene to be lit only by the flash. Finally, position your subject a long way from the background. This will keep the flash's reflected light from lighting up the background (figure 6.44).

OK, that's it for the flash modes on the SB-900. Let's continue on with the buttons and controls.

Test Firing Button

This button has a number of functions and can be programmed in a couple of different ways. Let's start with the default settings and then cover how to customize the button.

First of all, the button has a red light that indicates when the flash is ready to fire. When the READY light is on, it means that the flash's capacitor is fully charged and ready to take the next picture (figure 6.45).

After you take a photo, the READY light turns off while the flash recharges its capacitor. Once the capacitor is recharged, the READY light turns on again. The READY light also coincides directly with the beep of the flash in wireless mode.

Figure 6.44 - This image represents each pulse of the flash, starting from pulse #1 and ending at pulse #10. The ball was bouncing from right to left. The settings for this image were: Power: 1/32. Frequency: 5 Hz. Total Pulses: 10. Shutter Speed: two seconds. Aperture: f/8. Background: black sheet.

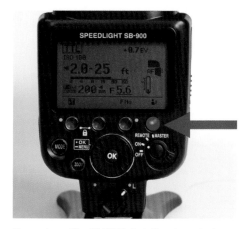

Figure 6.45 - The READY light is illuminated when the flash's capacitor is fully charged

When you are waiting between photos, the flash will periodically go into Standby mode. At that point, the READY light turns off until you wake up the flash by pressing it again or by pressing the camera's shutter release button (figure 6.46).

Because the flash does not have a battery level indicator, the READY light is the only way to really tell how much power remains in your batteries. Specifically, the longer it takes for the READY light to illuminate, the lower your battery life. If you find that it takes four to five seconds after each shot to recharge the flash, then it is probably time to change your batteries.

Finally, the READY light blinks rapidly if you take a photograph and the flash does not have enough power to light the scene. In this situation, the flash indicates under-exposure by a minus sign in the upper right corner of the LCD. The rapid blinking is your cue to check out the underexposed value and change aperture, ISO, distance, or zoom in order to take the shot (figures 6.47 and 6.48).

The second purpose of the Test Firing button is to activate the flash to make sure it is operating properly. In TTL BL or TTL mode, it serves no purpose other than to

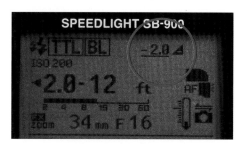

Figure 6.46 - When the flash goes into Standby, the READY light turns off

Figure 6.47 - This picture was underexposed by two stops. You can see the readout on the upper right corner of the LCD.

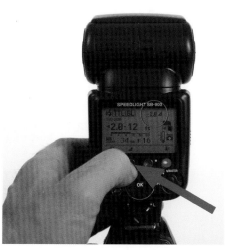

Figure 6.48 - To recall the underexposed value of the last photo, press Function Button 2

confirm that the flash is on and working properly. You can program the custom functions of the flash to make it output 1/128, 1/32, or 1/1 power when you press the Test Firing button (figure 6.49).

The third use of this button is when the flash is set for Manual mode. In this case, the flash will put out exactly the amount of power you set for flash output. If you use a hand-held flash meter in a traditional studio environment, this will allow you to take a meter reading without tripping the shutter on your camera to fire the flash.

The fourth use of this button is to trigger the Modeling Light. To set up the Test Flash button as a Modeling Light button, navigate to the Custom Settings Menus and change the button to MODELING (instructions for doing this appear later in this chapter). This setting allows you to see where the shadows will fall before you take the photo. To activate the Modeling Light, press the Test Flash button (figure 6.50), and the flash will turn into a Modeling Light.

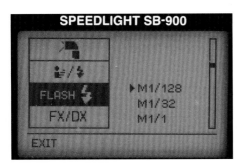

Figure 6.49 - You can program the SB-900 custom functions so that the Test Firing button will cause the flash to put out 1/128, 1/32, or 1/1 power

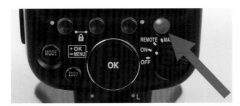

Figure 6.50 - Press the Test Flash button to activate the flash's own Modeling Light

I use the Modeling Light whenever I am worried about a shadow behind the subject. If I find a shadow, then I move the subject or myself until there is no longer a shadow. In addition, I might press the Modeling Light when bouncing the flash off the ceiling or a wall to see the effect on the subject's face or under their eyes.

The fifth and last function of the Test Flash button is used when you configure the SB-900 as a Master (Commander) unit. In Master mode (assuming your Test Flash button is programmed to FLASH in Custom Settings Menus), pushing the Test Flash button activates all the flashes listening to it. It serves to ping the other flashes, causing them to ping back. This is a valuable feature when you need to make sure all the flashes are set up to the same Channel and the correct Group. Plus, it's just plain fun to push the button and watch the other flashes respond!

Alternatively, if you have the Test Flash button configured as a Modeling Light button while in Master (Commander) mode, it will trigger the Remote flashes as Modeling Lights. Follow these steps to activate the Remote flashes' Modeling Lights:

1. Set up SB-900 as a Commander flash
2. Set up Test Flash button as a Modeling Light in Custom Settings Menus
3. Set up Remote flashes to correct Channel and Groups
4. Press Function Button 1 on Commander SB-900 until Group A is highlighted
5. Press Test Flash button (Group A flash triggers)
6. Press Function Button 1 on Commander SB-900 until Group B is highlighted
7. Press Test Flash button (Group B flash triggers)
8. Press Function Button 1 on Commander SB-900 until Group C is highlighted
9. Press Test Flash button (Group C flash triggers)

Sync Terminal

If you use standard studio lighting equipment, then you will use the Sync Terminal (figure 6.51). Back in the day, we called this the PC cable, which stood for Positive Connection. All of the old cameras had built-in PC ports, so you just hooked the PC cable to the lights and the studio flash power pack and voila, you were ready to go.

Nowadays, some cameras have built-in PC ports and others do not. For example, the Nikon D40, D50, D60, D70, D80, and D90 cameras do not have PC ports, but the D200, D300, D700, D2, D3, and F6 do (figure 6.52). Nikon provides a PC port on the SB-900 so it can be used as a studio light trigger even with cameras that don't have a PC port. Nikon sells PC sync cords such as the SC-11 and SC-15, but you can buy these types of cables from any camera store on the planet.

Here are the steps for using the PC terminal on the SB-900:

1. Turn off flash
2. Mount flash on camera
3. Turn on flash and set it for Manual mode
4. Connect sync cord to flash PC terminal
5. Connect sync cord to studio flash power pack
6. Turn on flash and power pack
7. Take picture

Two-Button Controls

The SB-900 has two hidden functions that are only accessible when you press two buttons together. The back side of the SB-900 shows the button combinations to access these settings as the "Lock" icon and the "Green Dots". Here are the hidden functions you can access when you push these buttons together:

- Function Button 1 and Function Button 2 = Button Lock. Use this when you want to prevent someone from changing the settings on the flash. This is useful when you have the SB-900 configured as a Remote and someone finds it; you'd be surprised at how many people are tempted to push the buttons. Push the ON/OFF and SEL buttons together again to unlock the flash.
- Function Button 1 and Function Button 3 = Reset. If you ever set up your flash and can't figure out how to get the system back to its defaults, press these two buttons together for a system reset. This will return all of your custom settings to the factory defaults.

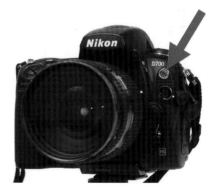

Figure 6.52 - The D700 PC port is built into the camera body

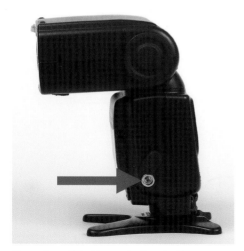

Figure 6.51 - PC cable terminal on the SB-900

SB-900 Custom Settings Menus

One of the best features of the SB-900 is the ability to customize its operation based on your own preferences. Accessing the Custom Settings Menus (CSM) is very simple, and navigating around the menus is a snap compared to the SB-600 and SB-800.

To access CSM, press and hold the OK button for about two seconds. To exit from the CSM, press Function Button 1 (EXIT).

Once you access CSM, you will notice that the screen changes to a stack of options on the left side (figure 6.53). Each item in the stack represents an individual menu item. To access any item, rotate the Selector Dial until the item is highlighted. To make a change to that menu item, press the OK button.

Here is the sequence in a list:

1. Press OK button for two seconds
2. Rotate Selector Dial to highlight menu item
3. Press OK button to activate menu item
4. Rotate Selector Dial to highlight option

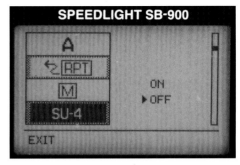

Figure 6.53 - Items in the Custom Settings Menus (CSM) are listed in a stack on the left side of the LCD panel

5. Press OK button to make selection
6. Press Function Button 1 (EXIT) to exit CSM

There are quite a few choices in CSM. Most people don't rotate the Selector Dial enough to notice that there are more settings down below. There are a total of 22 custom settings. Now that you can access the CSM, here is what each setting does and how to use it.

SB-900 Custom Settings Menus (CSM) Summary

Screen Symbol	Title and Description
	A – Auto Flash Mode Choose one of four settings for your flash when setting it up in Auto Flash mode. See the previous section in this chapter on Auto Flash for instructions on how to use these flash modes. • Auto Aperture Flash with monitor preflashes • Auto Aperture Flash without monitor preflashes • Non-TTL Auto Flash with monitor preflashes • Non-TTL Auto Flash without monitor preflashes
	RPT – Repeating Flash Mode This setting allows the SB-900 to control all your Remote flashes in Repeat Flash mode. When you choose ON, the Master mode on the SB-900 changes to Repeating Master. When you choose OFF, the Master mode behaves as normal. This mode is described in detail later in the chapter. **ON:** Activated **OFF:** Canceled

Table 6.2 SB-900 CSM descriptions

SB-900 Custom Settings Menus (CSM) Summary

Screen Symbol	Title and Description
	M – Flash Output Level in Manual Mode This setting allows you to change the EV step value between 1/1 (full power) and 1/2 (half power). I recommend setting this to ON so you have more flexibility with your flash. **ON:** Allows you to adjust by 1/3 (one third) steps between full power and half power. For example, you can choose 1/1 > 1/1 -0.3 > 1/1 -0.7 > 1/2. All other output levels can also be adjusted by 1/3 steps. **OFF:** Only allows you to make a full stop adjustment between full power and half power. You can choose 1/1 or 1/2. All other output levels can be adjusted by 1/3 steps.
	SU-4 – SU-4 Type Wireless Multiple Flash Shooting An SU-4 flash is a previous generation flash mode that allowed the user to wirelessly control older Nikon TTL flashes. See later in this chapter for specific configurations and setup directions. **ON:** SU-4 capability is activated **OFF:** SU-4 is not active. Flash operates normally.
	Illumination Pattern The SB-900 has a choice of three different illumination patterns. In general, I recommend the Standard setting. **CW:** Center Weighted pattern. This concentrates more of the flash's energy on the center of the image. You will notice more light fall-off towards the edges. A good use for this pattern is wildlife or portrait photography where the subject is in the middle of the frame. **STD:** Standard pattern. This is the same pattern that most other Nikon flashes use. I generally leave my flash set for this pattern. **EVEN:** Even pattern. This keeps the light at the edges of the frame the same brightness as the light in the middle. A good use for this pattern is group portraits.

Table 6.2 SB-900 CSM descriptions (continued)

SB-900 Custom Settings Menus (CSM) Summary

Screen Symbol	Title and Description
	Test Firing Button This menu item configures how the Test Firing button behaves when you push it. **FLASH:** Pushing the Test Firing button will cause the flash to emit a single pulse of light. In Manual mode, it will emit the same amount of power that you dial into the flash (e.g., 1/8 power). In TTL modes, it will emit the amount of light that you program into the next CSM item called FLASH. **MODELING:** Pushing the Test Firing button will cause the flash to illuminate like a Modeling Light in all flash modes. This will also allow you to trigger Remote flashes as Modeling Lights when the flash is configured as a Commander (Master) flash.
	FLASH This setting allows you to configure how much power the flash emits when you press the Test Firing button in TTL mode. When you use your flash as a TTL flash, you don't press the Test Flash button to calculate your exposures. Therefore, this setting is not useful. I recommend leaving the value set at 1/128 power so you can save battery life but still make sure the flash is operating. **M 1/128:** Flash emits 1/128 power **M 1/32:** Flash emits 1/32 power **M 1/1:** Flash emits 1/1 power
	FX/DX Selection The SB-900 has the ability to detect what format you are shooting with your camera and then modify the flash zoom for full coverage. FX is for full frame sensors like the D700 and D3. DX is for 1.5x crop sensors like the D60, D90, and D300. I recommend leaving the setting at FX-DX so that the flash can automatically switch between different cameras you might use. **FX < > DX:** Flash automatically sets the format depending on the camera **FX:** Flash only zooms for the FX format **DX:** Flash only zooms for the DX format

Table 6.2 SB-900 CSM descriptions (continued)

SB-900 Custom Settings Menus (CSM) Summary

Screen Symbol	Title and Description

M ZOOM – Power Zoom Off

This setting allows you to select whether or not the SB-900 will automatically zoom with your lens.

ON: Power Zoom off. This means that you can only zoom the flash by pressing the ZOOM button.
OFF: Power Zoom on. This means that the flash automatically zooms with the lens.

AF – AF Assist Illuminator/Flash Firing Off

When you take photographs in dark areas, the flash normally sends out a red Auto Focus (AF) grid that helps the sensors acquire focus. It is generally considered a good tool, and I recommend leaving this function on.

ON: Allows the AF Assist illumination beam to work
OFF: Turns off the AF Assist illumination beam
AF ONLY: Turns off the flash and allows only the AF Assist beam to work. Do this if you want to take photos without your flash but still want focus help from the AF Assist illumination beam.

STBY – Standby Function

During normal operation, the SB-900 quickly goes into Standby mode to help save battery power. The default setting is AUTO, which means that the SB-900 will temporarily turn off when the camera's exposure meter turns off. Most cameras are set for a four-second or six-second delay on the light meter, which means that your flash goes to sleep after four or six seconds. To wake the flash back up, just press the shutter release on the camera. I leave my flashes set to AUTO standby.

AUTO: Flash turns off when the camera's exposure meter turns off
40: 40-second delay
80: 80-second delay
160: 160-second delay
300: 300-second delay
- - -: Flash never goes into Standby mode

Table 6.2 SB-900 CSM descriptions (continued)

SB-900 Custom Settings Menus (CSM) Summary

Screen Symbol	Title and Description

ISO – ISO Sensitivity
Use this setting when you mount your flash on an older camera such as an FM3, FM10, FA, or N50. Nikon calls these cameras Group III to Group VII cameras. Their camera bodies can't speak to the flash, so you must set the ISO manually. Normally, when using the SB-900 on a newer SLR, the camera communicates the ISO directly to the flash, so there is no need to enter the ISO data manually.

The range of ISOs you can set is between 3 and 8000, in increments of 1/3 step.

READY – READY Light Setting for Remote Flash
This setting allows you to display a READY light signal on the back and the front of the flash. The default setting shows the READY light on back/front, but you can change it if you like. I recommend the default setting so you can easily see the status of your Remote flash.

REAR, FRONT: Shows the READY light on the rear of the flash at all times and the front of the flash when it is in Remote mode
REAR: Only shows the READY light on the rear of the flash
FRONT: Only shows the READY light on the front when the flash is configured as a Remote

LIGHT – LCD Panel Illuminator
This setting turns off the LCD backlight function. Normally, when you press any button on the flash, the backlight comes on. I regard this as a good thing and keep it on all the time. Maybe you would turn it off to keep from attracting moths to your flash at night!

ON: Allows backlight to turn on
OFF: Does not allow backlight to turn on

Thermal Cut-out
This setting activates the over-temperature protection on the SB-900. If you shoot rapid-fire flash photography, the flash can easily overheat and cause internal damage. The SB-900 has an internal temperature sensor that shuts down the flash if it is close to overheating. I recommend keeping it turned on.

ON: Turns on the thermal cut-out feature
OFF: Turns off the thermal cut-out feature

Table 6.2 SB-900 CSM descriptions (continued)

SB-900 Custom Settings Menus (CSM) Summary

Screen Symbol	Title and Description
	Sound Monitor In Wireless Remote mode, the SB-900 beeps to tell you the status of the flash (see chapter 10). Turn this setting on or off to activate or cancel the sound when the flash is used as a Remote. I generally like to keep the beeps on so I can hear if everything is working properly. A proper beep sequence is "Beep Beep …. Beeeeeep". That means everything worked, and you can move to the next photograph. **ON:** Beep On **OFF:** Beep Off
	LCD Panel Brightness This setting allows you to change the brightness and contrast of the LCD panel. Adjust the brightness by rotating the Selector Dial on the flash. You have nine brightness steps to choose from. I keep it at the default setting which is halfway (as shown in the example to the left).
	m/ft Distance Unit of Measure This setting allows you to choose the unit of measurement displayed on the LCD panel: metric (meters) or standard (feet). **m:** meters **ft:** feet
	Broken Wide Angle Adapter If you ever break off the built-in Wide Angle Adapter, you can use this setting to allow the flash head to zoom. Normally, when the Wide Angle Adapter is deployed, the flash sets the head at 10 mm and then stops zooming. If you break off the adapter (which happens more often than you might guess), go here and turn the setting to ON. Then you can manually zoom the flash by rotating the Selector Dial. Note that the ON setting does not activate the automatic zoom if you've broken the adapter. Bummer. **ON:** Manual setting activated (you can zoom flash manually) **OFF:** Manual setting canceled (you can't zoom flash at all)

Table 6.2 SB-900 CSM descriptions (continued)

SB-900 Custom Settings Menus (CSM) Summary

Screen Symbol	Title and Description
	My Menu This setting allows you to limit the number of CSM items. For example, if you only go into CSM to do one thing, like switch on SU-4 mode, then you can program My Menu to include just that one item. **FULL:** This displays all items in CSM. I recommend leaving the flash set to this. **MY MENU:** Shows only the items you selected in the SET UP portion of My Menu. **SET UP:** This is where you choose which items you want to display in the MY MENU area. Put a check in the box next to the items you want to show and remove the check from the items you want to hide.
	VER. – Firmware Version This setting shows the current version of the firmware installed in the flash. The SB-900 allows you to update the firmware whenever Nikon has software fixes or improved features. To update the firmware, connect the flash to the camera (only a D3 or D700) and follow the instructions provided by Nikon at the time of the update.
	RESET – Reset Custom Settings Choosing YES from this menu will reset almost all of the custom settings back to the factory defaults. It won't change the units of measuring distance or the settings for MY MENU. Everything else will be reset. **YES:** Reset custom settings to default **NO:** Do not reset

Table 6.2 SB-900 CSM descriptions (continued)

Using the SB-900 as a Dedicated Flash

Most people use the SB-900 as a Dedicated flash attached to the camera's hot shoe (figure 6.54). In this configuration, you can use the flash in any of these standard modes:

- TTL BL
- TTL
- Manual
- Auto
- Auto Aperture
- Guide Number
- RPT

A fully Dedicated flash means that all of the flash's capabilities can be used by the camera body. Also, the flash and the camera body communicate back and forth to relay information such as zoom settings, aperture, shutter speed, and power (figure 6.55).

The SB-900 also functions as a fully Dedicated flash when it is attached via a TTL remote cord such as the SC-17, SC-28, or SC-29. These cables provide full TTL operation just as if the flash were mounted on top of the camera.

In general shooting scenarios where you want to operate quickly, I suggest setting the flash mode to TTL BL. Table 6.3 shows some general settings for the camera and flash in various scenarios.

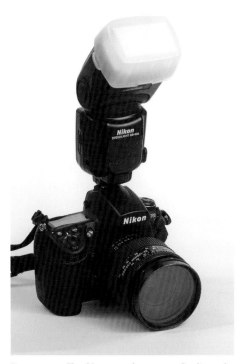

Figure 6.54 - The SB-900 makes a great Dedicated flash as shown here on the D700

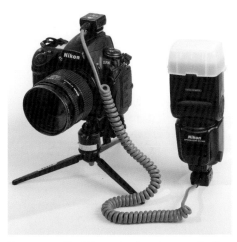

Figure 6.55 - The SB-900 also functions as a Dedicated flash when connected via a TTL cord like the SC-17, SC-28, or SC-29

System Setup for Common Shooting Scenarios

Shooting Scenario	Camera Sync Mode	Flash Mode	Flash Power	Comments
Outdoor & Travel	Slow + Rear	TTL BL	-0.7	Goal is to use subtle fill flash balanced with ambient light
Window Portraits	Slow + Rear	TTL BL	-0.7	Goal is to use subtle fill flash balanced with ambient light
Formal Studio Lighting (umbrellas, reflectors, etc.)	Normal (Front Curtain)	TTL BL or Manual	Variable	Goal is for flash to provide 100% of light, with no ambient light to speak of
Wedding Reception in Dark Room	Normal (Front Curtain)	TTL BL or AA	0.0 (but change as necessary)	Goal is for flash to provide 100% of light. Mount flash on bracket and use diffusion dome.

Table 6.3

Using the SB-900 as a Remote Flash

The SB-900 works exceedingly well as a Remote flash unit (figure 6.56). In this scenario, you need some type of Commander flash to send instructions to the Remote SB-900. The Commander can be another SB-900 (see the next section for how to set this up), an SB-

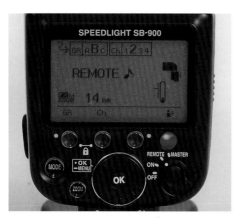

Figure 6.56 - REMOTE screen on the SB-900. This flash is set up to be a Remote for Channel 2, Group B. In order for it to fire, the Commander unit needs to send out information on Channel 2, Group B as well.

800, an SU-800, or the pop-up flash from a D70, D80, D90, D200, D300, or D700. See chapter 2 for a quick guide to configuring your SLR as a Commander unit. Chapter 7 shows how to set up the SU-800 as a Commander, and chapter 5 shows how to set up the SB-800 as a Commander.

Setting up the SB-900 as a Remote flash requires you to turn the Power Switch to the REMOTE setting and then configure the Channel and Groups appropriately.

Here are the steps to configure the SB-900 as a Remote:

1. Turn flash power switch to Remote
2. Press Function Button 1 to access Group
3. Rotate Selector Dial to set Group
4. Press Function Button 2 to access Channel
5. Rotate Selector Dial to set Channel
6. Make sure Commander flash is set to same Channel and Group
7. Take picture

A number of things must be set up properly between the Commander unit and the Remote unit. For example, both the Commander and Remote need to be set to

the same Channel (e.g., CH 1) and Group (e.g., Group C).

Once you configure the flash as a Remote unit, it takes all of its firing instructions from the Commander unit. These instructions are broadcast via light pulses which the Remote receives through the Light Sensor on the side of the flash (figure 6.57).

Make sure you point this Light Sensor towards the Commander flash. It is pretty sensitive, but there are times when communication fails because it literally can't see the light.

When people first learn this system, one of the most common problems is forgetting to turn on the Commander flash unit. I know it sounds obvious, but to first-time users, it is not intuitive. Remember, the Commander unit might be another SB-800, an SB-900, an SU-800, or a pop-up flash on your camera. Note: If the Commander is a pop-up flash, be sure to pop it up!

Using the SB-900 as a Commander Unit

The SB-900 can be configured as a Commander flash to control a host of Remote flashes (figure 6.58). I get very consistent results when using the SB-900 as a Commander as opposed to using a pop-up flash as a Commander. One reason is that the SB-900 packs a lot of punch, and its light pulses can be seen far and wide. In contrast, the camera's pop-up flash has a relatively small amount of power.

I typically see a 10-15% failure rate when I use the pop-up flash as a Commander, but I hardly ever get failed flash photos when I use the SB-900 as a Commander. This isn't because pop-up flashes are "bad"; the SB-900 simply has much more broadcast power. By the way, the SB-800 and the SU-800 are also very good Commander units with lots of broadcast power.

Figure 6.57 - The Light Sensor for Wireless TTL flash control is located beside the battery chamber. Point this sensor towards the Commander flash.

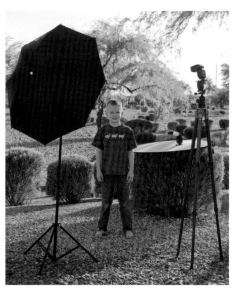

Figure 6.58 - In this lighting setup, the SB-900 is configured as a Commander to control three groups of flashes. Group A is on the left, Group B is on the right, and Group C is behind the subject.

Setting up the SB-900 as a Commander is a simple process now that Nikon has redesigned the user interface (figure 6.59). Here are the steps:

1. Turn flash power switch to Master
2. Press Function Button 1 to navigate to Master, Group A, Group B, and Group C
3. Press MODE button to change to TTL, M, AA, or - - -
4. Press Function Button 2 to navigate to flash output
5. Rotate Selector Dial to change flash output
6. Press the OK button
7. Press Function Button 2 to change between Channels 1, 2, 3, and 4
8. Make sure Remote flashes are set to same Channel and Group
9. Take picture

Let's talk more about each of these settings on the back of the flash (figure 6.59).

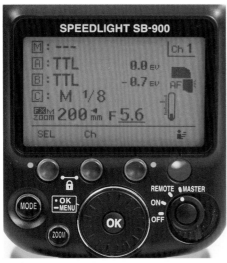

Figure 6.59 - SB-900 Commander mode screen. The Group icons are on the left (M, A, B, C). Mode is the second column (- - -, TTL, TTL, M). Output is the third column (0.0, -0.7). Channel is on the right (CH 1).

Group

The left column of letters on the flash's LCD represents the different group designations. You can't change the letters themselves, but it is helpful to know what they stand for:

- M = Master Flash Settings
- A = Group A Settings
- B = Group B Settings
- C = Group C Settings

Each Group can consist of one flash or multiple flashes. The Master flash (M) is the flash positioned on top of the camera—in this case, the SB-900.

Mode

Each Group can operate in a different flash mode. For example, the flashes in Group A can operate as TTL flashes while those in Group B can operate as Manual flashes. Pressing the MODE button changes the flash mode for a particular group. Here is what each designation means:

- TTL = Through The Lens mode. This mode behaves like the normal TTL mode described earlier. I use this mode for flashes that are set up in front of the subject.
- AA = Auto Aperture mode. This mode behaves like normal AA in that it uses the flash's sensor to judge flash output. If you set up a flash group as AA, then all the flashes must be capable of being AA flashes. In other words, you can't have SB-600 Remote flashes in a group set for AA. Also, make sure the SB-800 or SB-900 Remote flashes in the group have their light sensors pointed at the subject. That's the only way the system can properly judge exposure.
- M = Manual mode. This mode sets up the flashes as full Manual strobes. The Commander SB-900 sends out instructions to each flash in the group and tells them all what power level to shoot at. For example, all the flashes in Group A will fire at 1/128 power if you set the group value to 1/128.

- - - - = Off mode. You can turn off groups from the Commander unit by selecting - - - as the flash mode. This will deactivate the entire group for the photograph. Sometimes this is useful when you want to see each flash group's individual impact. Note that if you turn off the M group (Master flash), it won't fire during the actual exposure. This can be confusing to people because they see the Master (Commander) flash send out the pre-flashes when they push the shutter release. This has to happen because the Commander unit still sends out commands to the Remote units through light pulses. Nevertheless, the Commander unit will not fire during the actual exposure.

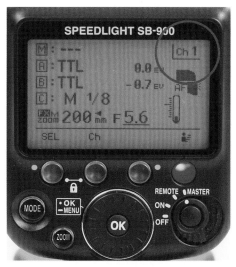

Figure 6.60 - There are four channels to choose from: 1, 2, 3, and 4. This flash is set up for CH 1.

Output

The neat thing about using the Nikon wireless system is the ability to change flash output from the back of the Commander unit. This means you don't have to walk over to each Remote flash unit to change the power. How cool is that?!

To change the flash power for a specific Channel, press the + and – buttons when that Channel is selected. In TTL mode, the readout is in terms of stops. For example, +1.3 means one-and-a-third stops brighter than 0.0. In Manual mode, the readout is in terms of fractions. For example, 1/64 means one-sixty-fourth power.

Channel

Nikon's wireless system allows photographers to choose from Channels 1, 2, 3, and 4 (figure 6.60). This is helpful when two or more photographers in the same vicinity want to use Nikon CLS wireless flashes. Here are a couple of situations where it makes sense to use different Channels:

1. At a press conference where there are multiple Nikon shooters and each one has a wireless setup. Before the event, meet with the other photographers to determine who will be on what channel.

2. At a high school dance with your photo assistant. You take formal photographs along a wall with a wireless studio setup on Channel 1. Your assistant takes informal photographs on the dance floor on Channel 2 with lights set up at each corner to provide ample coverage.

You may be wondering whether any other manufacturer's flashes will set off the Nikon wireless system. The answer is no, for the most part. For example, if you are at a wedding and Aunt Matilda takes a photo with her Olympus point-and-shoot, it won't affect your wireless setup. However, there are some manufacturers such as Metz and Radio Popper who design their equipment to interface with the Nikon wireless flash system.

Other SB-900 Commander Functions

Modeling Light

If you want to preview your lighting setup, you can use the SB-900 to activate each light in your system by pressing the Modeling Light button on the back of the flash. More specifically, you can activate each Group together by selecting that Group and then pressing the Modeling Light button. Here are the specific steps:

1. Go into the Custom Settings Menus and set the item called Test Firing button to MODELING
2. Set up SB-900 as a Commander flash
3. Press Function Button 1 (SEL) until Group A is highlighted
4. Press Test Firing button

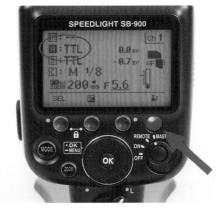

Figure 6.61 - The Modeling Light is a great feature in wireless Commander mode because you can activate each of the Remote flashes' Modeling Lights while standing behind your camera. In this image, the Modeling Lights on the Group A flashes will fire when the Modeling Light button is pressed.

You can continue through this process to activate the Modeling Lights of each Group by simply highlighting Group B and then Group C (figure 6.61).

Also, if you have a D200, D300, D700, D2, or D3 (figure 6.62), you can activate all the flashes together by pressing the Depth of Field (DOF) Preview button on the camera body (see chapter 13 for more information).

Figure 6.62 - Pressing the Depth of Field (DOF) Preview button on your D200, D300, D700, D2, or D3 will activate all the Modeling Lights in your entire wireless system.

Flash Button

Sometimes it is beneficial to see if each of the Remote flashes is "listening" before you trip the shutter. You can press the SB-900's Test Firing button to ping all the remote flashes in the wireless system (figure 6.63). When you do this, each Channel will ping back in sequence. If a Remote flash is tuned to the wrong Channel, it won't ping in response to the Commander flash. By the way, the ping I'm referring to is a single pulse of light.

Here are the steps to do this:

1. Go into the Custom Settings Menus and set the item called Test Firing button to FLASH
2. Set up SB-900 as a Commander flash
3. Press Test Firing button
4. Watch the remote flashes ping back

Figure 6.63 - Pushing the Test Firing button in Commander mode will ping all of the other flashes. Each flash in Group A, B, and C will ping back in sequence if set to the correct Channel and Group. This is a great way to check your system setup before actually taking photos.

Using the SB-900 as a Repeat Commander Unit

This mode is different from the standard SB-900 Commander mode. Use this mode when the regular Repeat (RPT) mode on the flash doesn't have enough power to illuminate the scene by itself. In this scenario, you can configure the SB-900 as a Repeat Commander unit (figure 6.64) and instruct a bank of Remote flashes to fire in sync.

Here is how to set up the SB-900 as a Repeat Commander unit:

1. Go into the Custom Settings Menus and set the item called RPT to ON
2. Press Function Button 1 (SEL) to access Master, Group A, Group B, and Group C
3. Press Function Button 2 (ON/OFF) to turn the Group on or off
4. Press OK button
5. Press Function Button 2 to access Channel and rotate Selector Dial to change Channel
6. Press Function Button 3 to access Repeat functions (RPT)
7. Press Function Button 1 to access Output (M) and rotate Selector Dial to change output
8. Press Function Button 2 to access TIMES and rotate Selector Dial to change TIMES
9. Press Function Button 3 to access Hz and rotate Selector Dial to change Hz
10. Make sure Remote flashes are set to same Channel and Groups
11. Take picture

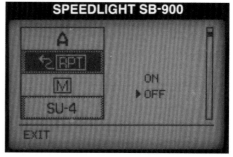

Figure 6.64 - Access the Master REPEAT mode from the Custom Settings Menus

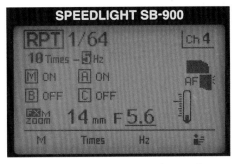

Figure 6.65 - This is the main control screen for Repeat Commander mode. Push the SEL button to jump from setting to setting.
M = Master Flash
A = Channel A
B = Channel B
C = Channel C
ON = Flash will Repeat
OFF = Flash is off
1/64 = Output for each pulse
10 Times = 10 pulses per second
5 Hz = 5 pulses per second
CH 4 = Channel 4

Let's talk about each of the settings shown in figure 6.65.

Group

The letters M, A, B, and C on the flash's LCD represent the different Group designations. You can't change the letters themselves, but it is helpful to know what they stand for:

- **M** = Master Flash Settings
- **A** = Group A Settings
- **B** = Group B Settings
- **C** = Group C Settings

Each Group can consist of one flash or multiple flashes. The Master flash (M) is the flash positioned on top of the camera—in this case, the SB-900.

Mode

Each Group can operate in one of two flash modes: ON or OFF. For example, Group A can operate as RPT (ON) while Group B is turned OFF (- - -). Pressing Function Button

2 changes the flash mode for the Group. Here is what each designation means:

- **ON** = Repeat Flash mode. This activates the group as a Repeat flash.
- **OFF** = Off mode. You can turn off Groups from the Commander unit by selecting OFF as the flash mode. This will deactivate the entire Group for the photograph. Sometimes this is useful when you want to see each flash Group's individual impact. Note that if you turn off M (Master flash), it won't fire during the actual exposure. This can be confusing because the Master flash still sends out pre-flashes when you push the shutter release. This has to happen because the Master unit sends out instructions to the Remote units through light pulses. But, when it comes to firing during the actual exposure, the Commander unit doesn't fire.

Output

Just like in a normal wireless setup, you can change flash output from the back of the Commander unit. This means you don't have to go over to each Remote flash unit to change the power. To change the flash power, press the + and - buttons. In this mode, the readout is in terms of fractions. For example, 1/64 means one sixty-fourth power.

Frequency

Frequency is how many pulses per second the flash will fire. For example, 5 Hz means the flash fires five times per second.

Quantity of Pulses

This is how many times the flash fires until it stops. For example, a value of 10 means the flash fires 10 times and then stops firing.

Channel

You still have four Channels to choose from in Wireless Repeat mode: Channels 1, 2, 3, and 4. Generally, you work alone in a studio when using Repeat Commander mode, so

there is less need for all four Channels than when photographing in a group of other photographers.

When it comes time to take the photograph, set the camera's exposure mode to Manual. You then need to figure out the shutter speed and aperture. Here's how:

- **Calculating Shutter Speed:** Divide the Quantity of flashes by the Frequency. For example, if the flash fires a total of 10 times and the Frequency is five flashes per second, then the duration of the sequence is two seconds (10 flashes divided by five flashes per second is two seconds). Another example: if your flash fires at two flashes per second and you fire a total of 20 times, then the duration of the sequence is 10 seconds (20 flashes divided by two flashes per second is 10 seconds). You then set that value as the shutter speed.

- **Figuring Out Aperture:** The smaller the aperture you use, the closer you must be to your subject. For example, f/11 might require you to be two feet away, whereas f/4 would allow you to be eight feet away. Keep adjusting the aperture on the camera body until you are happy with the working distance between the flash and the subject.

Some Other Tips

Make sure the ambient light is very low or even nonexistent so your subject is only exposed by the flash. Also, try to make your backgrounds very dark in color. In other words, make your studio almost completely black. The reason is that you typically want the entire scene to be lit up just by the flash and not by any ambient light. Finally, position your subject far away from the background. This will keep the flash's reflected light from lighting up the background.

Using the SB-900 as an SU-4 Unit (Commander or Remote)

A few years ago, Nikon introduced a simple system aimed at allowing "wireless" TTL flash control. This system was introduced in the era of the N90s and the F5 film cameras and was actually pretty ingenious. It required the use of an SU-4 unit (figure 6.66) attached to a normal TTL flash such as an SB-26 or SB-28 (figure 6.67).

If you have older flashes and SU-4 units lying around, you might like to use them in a wireless setup. As you know, though, they will not work with the Nikon CLS wireless setup. Fortunately, Nikon installed a function in the SB-900 that allows it to operate like older TTL flash systems that didn't have pre-flash technology.

Figure 6.66 - The SU-4, Nikon's original wireless remote module. This unit and SU-4 flash mode are still supported via the Custom Settings Menus and the SB-900's built-in Light Sensor.

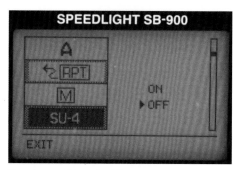

Figure 6.67 - This is the CSM screen to set up SU-4 mode on the SB-900

When you set up the SB-900 in this mode (figure 6.68), the flash emits only one pulse of light (rather than the two you would normally get with the iTTL pre-flash). When the SB-900 stops putting out light, all of the SU-4 Remote flashes also stop putting out light. Simple.

This next part is a little bit confusing. The SU-4 Remote unit shown in figure 6.68 operates in SU-4 flash mode when mounted on another Nikon flash like the SB-26. Many times people refer to an SU-4 when they are talking about the actual unit (figure 6.66). They also refer to SU-4 *mode*, which references the setting in the SB-900 flash that simulates the operation of the SU-4 unit.

Figure 6.68 shows an SB-600 attached to an SU-4 Remote module. This allows the flash to listen to SU-4 instructions from the SB-900. When the SB-600 is attached to an SU-4 module, it needs to be set for Manual output (figure 6.69). Also, the switch on the SU-4 module needs to be set for Manual.

You can also use your older Nikon flashes such as the SB-26, SB-80, etc. with the SU-4 Remote module (figure 6.70) as long as they receive instructions from the SB-900 that is set up in SU-4 mode.

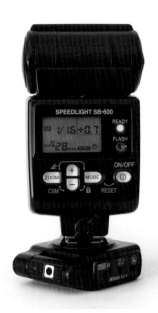

Figure 6.69 - Note that when the SB-600 is mounted on an SU-4 unit, the flash must be set up in Manual mode

Figure 6.68 - The SB-600 can be attached to an SU-4 and will work just fine as a Remote unit

Figure 6.70 - Older flashes like the Nikon SB-26 work great in SU-4 mode. You can also use it with flashes from Metz, Vivitar, Canon, etc. if they are set up in Manual mode.

Here's how to set up SU-4 mode on the SB-900:

1. Mount the SB-900 on your camera
2. Turn on the SB-900 and camera
3. Go into the Custom Settings Menus and set the item called SU-4 to ON
4. Turn power switch to Master
5. Press MODE button to choose flash mode (M, AA, GN)
6. Set flash power on SB-900 with Selector Dial
7. Attach SU-4 unit to Remote flashes (e.g., SB-26)
8. Turn SU-4 switch to Auto or Manual
9. Take picture

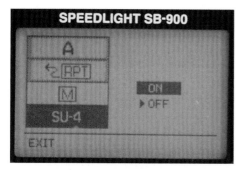

Figure 6.71 - Here is the SB-900 Custom Settings Menu for SU-4 mode

The flash modes available in SU-4 mode are limited to Manual, Auto Aperture, and Guide Number. However, these modes behave differently from their normal operation. Let's review each flash mode here to understand what is happening. Press the MODE button to toggle between each of these modes.

AA (SU-4)

AA SU-4 mode is shown in figure 6.73. Here, you can use the SU-4 Remote flash's own light sensor to judge flash output. This mode is not a TTL mode and relies heavily on the Remote flash's ability to judge exposure. Therefore, the Remote flash needs to be capable of Auto Flash operation by itself. For example, an SB-600 cannot be an SU-4 Remote AA flash, but the SB-26 can be an SU-4 Remote flash in AA mode *if* you have the SB-900 Commander configured for AA mode.

Make sure the Remote flash's Light Sensor is aimed squarely at the subject with nothing in the way. For example, if you place the Remote flash behind an umbrella in AA mode, the flash will judge exposure off the back of the umbrella!

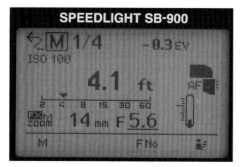

Figure 6.72 - This is what the SB-900 screen looks like in SU-4 Manual mode. Notice that the squiggly arrow points to the left. That is Nikon secret code speak for "Commander" in SU-4 mode.

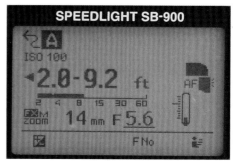

Figure 6.73 - Here is SU-4 AA mode on the SB-900. This mode works just great. Be sure to also configure your Remote flash as an AA flash.

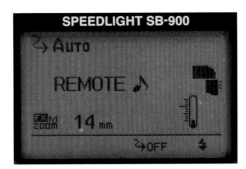

Figure 6.74 - This is what the SB-900 screen looks like in SU-4 AA mode as a Remote flash. It is not connected to the SU-4 control module because the SB-900 has its own built-in SU-4 controller. Notice also that the squiggly arrow points to the right, which is Nikon secret code speak for "REMOTE" in SU-4 mode.

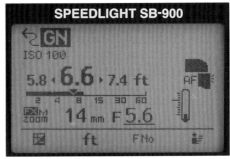

Figure 6.75 - When you configure the SB-900 as an SU-4 GN flash, it only works using the GN calculation. The Remote SU-4 flashes work as regular Manual or Auto flashes, depending on how you configure them.

When in AA mode, be sure the SU-4 Remotes are in the same mode. This means they must be set up as Auto Flashes in SU-4 mode. Here's how to do this on three flash models:

- **SB-26:** Mount the SB-26 to the SU-4 controller. Set the SU-4 to AUTO. Set the SB-26 to A (Auto).
- **SB-800:** Turn the SB-800 to SU-4 mode from the Custom Settings Menus. Press the MODE button until you see A (figure 6.74). Notice that the SB-800 does not require mounting an additional SU-4 unit, since the SB-800 is its own SU-4 controller.
- **SB-900:** Turn the SB-900 to SU-4 mode from the Custom Settings Menus. Rotate the power switch to Remote. Press the MODE button until you see A. Like the SB-800, the SB-900 doesn't require an additional SU-4 unit to be mounted, since the SB-900 is its own SU-4 controller.

GN (SU-4)

When you have the SB-900 mounted as an SU-4 Commander (figure 6.75), you can still use GN mode. This mode only configures the SU-4 Commander as a GN flash. The SU-4 Remote flashes operate as either M (Manual) or A (Auto) flashes, depending on how you set them. For more information on GN usage, read the GN mode section earlier in this chapter.

M (SU-4)

M (Manual) mode is probably the most practical of the SU-4 modes because it gives you the most control (figure 6.76). You also need some method to determine your exposures, so I recommend using a hand-held light meter when you set up your lighting arrangement.

The first step in using SU-4 Manual mode is to set up your Commander SB-900 as an SU-4 unit as explained above and mount it on your camera. Next, press Function Button 1 to access the output setting and rotate the Selector Dial to adjust power (figure 6.77).

Now, set up your Remote flashes as SU-4 remotes:

- **Old Flash Models**: Mount the older flash (e.g., SB-26 or other manufacturer's flash unit) to the SU-4 controller module (figure 6.78). Set the SU-4 to M (Manual). Set the flash's mode to M (manual). Adjust power output on the Remote flash.

- **SB-800**: Turn the SB-800 to SU-4 mode from the Custom Settings Menus. Press the MODE button until you see M. Notice that the SB-800 does not require mounting an additional SU-4 unit since it is its own SU-4 controller. Press the + and - buttons to set the power output.

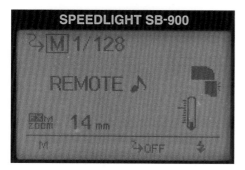

Figure 6.76 - Manual is the most practical method to use in SU-4 mode because you have full control over the lighting in your scene. This SB-900 is configured as an SU-4 Remote. You can tell because the squiggly arrow is pointing to the right.

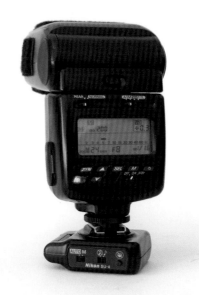

Figure 6.78 - The SB-26 is mounted on an SU-4 control module and will work well as an SU-4 Manual Remote flash unit. Just about any other flash you own will also work fine with the SU-4 control module.

Figure 6.77 - Set the switch on the SU-4 controller module to M when your flash system is set up in Manual mode

- **SB-900:** Turn the SB-900 to SU-4 mode from the Custom Settings Menus. Turn the power switch to Remote. Press the MODE button until you see M. The SB-900 does not require mounting an additional SU-4 unit since it is its own SU-4 controller. Change the power by pressing Function Button 1 and then rotating the Selector Dial.

- **SB-600:** Set the SB-600 for Manual mode. Press the MODE button until you see M. The SB-600 requires mounting an SU-4 unit to its base. Set the SU-4 to M (Manual). Press the + and - buttons on the flash to set the power output.

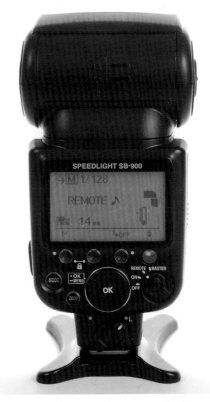

Figure 6.80 - The SB-900 does not need to be attached to anything to work as an SU-4 Remote flash unit. Just set up the CSM menu for SU-4, then press the MODE button until the LCD screen shows M.

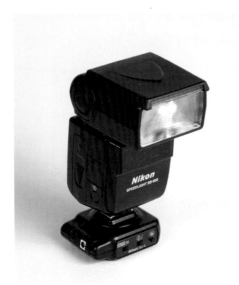

Figure 6.79 - The SB-600 is mounted on an SU-4 control module and will also work well as an SU-4 Manual Remote flash unit

SU-800, SB-R200, and R1C1 Operation

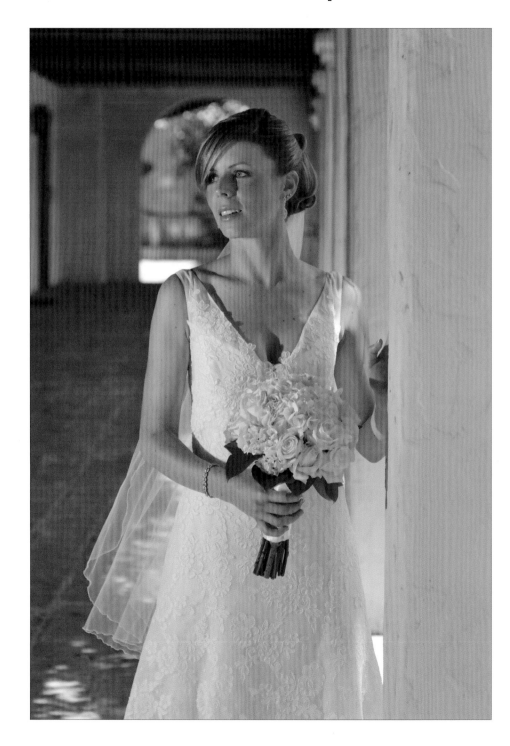

Nikon's R1C1 close-up lighting kit complete-ly integrates with the CLS. The SU-800 Commander and the SB-R200 Remote flashes are part of the Nikon R1C1 system along with a host of other hardware pieces. The entire kit is very well thought out, but like everything else in the Nikon CLS, using it properly takes practice and knowledge.

Table 7.1 breaks down the flashes and kits that make up this system.

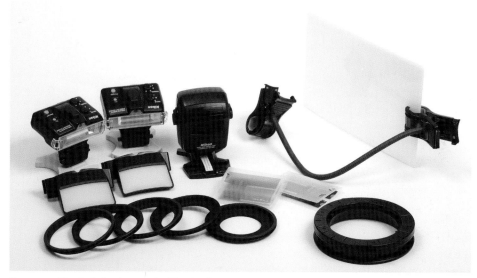

Figure 7.1 - The R1C1 kit ships with all kinds of goodies!

Flashes and Kits

Name	Description	Includes
SU-800	Wireless Speedlight Commander	Only the SU-800
SB-R200	Wireless Speedlight Remote	Only the SB-R200
R1C1	Close-up Speedlight Commander Kit	SU-800, SB-R200, gels, adapter rings, light stands, diffusion panel, close-up lighting adapters
R1	Close-up Speedlight Remote Kit	Everything in the R1C1 except the SU-800. This kit is typically purchased by photographers who own SLRs with Commander flashes like the D80, D90, D300, and D700.

Table 7.1

SU-800 Buttons and Controls

The SU-800 can be purchased as a stand-alone unit for about the same price as an SB-800 flash. However, the difference between them is that the SU-800 can only function as a Commander unit. In other words, it cannot be used as a flash itself to light up a scene; it can only command other flashes.

Photographers use the SU-800 for a variety of reasons. The main reason is that it is very lightweight compared to an SB-800 or SB-900 Commander. Another reason is that the operation of the SU-800 is very simple and quick. You don't need to go into numerous submenus to activate the features of the flash because they are already active when you turn it on.

Commander Transmit Window

Unlike other flashes in the Nikon system, the SU-800 does not have a flash head that emits visible light. The Transmit Window shown in figure 7.2 simply broadcasts the Commander infrared light pulses to the other flashes in your system. Notice that the window only points forward, so you have the best chance of success if you position your Remote flashes in front of the SU-800.

If you are in a smaller room like a typical living room or hotel conference room, you might be able to trigger flashes located behind the SU-800 since the command light signals can bounce off the walls.

First-time users of the SU-800 are often surprised to learn that it does not use visible pulses of light to trigger the Remote flashes. Instead, it uses infrared (IR) light to control all the Remote flashes in the system. You won't visually see the pulses of light, but you can hear them firing if you pay close attention to the clicking noises the SU-800 makes.

AF Assist Illuminator

The large red area shown in figure 7.3 automatically activates when it is dark to help your camera auto focus. This feature normally overrides the camera body's AF Assist

Figure 7.2 - The Commander Transmit Window only sends command signals forward, so make sure your Remote flashes are located in front of the SU-800

Figure 7.3 - The AF Assist Illuminator for the SU-800 activates when it is dark to help your camera auto focus

IMPORTANT!

You must set up the following things properly for the Wide Area AF Assist Illuminator to work:

1. Turn on the autofocus (the switch on the camera body down by the lens mount)
2. Set your camera to AF-S (not AF-C)
3. Position the autofocus sensor so it can "see" the flash's red pattern–for example, in the center position of your camera's viewfinder
4. Make sure the ambient light is dark enough for the camera to activate the red pattern
5. Turn on your flash and your camera
6. Turn on your flash's Custom Settings Menus for AF-ILL

Once these conditions are met, the AF Illumination pattern will work from the flash head. (Why can't they make this stuff easier?)

Figure 7.4 - SU-800 Battery Chamber Lid

Figure 7.5 - SU-800 Commander/Close-up Select Switch

Illuminator (found on the D60, D90, and D700). This pattern also activates when the flash is used with a TTL extension cord such as the SC-17, SC-28, or SC-29.

Battery Chamber Lid

The Battery Chamber Lid is simple to operate: just slide the cover down to the "unlocked" position and then open up the chamber (figure 7.4). Notice that the SU-800 uses CR-123 Lithium batteries rather than the usual AA batteries. This helps to reduce the overall size and weight of the unit.

I find that over time the battery contacts may corrode, causing a poor connection between the batteries and the flash. To remedy the problem, I clean them with a pencil eraser or lightly scrape them with a pocket knife. Also, the tabs deep inside the battery chamber can form light corrosion, so I clean those off as well.

Commander/Close-up Select Switch

This switch is hidden behind the battery door and toggles between the Close-up and Commander modes on the SU-800 (figure 7.5). In general, I recommend leaving the switch set for Commander mode (bottom position) for all of your shooting. The user interface is easier to understand, and it works just fine for close-up/macro photography when you are in Commander mode. Later in this chapter I describe each of the modes and when to use them.

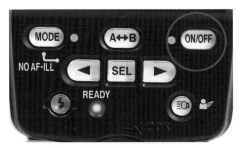

Figure 7.6 - SU-800 ON/OFF Button

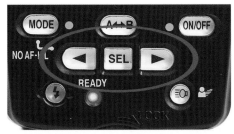

Figure 7.7 - Right and Left buttons are used to control flash power

ON/OFF Button

Make sure you turn the flash off before you attach or remove it from the camera body (figure 7.6). This prevents any short circuits as well as preventing the flash from firing.

Of course, the ON/OFF button is used to turn the flash on and off, but it also is used to reset all the settings to their default values. To do this, simultaneously press the ON/OFF and MODE buttons for two seconds. The LCD panel will blink three times to indicate that the system has reset.

Right and Left Buttons

The Right and Left buttons are generally used to control the power output of the flash (figure 7.7). Depending on what mode the flash is in, the output is shown in terms of stops or fractions.

In TTL mode or AA mode, the Right and Left buttons control flash output in stops. Note that they control flash output compensation and are independent from the exposure compensation button on the top of your camera (figure 7.8).

The default setting for the flash is 0.0, which means the flash will put out enough light to make the scene medium brightness. Stated another way, if your flash is set up for 0.0, then it will try to expose the subject as bright as an 18% gray card.

Pressing the Right button increases the amount of flash compensation. If you press it one time in TTL mode, the flash will display +0.3 on the LCD. The +0.3 symbol will blink for

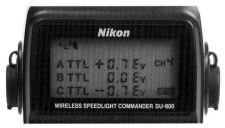

Figure 7.8 - Flash compensation on the SU-800 is shown in terms of stops. In this case, +0.7 means two-thirds of a stop more light than 0.0.

a few seconds and then stop blinking to indicate the new setting. When you take a picture with +0.3, the exposure will end up being brighter by 0.3 stops than the same photo with 0.0 (figure 7.9).

On the other hand, if you press the Left button, you decrease the amount of flash compensation. For example, a value of -0.7 will decrease flash output by 0.7 stops from 0.0. Stated another way, the flash will put out 2/3 stops less from what would be required to illuminate your subject at an 18% gray brightness value (figure 7.10).

When your flash mode is set up for Manual, the +/- buttons still control flash output, but now the readout changes to fractions. Remember, in TTL mode, the camera automatically controls the flash output to what it thinks is correct. However, in Manual mode, *you* are the brains behind the output. You must figure out how much light to add to the scene either by using a Guide Number calculation, a hand-held light meter, or by trial and error.

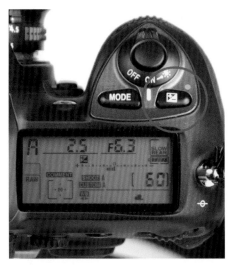
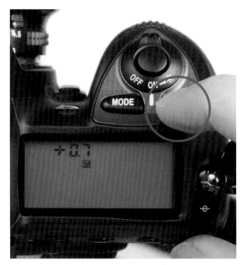

Figure 7.9 - The Exposure Compensation button on your camera is different from the Flash Compensation button (figure 7.8). Exposure Compensation changes the amount of ambient light in the exposure.

Figure 7.10 - The Flash Compensation button on your camera only changes flash output. Exposure Compensation only changes shutter speed or aperture.

MODE Button

Like most of the control buttons on the SU-800, the MODE button (figure 7.11) performs a number of functions depending on how the flash is configured.

When using the SU-800 in normal operation, the MODE button sets the operational mode of the Remote flashes in your system. For example, press the MODE button to change the flashes in Group A from Manual to TTL mode. Remember, you are not setting the SU-800 as a TTL flash, but rather telling the Remote flashes to behave like TTL flashes.

There are four different modes you can select: TTL, AA, M, and - - -. Here is what each designation means:

- **TTL = Through The Lens mode.** This mode behaves like the normal TTL mode described earlier. I use this mode for flashes that are set up in front of the subject.
- **AA = Auto Aperture mode.** This mode behaves like normal AA in that it uses the flash's sensor to judge flash output. If you set up a flash group as AA, then all the flashes must be capable of being AA flashes. In other words, you can't have SB-600 Remote flashes in a group set for AA. Also, make sure the SB-800 or SB-900 Remote flashes in the group have their body sensors pointed at the subject. That's the only way the system will be able to properly judge exposure.

- **M = Manual mode.** This mode sets up the flashes as full Manual strobes. The Commander SU-800 sends out instructions to each flash in the group and tells them all what power level to shoot at. For example, all the flashes in Group A will fire at 1/128 power if you set the group value to 1/128.
- **- - - = Off mode.** You can turn groups off from the Commander unit by selecting - - - as the flash mode. This will deactivate the entire group for the photograph. Sometimes this is useful when you want to see each flash group's individual impact.

A - B Button

This button turns your Remote flashes on or off when you configure the SU-800 in Close-up Commander mode. Push the button once to turn off Group B. Push the button a second time to turn off Group A. Push it a third time to reactivate both Groups (figure 7.12).

Figure 7.12 - The A – B button turns your Remote flashes on or off when you are in Close-up Commander mode

Figure 7.11 - SU-800 MODE button

SEL Button

Use this button to select different settings on the flash. In normal operation, press the SEL button to jump between Groups so that you can individually change the brightness. You can also press the SEL button to navigate to the Channel area of the LCD screen and change between Channels 1 – 4 (figure 7.13).

In addition, if you push the SEL button for two seconds, you activate the Repeat Commander flash mode. I cover that mode later in the chapter.

READY Light

When the READY light is on, it means that the flash's capacitor is fully charged and ready to take the next picture (figure 7.14). After you take a photo, the READY light turns off while the flash recharges its capacitor. Once the capacitor is recharged, the READY light turns on again. The READY light also coincides directly with the beep of the flash in wireless mode.

When you are waiting between photos, the flash will periodically go into Standby mode. At that point, the READY light turns off until you wake up the flash by pressing the ON/OFF button or the camera's shutter release button (figure 7.15).

The SU-800 does have a battery level indicator that shows up on the LCD panel if the READY light doesn't turn on in about 30 seconds. In general, though, the READY light is the best way to really tell how much power remains in your batteries. The longer it takes for the READY light to illuminate, the lower your battery life. If you find that it takes four to six seconds between shots to recharge the flash, then it is probably time to change your batteries.

Figure 7.13 - SU-800 SEL button

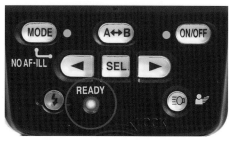

Figure 7.14 - The READY light is illuminated when the flash's capacitor is fully charged

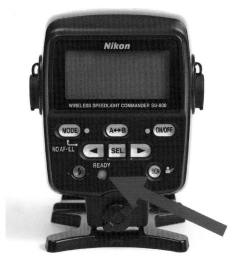

Figure 7.15 - When the flash goes into Standby, the READY light turns off

Flash Button

The Flash button on the SU-800 (figure 7.16) is used primarily to "speak" to the other flashes in the wireless system. When you push the Flash button, all of the flashes listening to the SU-800 will flash back in sequence to let you know they are set to the right Channel and Group. This is a valuable feature to help you make sure everything is programmed correctly. Plus, it's just plain fun to push the button and watch the other flashes respond!

Note that the SU-800 does not output a visible flash by itself when you press the Flash button. Remember, it only uses IR light for the instructions. If you listen carefully, you can hear a little click when you press the Flash button to let you know that it fired. One final note: make sure that that the SU-800's READY light is on when you press the Flash button; otherwise, it won't work.

Mounting Foot Lock Lever

Obviously, this lever locks the flash on top of the camera. I highly recommend using it so that your flash doesn't fall off your camera while you are taking pictures (figures 7.17 and 7.18).

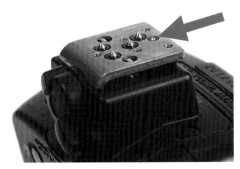

Figure 7.17 - Lever is unlocked. Notice that the locking pin does not protrude from the base.

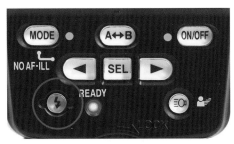

Figure 7.16 - SU-800 Flash button

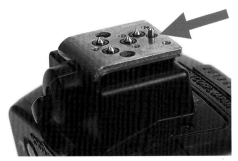

Figure 7.18 - Lever is locked. Here, the locking pin does protrude from the base. When the flash is mounted, the pin will lock into the hot shoe and prevent the flash from falling off the camera.

Hot Shoe Contacts

There are four metal contacts on the bottom of the flash and four round circular contacts on the camera's hot shoe. Obviously, all four pins on the bottom of the flash must match up properly with all four contacts on the camera. If not, then the flash and camera cannot communicate. I have had this happen many times when I moved too quickly and didn't fully secure the flash to the camera body (figures 7.19 and 7.20).

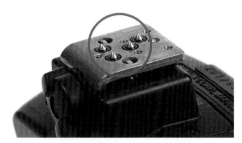

Figure 7.19 - The flash has four conical electrical contacts that need to mate up with the four contacts on the camera

Figure 7.20 - The camera has four hot shoe points that need to match up with the four contact pins on the flash

Modeling Light Button

The SU-800 Modeling Light button allows you to see where the shadows will fall from your Remote flashes before you take a photo. I use this feature to check out my lighting positions when setting up my flashes. I can press the Modeling Light button on the SU-800 and have my Remote SB-800 trigger while I look at the subject. I am looking to make sure the shadows are positioned properly and that the catch lights in my model's eyes are visible (figure 7.21).

The SU-800 triggers Modeling Lights for the SB-600, SB-800, SB-900, and SB-R200 flashes. Here's how to set up the SU-800 to trigger the Remote flashes' Modeling Lights:

1. Set up SU-800 to correct Channel and Groups
2. Set up Remote flashes to correct Channel and Groups
3. Press SEL button on Commander SU-800 until Group A letters blink
4. Press Modeling Light button (Group A flash triggers)
5. Press SEL button on Commander SU-800 until Group B letters blink
6. Press Modeling Light button (Group B flash triggers)
7. Press SEL button on Commander SU-800 until Group C letters blink
8. Press Modeling Light button (Group C flash triggers)

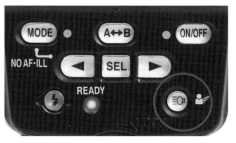

Figure 7.21 - Press the SU-800's Modeling Light button to activate the Remote flash's Modeling Light

TTL Cord Terminal

The R1C1 kit can be used wirelessly on CLS compatible cameras like the D90, D300, and D3. It can also be used on older, non-CLS compatible film and digital cameras like the F4, N90s, and D1. You accomplish this by connecting the SB-R200 flashes to the SU-800 via a special Nikon cable called the SC-30 (figure 7.22).

When the R1C1 is configured with the SC-30 cable, you can use SB-R200 flashes in TTL BL, TTL, or Manual modes as long as your camera supports those options. If you own an F3, you can only use Manual mode since that camera does not have a TTL flash meter.

Two-Button Controls

The SU-800 has two hidden functions that are only accessible when you press two buttons together.

1. MODE and Left Arrow = No AF-ILL. Use this combination when you want to turn off the AF Illumination (AF-ILL) feature of the SU-800 Commander. Figure 7.23 shows what the LCD panel looks like when No AF-ILL is activated (figure 7.23).

2. MODE and ON/OFF = Reset. If you ever set up your flash and can't figure out how to get the system back to its defaults, then press these two buttons together for a system reset.

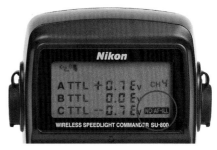

Figure 7.23 - SU-800 Commander with No AF-ILL activated

Figure 7.22 - The TTL cord terminal is used to hook up SB-R200 flashes to the SU-800 Commander on older Nikon cameras

Using the SU-800 as a Commander Unit

The only way you can use an SU-800 is as a Commander. Like the SB-800 and SB-900, the SU-800 allows you to control four different Channels and three Groups per channel. I get very consistent results using the SU-800 as a Commander instead of using a pop-up flash as a Commander. One reason is that the SU-800 packs a lot of punch, and its IR light pulses can be seen far and wide. In contrast, the camera's pop-up flash has a relatively small amount of power (figure 7.24).

I typically see a 10-15% failure rate when I use the pop-up flash as a Commander, but I hardly ever get failed flash photos when I use the SU-800 as a Commander. This isn't because pop-up flashes are "bad"; the SU-800 simply has much more broadcast power. By the way, the SB-800 and the SB-900 are also very good Commander units with lots of broadcast power.

The SU-800 has three different Commander modes:

- Commander mode
- Close-up Commander mode
- Repeat Commander mode

The most useful mode is Commander mode. In fact, this is the mode I use 99% of the time. I can't honestly remember the last time I used Close-up Commander mode or Repeat Commander mode (figure 7.25).

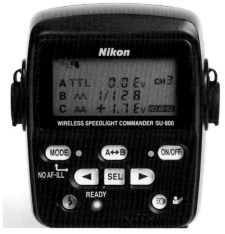

Figure 7.25 - SU-800 Commander mode screen. The Group icons are on the left (A, B, C). Mode is the second column (TTL, M, AA). Output is the third column (0.0, -1.2, +1.7). Channel is on the right (CH 3).

Figure 7.24 - In this lighting setup, the SU-800 is configured as a Commander to control three Groups of flashes. Group A is on the left, Group B is on the right, and Group C is behind the subject.

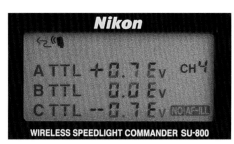

Figure 7.26 - SU-800 LCD panel in Commander mode

Commander Mode

This is the most useful mode for the majority of your photography. To access it, open up the battery cover and move the switch down to the bottom position (not the flower position).

The flash's LCD panel (figure 7.26) now looks very similar to the LCD panel on Nikon's other Commander flashes, like the SB-800 and SB-900. If you have used the SB-800 before, then operation of the SU-800 will be very straightforward. Here is how to set up the LCD panel:

1. Turn on flash
2. Press SEL button to navigate between Group A, Group B, Group C, and CH settings
3. Press MODE button to change Group flash mode (TTL, AA, M, - - -)
4. Press Left and Right buttons to change Groups
5. Make sure Remote flashes are set to same Channel and Groups
6. Take picture

Let's talk more about each of these settings on the back of the flash.

Group

The left column of letters on the flash's LCD represents the different Group designations. You can't change the letters themselves, but it is helpful to know what they stand for:

- **A** = Group A Settings
- **B** = Group B Settings
- **C** = Group C Settings

Each Group can consist of one flash or multiple flashes. The SU-800 does not have a Master (M) line item like the SB-800 and SB-900. This is because the SU-800 cannot output visible light, but rather acts only as a Commander unit for the Remote flashes in your system.

Mode

Each Group can operate in a different flash mode. For example, the flashes in Group A can operate as TTL flashes while those in Group B can operate as Manual flashes. Pressing the MODE button changes the flash mode for a particular group. Here is what each designation means:

- **TTL** = **Through The Lens mode.** This mode behaves just like the normal TTL mode previously described. I use this mode for flashes that are set up in front of the subject.
- **AA** = **Auto Aperture mode.** This mode behaves like normal AA in that it uses the flash's sensor to judge flash output. If you set up a flash group as AA, then all the flashes must be capable of being AA flashes. In other words, you can't have SB-600 Remote flashes in a Group set for AA. Also, make sure the SB-800 or SB-900 Remote flashes have the light sensors pointed at the subject. That's the only way the system can properly judge exposure.
- **M** = **Manual mode.** This mode sets up the flashes as full Manual strobes. The Commander sends out instructions to each flash in the group and tells them all what power level to shoot at. For example, all of the flashes in Group A will fire at 1/128 power if you set the Group value to 1/128.
- **- - - = Off mode.** You can turn off Groups from the Commander unit by selecting - - - as the flash mode. This will deactivate the entire group for the photograph. Sometimes this is useful when you want to see each flash group's individual impact.

The neat thing about the Nikon wireless system is the ability to change flash output from the back of the Commander unit. This means you don't have to walk over to each Remote flash unit to change the power. How cool is that?!

To change the flash power for a specific Channel, press the Left and Right arrow buttons when that Channel is selected. When you are in TTL mode, the readout is in terms of stops. For example, +1.3 means one-and-a-third stops brighter than 0.0. When you are in Manual mode, the readout is in terms of fractions. For example, 1/64 means one-sixty-fourth power.

Channel

Nikon's wireless system allows you to choose from Channels 1, 2, 3, and 4 (figure 7.27). This is helpful when two or more photographers in the same vicinity want to use Nikon CLS wireless flashes. Here are a couple of situations where it makes sense to use different Channels:

1. At a press conference where there are multiple Nikon shooters and each one has a wireless setup. Before the event, meet with the other photographers to determine who will be on what channel.
2. At a high school dance with your photo assistant. You take formal photographs along a wall with a wireless studio setup on

Channel 1. Your assistant takes informal photographs on the dance floor on Channel 2 with lights set up at each corner to provide ample coverage.

You may be wondering whether any other manufacturer's flashes will set off the Nikon wireless system. The answer is no, for the most part. For example, if you are at a wedding and Aunt Matilda takes a photo with her Olympus point-and-shoot, it won't affect your wireless setup. There are some manufacturers such as Metz and Radio Popper who design their equipment to interface with the Nikon wireless flash system.

Repeating Flash Commander Mode

In Repeating Flash Commander mode, the SU-800 causes the Remote flashes to fire repeatedly during a single exposure. This creates a stroboscopic multiple-exposure effect for each photograph you take. An example would be photographing a dance routine where the flashes fire repeatedly to "freeze" the dancer in various positions.

In order to pump out enough light to freeze the dancer, the Remote flashes need plenty of power and fast recycle times. Therefore, in this case, you can't use SB-R200 flashes as Remotes, but you can use SB-600, SB-800, and SB-900 flashes as Remotes.

Set the Commander/Close-up select switch on the SU-800 to Commander mode. Then press and hold the SEL button for two seconds. Your LCD panel will now look like figure 7.28.

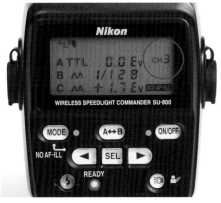

Figure 7.27 - There are four Channels to choose from: 1, 2, 3, and 4. This flash is set up for CH 3.

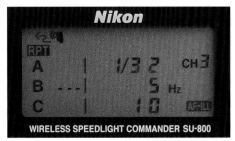

Figure 7.28 - The RPT symbol indicates that the SU-800 is configured as a Repeating Flash Commander

Figure 7.29 - Screen identification for Repeating Commander Mode on the SU-800

Quickly tapping the SEL button allows you to access any one of the screen's settings. Figure 7.29 identifies each of the screen icons.

Mode

Each Group can operate in one of two flash modes: (Blank) or - - -. For example, Group A can operate as Repeat flashes (Blank, or On) while Group B is turned off (- - -). Pressing the MODE button changes the flash mode for the Group. Here is what each designation means:

- (Blank) = **Repeat Flash mode.** This activates the group as a Repeat flash.
- - - - = **Off mode.** You can turn Groups off from the Commander unit by selecting - - - as the flash mode. This will deactivate the entire Group for the photograph. Sometimes this is useful when you want to see each flash Group's individual impact.

Output

Just like in a normal wireless setup, you can change flash output from the back of the Commander unit. This means you don't have to go over to each Remote flash unit to

change the power. To change the flash power, press the + and - buttons.

In this mode, the readout is in terms of fractions. For example, 1/64 means one sixty-fourth power. The total range of output is between 1/8 and 1/128 power. Note that Output controls all remote flashes equally; you can't make Group A put out more light than Group B.

Frequency

This is how many pulses per second the flash will fire. For example, 5 Hz means the flash fires five times per second.

Quantity

This is how many times the flash fires until it stops. For example, a value of 10 means the flash fires 10 times and then stops firing.

Channel

You still have four Channels to choose from in Wireless Repeat mode: Channels 1, 2, 3, and 4. Generally, you work alone in a studio when using Repeat Commander mode, so there is less need for all four Channels than when photographing in a group of other photographers.

When it comes time to take the photograph, set the camera's exposure mode to Manual. You then need to figure out the shutter speed and aperture. Here's how:

- **Calculating Shutter Speed:** Divide the Quantity of flashes by the Frequency. For example, if the flash fires a total of 10 times and the Frequency is five flashes per second, then the duration of the sequence is two seconds (10 flashes divided by five flashes per second is two seconds). Another example: if your flash fires at two flashes per second and you fire a total of 20 times, then the duration of the sequence is 10 seconds (20 flashes divided by two flashes per second is 10 seconds). You then set that value as the shutter speed.

- **Figuring Out Aperture:** The smaller the aperture you use, the closer you must be to your subject. For example, f/11 might require you to be two feet away, whereas f/4 would allow you to be eight feet away. Keep adjusting the aperture on the camera body until you are happy with the working distance between the flash and the subject.

Some Other Tips

Make sure the ambient light is very low or even nonexistent so that your subject is only exposed by the flash. Also, try to make your backgrounds very dark in color. In other words, make your studio almost completely black. The reason is that you typically want the entire scene to be lit up just by the flash and not by any ambient light. Finally, position your subject far away from the background. This will keep the flash's reflected light from lighting up the background.

Here are the actual steps for setting up the SU-800 as a Repeating Flash Commander unit:

1. Turn Groups On/Off
 - A. Press the SEL button until the Group value blinks
 - B. Press the MODE button to turn the Group On or Off. - - - means the Group is Off. (Blank) means the Group is On.
2. Change Remote Flash Output level
 - A. Press SEL button until Flash Output level blinks
 - B. Press Right or Left arrow button to change power between 1/8 and 1/128 power
3. Change Frequency of light pulses
 - A. Press SEL button until Flash Frequency blinks
 - B. Press Right or Left arrow button to change Frequency
 - C. 1 Hz = one flash pulse per second; 5 Hz = five flash pulses per second
4. Change total Quantity of light pulses
 - A. Press SEL button until Quantity of light pulses blinks
 - B. Press Right or Left arrow button to change Quantity
 - C. 5 = five total flash pulses; 10 = 10 total flash pulses
5. Set the Channel
 - A. Press SEL button until CH blinks
 - B. Press Right or Left arrow button to change Channel (1, 2, 3, 4)

It takes great skill and imagination to use Repeating Flash Commander mode. It is not for the faint of heart!

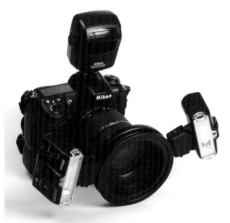

Figure 7.30 - When the SU-800 is in Close-up Commander mode, a flower icon appears on the LCD panel

Figure 7.31 - This is how SB-R200 flashes are typically set up for Close-up Commander mode

Close-up Commander Mode

Use Close-up Commander mode when you are doing mostly macro photography with SB-R200 flashes. To access this mode, open up the battery cover and move the switch up to the top position (the flower icon position). After you activate Close-up mode, you will notice a new flower symbol on the SU-800's LCD panel (figure 7.30). Figure 7.31 shows a typical setup for Close-up Commander mode.

The key advantage of this mode is that it allows you to set the Remote flashes in terms of lighting *ratios* rather than the traditional power settings, such as +1.3 EV or 0.0 EV. A ratio of 1:1 means that each side of the subject is equally illuminated. A 1:2 ratio means that one flash is twice as bright as the other flash (a one-stop difference). A 1:8 ratio means that one flash is eight times as bright as the other (a three-stop difference). Table 7.2 shows the ratio values and the associated difference in stops.

Lighting Ratios

Ratio	Difference in Stops
1:1	0
1:1.5	0.5
1:2	1
1:3	1.5
1:4	2
1:6	2.5
1:8	3

Table 7.2

Figure 7.32 - The left photo was taken with a 4:1 ratio, the middle photo was 1:1, and the right photo was 1:8

Figure 7.32 shows the effect of different lighting ratios. Higher ratios produce more dramatic lighting. Typically, high ratios bring out texture and detail in subjects like wood grain and flowers. Lower ratios create a softer look, as in portraits of children.

You don't need to be in Close-up Commander mode to use SB-R200 flashes, though. You can do close-up photography just fine with the SU-800 set as a regular Commander unit. In fact, this is how I do almost all of my photography. Like I said earlier, the key advantage of Close-up Commander mode is that you can use ratios to set flash power rather than traditional +/- EV settings.

To change the settings for the Remote flashes, press the SEL button to toggle between output level ratio, compensation (EV), and Channel. Once you select the output level ratio (it will blink), simply press the Left or Right arrow button. Pushing the Left arrow button will make the A flash brighter. Pushing the Right arrow button will make the B flash brighter. Notice that Close-up Commander mode allows you to adjust your two macro flashes between 8:1 and 1:8 ratio settings.

Not only can you set the ratios between flashes, you can also set the overall brightness level of the Remote system. In other words, you can cause all the Remote flashes to be brighter or darker in equal amounts.

Let's say you are photographing a flower and are happy with the lighting ratio between the left and right sides. But, if you want to increase the overall brightness, you can use an EV adjustment.

Figure 7.33 shows what the SU-800 LCD panel looks like when you increase the overall brightness by +0.7 EV. All this setting does is increase or decrease the amount of light the Remote flashes send out based on a 0.0 EV shot. The ratios between the A and B flashes remain constant, but the overall brightness changes depending on the EV setting.

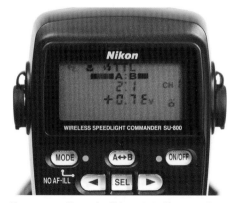

Figure 7.33 - Here, the SU-800 is in Close-up Commander mode with the A flash putting out twice as much light as the B flash. In addition, both flashes are putting out +0.7 EV more light than a 0.0 EV shot of the same scene.

If you don't want to use the ratio calculations in Close-up mode, you have the option of using Manual calculations for the Remote flashes. Figure 7.34 shows what the screen looks like in Manual Close-up mode. Activate this screen by pressing the MODE button on the flash. The total range of adjustment for each of the Remote flashes (A and B) is from 1/1 to 1/64 power.

Traditionally, you use just two flashes in Close-up Commander mode: one for the right side and another for the left side. These are Group A and Group B. However, Nikon

allows you to control a third remote flash in this mode, Group C. Activate the third Group by pressing and holding the SEL button for about two seconds. When you do this, Group C shows up at the bottom of the LCD panel (figure 7.35).

Group C can only be adjusted as a Manual output flash. It can't be used as a TTL flash, nor can it be included in the lighting ratio calculations that you used for the A and B flashes. Typically, you would use the Group C flash as a background or a backlight flash.

To make changes to Group C, press the SEL button until Group C blinks, then press the Left or Right arrow button to change the power output. The available range is from 1/1 (full power) to 1/64. To deactivate Group C, press SEL for two seconds and it will disappear from the LCD panel.

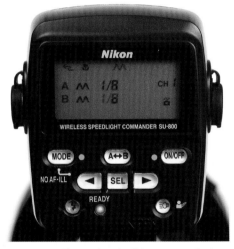

Figure 7.34 - This is what the SU-800 screen looks like in Manual Close-up mode. Rather than adjusting the Remote flashes in ratios, you now adjust them in fractions of full power.

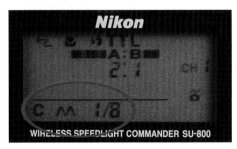

Figure 7.35 - When you are in Close-up Commander mode, press the SEL button for two seconds to activate Group C at the bottom of the LCD panel

SB-R200 Buttons and Controls

I wish all of Nikon's products were as easy to use as the SB-R200 flashes. Their operation is intuitive and simple. The SB-R200 strobes can only be used as Remote flashes (as opposed to Dedicated or Commander flashes) (figure 7.36).

Figure 7.36 - SB-R200 Remote Flashes are simple to use and great for all kinds of photography. Most people use them for macro work, but they can be equally effective in portrait and landscape situations if used properly.

ON/OFF Button

This is used to power the flash on or off. With most other Nikon flashes, the ON/OFF button has multiple functions. However, with the SB-R200, its only function is to turn the flash on or off.

Flash Head

Unlike other flashes in the Nikon lineup, the SB-R200 flash does not have a zoom function built into the flash head.

Channel Select Dial

Use this dial to set the Channel for the flash. Your choices are 1, 2, 3, or 4.

Group Select Dial

Use this dial to set the Group for the flash. Your choices are A, B, or C.

Target Light (Focus Assist Illuminator)

I use this light to make sure that the flash is pointed correctly at my scene. Activate the Target Light by pressing the Target Light button on top of the flash (figure 7.37).

You can also use this light to help you focus the lens in dark environments. If you press the Target Light button once, the LED will stay on while you position the SB-R200. Press the Target Light button again to turn off the LED.

Mounting Foot

The mounting foot on the SB-R200 is completely different from all the other Nikon Speedlights. It will only fit into special mounts such as the AS-20 or the SX-1. To insert it into one of the mounting plates, flip the lock switch to the open position, place the foot into the plate, and flip the lock switch to the locked position (figures 7.38 and 7.39).

Figure 7.38 - Notice the difference between the SB-R200 foot and the SB-900 foot

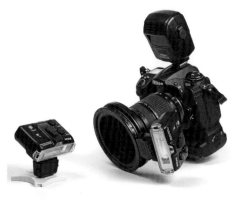

Figure 7.39 - The SB-R200 will only fit in the AS-20 (left) or the SX-1 ring mount (right)

Figure 7.37 - The Target Light is a great tool to help you position the flash before shooting. It can also be used to light up the scene so you can focus the lens in a dark environment.

TTL Cord Terminal

The R1C1 kit can be used wirelessly on CLS compatible cameras like the D90, D300, and D3. It can also be used on older, non-CLS compatible film and digital cameras like the F4, N90s, and D1. You accomplish this by connecting the SB-R200 flashes to the SU-800 via a special Nikon cable called the SC-30 (figure 7.40).

When the R1C1 is configured with the SC-30 cable, you can use SB-R200 flashes in TTL BL, TTL, or Manual modes as long as your camera supports those options. If you are using an older F3, you will only be able to use Manual mode since that camera does not have a TTL flash meter.

Figure 7.40 - The TTL cord terminal is used to hook up SB-R200 flashes to the SU-800 Commander on older Nikon cameras

READY Light

When the READY light is on, it means that the flash's capacitor is fully charged and ready to take the next picture (figure 7.41). After you take a photo, the READY light turns off while the flash recharges its capacitor. Once the capacitor is recharged, the READY light turns on again.

One difference between the SB-R200 READY light and Nikon's other flashes is that it turns green when the capacitor is charging and red when the flash is ready to fire. This is the opposite of how most people think in terms of color codes. Most think that green means "go" and red means "stop". I still get confused by the READY light colors on the SB-R200.

Because the flash does not have a battery level indicator, the READY light is the only way to really tell how much power remains in your batteries. Specifically, the longer it takes for the READY light to illuminate, the lower your battery life. If you find that it takes four to five seconds after each shot to recharge the flash, then it is probably time to change your batteries.

Figure 7.41 - The READY light is illuminated when the flash's capacitor is fully charged

Light Sensor for Wireless Remote

This sensor is where all the communication takes place between the SB-R200 and the Commander flash (figure 7.42). When you use the flash as a Remote, be sure to point this window towards the Commander flash so that it is in the direct line of sight.

The window works best in the shade or in a dark room away from bright ambient light. I've had some problems making the system work in direct sun and assume the reason is because the Remote flashes have a hard time distinguishing between flash pulses and direct sun.

Figure 7.42 - The Light Sensor Window for wireless flash operation

Using the SB-R200 as a Remote Flash

The SB-R200 flashes are fantastic units designed to work in close proximity to the subject. Since Nikon designed them primarily for macro and close-up work, they aren't very powerful and can't really be used to light up an entire room.

To use the SB-R200 as a Remote flash, you need some type of Commander to send instructions to it. The Commander can be an SB-800, SB-900, SU-800, or the pop-up flash from a D70, D80, D90, D200, D300, or D700.

Configuring the SB-R200 as a Remote is simple because there are no custom menus or other hidden setups. Just turn it on, set the Channel and Group, and start taking photographs. Here are the steps:

1. Turn on flash
2. Use dials to set Channel and Group
3. Confirm that the red READY light is on
4. Set Commander flash to same Channel and Group
5. Take picture

Once you configure the flash as a Remote unit, it takes all of its firing instructions from the Commander unit. These instructions are broadcast via light pulses which the Remote receives through the Light Sensor on the back of the flash (figure 7.43).

Make sure you point this sensor towards the Commander flash. It is pretty sensitive, but there are times when communication fails because it literally can't see the light.

When people first learn this system, one of the most common problems is forgetting to turn on the Commander flash unit. I know it sounds obvious, but to first-time users, it is not intuitive. Remember, the Commander unit might be another SB-800, an SB-900, an SU-800, or a pop-up flash on your camera. Note: If the Commander is a pop-up flash, be sure to pop it up!

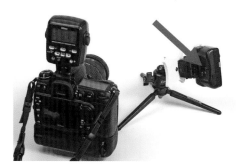

Figure 7.43 - The Light Sensor for wireless TTL flash control is located on the back of the flash. Point this sensor towards the Commander flash.

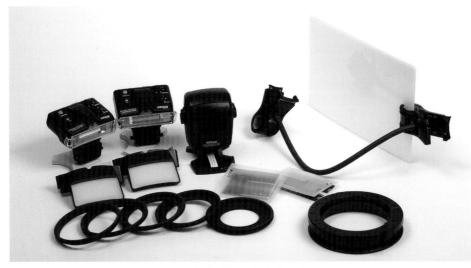

Figure 7.44 - Here is the entire R1C1 kit with all of the included hardware

Using the R1C1 Kit

The R1C1 kit consists of a number of flash toys packed in a big black carrying case. Figure 7.44 shows the entire kit along with the carrying case. The kit includes:

R1C1 Kit Contents

Item	Qty
SU-800 Commander	1
SB-R200 Remote flashes	2
Lens mounting rings	5
SX-1 attachment ring	1
Color filter set	4
IR panel for pop-up flash	1
Close-up diffuser for SB-R200	2
AS-20 light stand for SB-R200	2
Translucent diffuser	1

Table 7.3

Using the AS-20 Mounting Foot

Using Remote flashes is always easier if you can mount them hands-free to some type of light stand. The AS-20 Mounting Foot allows you to set the SB-R200 on the ground as a free-standing flash, or mount it to a light stand/tripod (figure 7.45).

I like to travel as light as possible and often bring along a mini-tripod to hold my small Remote flashes. Figure 7.45 shows a typical setup with the SB-R200 mounted to a Manfrotto mini-tripod. Figure 7.46 shows the back side of the AS-20 and the included 1/4" x 20 threaded socket (figure 7.47).

Figure 7.46 - The AS-20 Mounting Foot can be attached to a light stand with the 1/4"x 20 threaded socket on the bottom side

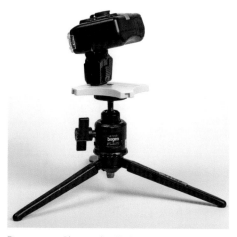

Figure 7.45 - Placing the SB-R200 on a mini-tripod is a cinch with the AS-20 Mounting Foot

Figure 7.47 - You can also use the AS-20 as its own stand to hold up the flash on a table, on the floor, or on the ground

Using the SX-1 Attachment Ring

Another way to use your SB-R200 flashes is to attach them to the front of the camera lens using the SX-1 (figure 7.48).

Figure 7.48 - The SX-1 Attachment Ring allows you to mount the SB-R200 to the front of the camera lens

In addition to the SX-1, Nikon ships five adapter rings in the R1C1 kit that allow you to fit the SX-1 onto most lenses. Screw the adapter ring onto the front of the lens, then attach the SX-1 to the adapter ring. The SX-1 allows you to attach up to eight SB-R200 flashes around the perimeter, or you can also attach the Flexible Arm Clip. A couple of configurations are shown in figure 7.49.

Another neat feature of the SX-1 is that you can insert an AS-20 Speedlight Stand inside the SX-1 and then mount the whole kit to a light stand. This allows you to mount several SB-R200 flashes to the same light stand if necessary (figure 7.50).

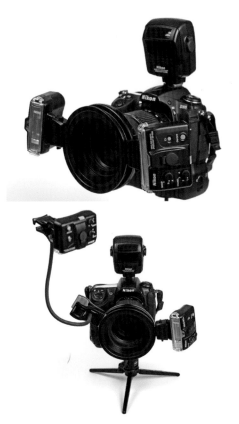

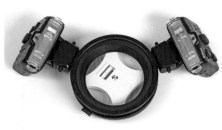

Figure 7.50 - You can insert the AS-20 Speedlight Stand inside the SX-1 Attachment Ring and then mount the whole kit to a light stand

Figure 7.49 - Here are two ways to use the SX-1 Attachment Ring with your camera

Using the Diffuser and Flexible Arm Clip

In keeping with the intended use of the R1C1 system, Nikon includes a small diffusion panel called the SW-12. Its purpose is to soften the light on your close-up subjects. Figure 7.51 shows a couple of different uses for this panel. The top photo shows the panel being used as a reflector board, while the bottom photo shows an SB-R200 firing through the panel.

The SW-C1 Flexible Arm Clip can be used for all kinds of purposes in your

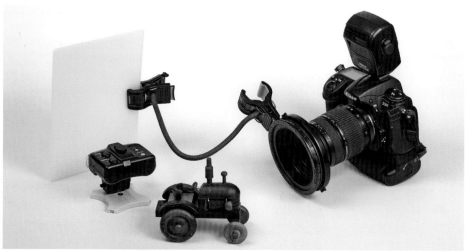

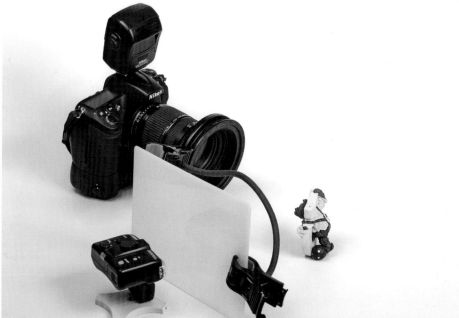

Figure 7.51 - The SW-12 can be used as a reflector board (top) or a diffusion panel (bottom). It is held in place by the SW-C1 Flexible Arm Clip.

close-up system. Once attached to the SX-1 Attachment Ring, it can hold an SW-12 Diffuser, an SB-R200 flash, or even a branch so it doesn't move in the wind (figure 7.52).

Using the SG-3IR Panel

At first glance, the SG-3IR seems like a gimmicky part that you won't use much. However, I actually use it quite a bit when my pop-up flash is the Commander unit. As I mention in chapter 2, the pop-up flash can be a great tool when you need to travel light and want to control Remote flashes.

When you use the pop-up flash as a Commander, it is generally a good idea to turn the built-in flash off (- - -) as shown in figure 7.53. Even when the built-in flash is off, it still causes a tiny bit of light to fall onto the scene. When you photograph people, you can often see a very small catch light in the subject's eyes (figure 7.54). Purists work hard to get catch lights looking just right, so any other type of catch light can be a big distraction in the final photograph.

The solution to this problem is to use the SG-3IR to block the visible light from your

Figure 7.52 - The SW-12 can also be used to hold an SB-R200 flash or a branch

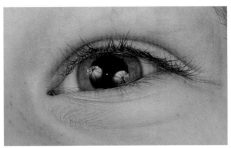

Figure 7.54 - Even if you turn the built-in flash off, you can still get a tiny catch light in the subject's eyes

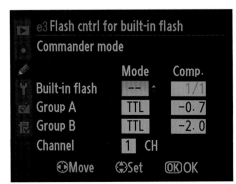

e3 Flash cntrl for built-in flash

Commander mode

	Mode	Comp.
Built-in flash	--	1/1
Group A	TTL	-0.7
Group B	TTL	-2.0
Channel	1 CH	

⟳Move ⟳Set OK OK

Figure 7.53 - When you use your camera's pop-up flash as a Commander, be sure to turn off the built-in flash so it doesn't contribute to the exposure

Figure 7.55 - The solution is to use the SG-3IR to block all visible light from the built-in flash while still allowing IR light to trigger your remote flashes

built-in flash. This panel allows only IR (infrared) light to pass through so the built-in flash can command the Remote flashes. It is really a great tool, and I encourage you to use it in your photography (figure 7.55).

Figure 7.56 - The Color Filter Holder holds the gel in front of the SB-R200

Using Gels with the SB-R200

Nikon includes four color filters in the R1C1 kit that can be used for color correction or for creating dramatic lighting. Read chapter 11 for more information on the proper use of gels in photography.

To insert gels into the SB-R200, carefully remove the Color Filter Holder as shown in figure 7.56. Take a gel and insert it into the back side of the Color Filter Holder underneath the tabs. Then click the Color Filter Holder back onto the SB-R200 and start taking photographs.

Using the Extreme Close-up Adapter

When you photograph a tiny object that is very close to the camera lens, SB-R200 flashes have a hard time completely illuminating the subject. So Nikon includes the Extreme Close-up Adapter in the R1C1 kit to provide better lighting coverage (figure 7.57).

To mount the Extreme Close-up Adapter to the SB-R200, remove the Color Filter Holder and slide the adapter over the flash head.

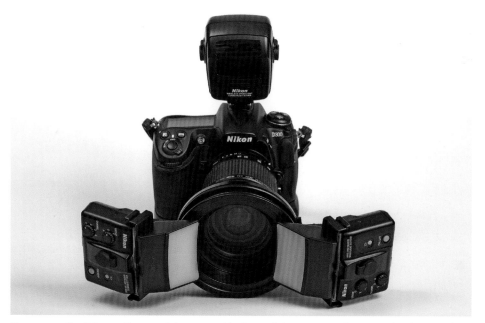

Figure 7.57 - The Extreme Close-up Adapter provides better light coverage when you take photographs of small subjects very close to the lens

Five-Step Plan for Great Flash Photography

OK, now that you have read through the previous chapters and fully understand flash modes, camera modes, power settings, zoom, distance, etc., you now actually have to take a photograph: not just any photograph, but a *great* photograph. How do you put all this knowledge together? The answer is the Five-Step Plan.

Five-Step Plan

1. Set Camera Shutter Sync
2. Set Flash Mode
3. Set Flash Power
4. Take Picture and Review Result
5. Change Settings as Needed and Shoot Again

My goal is to make flash photography as simple as possible. Since it can be very complicated and confusing, I made up a straightforward, five-step plan that I follow whenever I take flash photos. This plan is deceptively simple but will add years to your life just by reducing your frustration. Here it is in a nutshell. I'll explain each step in more detail below.

I follow this plan for every flash setup that I use. For example:

1. Pop-up flash on camera
2. SB-800 mounted on camera as Dedicated TTL BL flash
3. Wireless TTL setup with SB-900 as Commander and assorted SB-600s and SB-800s as Remotes
4. Traditional studio lights such as Speedotrons or Alien Bees synced with PC cables
5. Network of SU-4 flashes

Since the Five-Step Plan only deals with the flash portion of the photo process, there are quite a few things left out. For example, I did not include setting white balance (chapter 11), ISO (chapter 3), aperture (chapter 3), or lighting stands (chapter 15). I guess there really should be a Step Zero called "Set Up Everything Else" before you start the Five-Step Plan.

Here is the detailed information for each step in the plan.

Step 1: Set Camera Shutter Sync

Even though there are five shutter sync modes to choose from (Normal, Normal + Red-eye, Slow, Slow + Red-eye, Slow + Rear), I choose Normal or Slow + Rear for the vast majority of my photography. Chapter 3 has more information on each shutter sync mode.

1. Normal (Front Curtain) (figure 8.1)
 - Use for studio lighting setup
 - Use for situations with no ambient light
2. Slow + Rear (figure 8.2)
 - Use for travel/nature/outdoor fill flash
 - Use for subtle fill flash
 - Use for window portraits for subtle fill flash

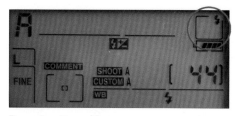

Figure 8.1 - Normal Sync

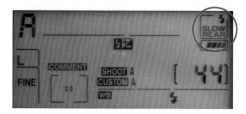

Figure 8.2 Slow + Rear Sync

Step 2: Set Flash Mode

There are many flash modes to choose from on the SB-600, SB-800, and SB-900 strobes. Even so, I typically use only two for most of my photography.

1. TTL BL (figure 8.3)
 - Use for shooting quickly
 - Use for sports
 - Use for travel/nature/outdoor
2. Manual (figure 8.4)
 - Use for accuracy (with hand-held light meter)
 - Use for consistency from shot to shot (e.g., photographing for a church directory or school classroom)
 - Use for situations where TTL BL breaks down (e.g., very high contrast scenes or difficult lighting situations that confuse TTL BL)

Step 3: Set Flash Power

Setting flash power can be a very subjective decision. Who's to say a photo will look better if it is brighter or darker? Most of the time I want a "properly" exposed photograph, and that is what my camera tries to deliver in automatic modes like TTL BL, TTL, and AA. Even so, sometimes I want the flash output to be a bit darker or lighter than my camera would normally provide. That's why I make a flash power decision before I take the first shot.

Here are some recommended starting points for flash power. Remember that they are only recommendations, and your actual choices may vary.

- **Travel/Outdoor/Nature:** Set power from -0.7 to -1.7 for most scenes to provide a nice subtle fill flash.

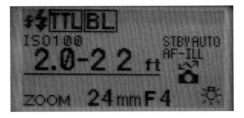

Figure 8.3 - TTL BL mode on the SB-800

Figure 8.4 - Manual mode on the SB-600

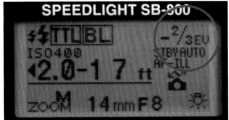

Figure 8.5 - Power output is -2/3 of a stop

Figure 8.6 - Flash output is set at 1/8 power on the SB-600

- **Portraits by a Window:** Set power from 0.0 to -1.7 for most scenes. 0.0 means the flash power approximately equals the ambient window light, and -0.7 means the flash power is 2/3 of a stop below ambient light, therefore serving as a fill flash.
- **Studio Portraits:** Set power for 0.0 for medium brightness subjects, +0.7 to +1.3 for brighter subjects, and -0.3 to -1.0 for darker subjects
- **Event Photography (weddings, dances):** Set power anywhere from +1.0 to -1.0 depending on the scene
- **In Manual mode:** Set power by working with a hand-held light meter to judge proper exposure (I like the Sekonic L-358, www.sekonic.com)

Step 4: Take Picture and Review Result

One of the best things about digital photography is the ability to quickly review the results on the camera's LCD. After taking a flash photograph, I typically check out two items. The first is the Highlights screen to see if there are any blown highlights (figure 8.7). The second is the Histogram screen to see where the overall exposure lies (figure 8.8).

On the histogram, I just make sure the tonality of the exposure is in the proper range. For example, if I take a picture of a bride in a white dress, then I expect to see a spike of data on the right side of the graph from the white dress. If I take a photo of a groom in a black tuxedo, then I expect to see a spike on the left side of the graph. If I don't see what I expect to see, then I need to shoot again with new settings.

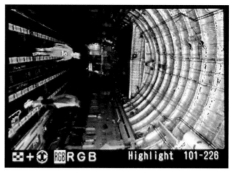

Figure 8.7 - This is the Highlights screen. I look for blinking areas that indicate overexposure. This image was taken inside a Boeing C-17, and I wanted to show how large the interior was. I had two young boys stand inside for a sense of scale. The picture was taken with a D2X and an SB-800 mounted on the hot shoe. In addition, I used a diffusion dome to soften the light and spread it around the interior. Step 1: Slow + Rear. Step 2: TTL BL. Step 3: -2/3. Step 4: No blown highlights in the important areas. Step 5: No action needed.

Figure 8.8 - Just out of curiosity, I like to take a peek at the Histogram screen to check the overall brightness (tonality) of the scene. In this image, the picture is well within the dynamic range of the camera because there are no significant blown highlights (right side) or lost shadows (left side).

Common Flash Mistakes

Problem	Solution
Subject too bright	Dial down flash power
Subject too dark	Dial up flash power, increase ISO, get flash closer, open up aperture, increase zoom setting
Highlights on the subject's forehead	Dial down power, diffuse the light, bounce light off ceiling
Colors are off	Set white balance properly
Subject and background blown out (way too bright)	Maximum shutter sync speed is probably exceeded. Change camera aperture so shutter speed is lower (e.g., 1/500 second for D70; 1/250 second for D80, D200, D2, D3; 1/320 second for D300, D700) or change menus to enable High Speed FP Sync (D80, D200, D300, D700, D2, D3).

Table 8.1

Above are some common flash mistakes and how to fix them (Table 8.1).

Step 5: Change Settings as Needed and Shoot Again

The last step is to make the changes outlined in Step Four, then retake the picture. Hopefully, you are done fiddling and can move on to create great flash photographs like these (see chapter 14 for details about how each one was created):

Although I printed this table in chapter 5, it bears repeating now that you have read about the Five-Step Plan (Table 8.2).

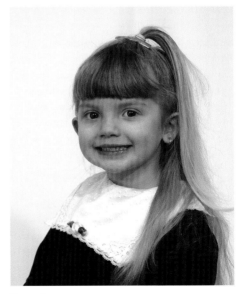

Figure 8.9

Figure 8.10

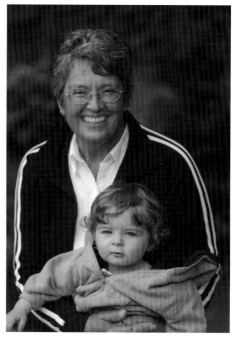

Figure 8.11

System Setup for Common Shooting Scenarios

Shooting Scenario	Camera Sync Mode (Step 1)	Flash Mode (Step 2)	Flash Power (Step 3)	Comments
Outdoor & Travel	Slow + Rear	TTL BL	-0.7	Goal is to use subtle fill flash balanced with ambient light
Window Portraits	Slow + Rear	TTL BL	-0.7	Goal is to use subtle fill flash balanced with ambient light
Formal Studio Lighting (umbrellas, reflectors, etc.)	Normal (Front Curtain)	TTL BL or Manual	Variable	Goal is for flash to provide 100% of light, with no ambient light to speak of
Wedding Reception in Dark Room	Normal (Front Curtain)	TTL BL or AA	0.0 (but change as necessary)	Goal is for flash to provide 100% of light. Mount flash on bracket and use diffusion dome.

Table 8.2

Wireless Flash Camera Capabilities

I always run into lots of questions about camera and flash compatibility. Most owners want to fully understand which cameras work with which flashes, so I summarize the information here:

Using the D70 as a Commander

When you use the D70 pop-up flash as a Commander (CSM 19), it is always active and participating in the exposure. In other

How Different Cameras Work with Wireless Flashes

Camera Model	Pop-up Flash	When mounted with an SB-800, SB-900 or SU-800 Commander (Master)
D70/D70s	Works as a Commander for one Channel and one Group (CH 3, Group A). Access from CSM 19.	Works as a Commander for up to four Channels and three Groups per Channel
D40, D40x, D50, D60	Does not work as a Commander for the Nikon wireless flash system	Works as a Commander for up to four Channels and three Groups per Channel
D80	Works as a Commander for two Channels and three Groups per Channel. Access from CSM 22.	Works as a Commander for up to four Channels and three Groups per Channel
D90	Works as a Commander for two Channels and three Groups per Channel. Access from CSM e2.	Works as a Commander for up to four Channels and three Groups per Channel
D200, D300, D700	Works as a Commander for two Channels and three Groups per Channel. Access from CSM e3.	Works as a Commander for up to four Channels and three Groups per Channel
D2-series, D3-series	These cameras do not have pop-up flashes, so they can only control Remote flashes with an SB-800, SB-900, or SU-800 mounted on the hot shoe	Works as a Commander for up to four Channels and three Groups per Channel
F6	This camera does not have a pop-up flash, so it can only control remote flashes with an SB-800, SB-900, or SU-800 mounted on the hot shoe	Works as a Commander for up to four Channels and three Groups per Channel
Other SLRs, D100, D1X, D1H, F100, FM, N90s	Not compatible with the Nikon wireless flash system	Not compatible with the Nikon wireless flash system

words, it fires during the flash sequence just as it normally would if it were by itself.

Even though the pop-up flash *is* pretty wimpy in Commander mode, you might be able to see its effect if your subject is close. But, if you are photographing a subject more than 10 feet away, you might not be able to detect the pop-up flash's influence on the photograph. The reason is that the pop-up sends out flash pulses for the command information and then immediately fires for the real photograph. The camera's capacitor (which powers the flash) is fairly small, and the D70 pop-up just plain runs out of energy (figures 9.1 and 9.2).

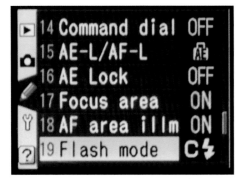

Figure 9.1 - D70 CSM 19 controls the pop-up flash

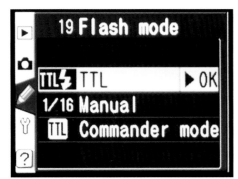

Figure 9.2 - You have three choices in D70 Commander mode: TTL = Through The Lens (normal pop-up flash mode); AA = Auto Aperture (pop-up flash instructs Remote flashes to be AA flashes); and M = Manual flash output (pop-up flash tells Remote flashes to put out a set amount of power, e.g., 1/4).

On the shots where you notice the D70 pop-up's influence, you are probably pretty close to the subject (or using a higher ISO or wide aperture). I often notice the pop-up's influence on portraits where the subject is standing close to a wall. In that situation, you can almost always see the shadow cast behind them by the pop-up flash. On shots where you don't notice the pop-up's influence, you are probably farther away from the subject (or using a low ISO or small aperture).

From a technique standpoint, the closer your Remote flash (SB-600, SB-800, SB-900, or SB-R200) is to the subject, the less influence your D70 pop-up has because the Remote becomes the dominant light source. The D70 pop-up basically serves as a communicator for the Remote.

Using the D80, D90, D200, D300, or D700 as a Commander

The operation of the D80, D90, D200, D300, and D700 is almost identical in pop-up Commander mode. The only major difference is that you access the pop-up (built-in) flash menus in different locations on different cameras. The D80 menu is in CSM 22m, the D90 menu is in CSM e2, and the D200, D300, and D700 menus are in CSM e3. Everything else is the same.

You can control each camera's pop-up flash power under the Custom Settings Menu (figure 9.3). In fact, you can even turn off the pop-up during the exposure by selecting - - - (figure 9.5). This is a great benefit for pop-up users because it allows you to fully control the Remote flashes while canceling the pop-up when the camera's shutter is open. I give Nikon major kudos for this feature! In fact, I recommend shooting this way (i.e., selecting - - - for the built-in flash) most of the time so your photographs don't look like they were taken with a pop-up flash.

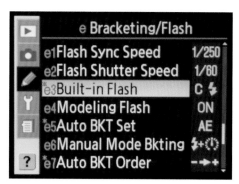

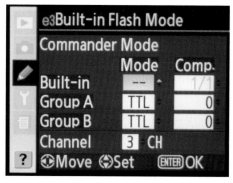

Figure 9.3 - The D200 and D300 built-in (pop-up) flash menus are in CSM e3

Figure 9.5 - The Commander mode screen is identical in the D80, D90, D200, D300, and D700. Here the built-in (pop-up) flash is turned off. Even though it is off during the actual exposure, it still sends out light pulses to control all of the Remote flashes in the system.

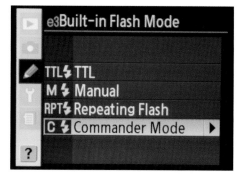

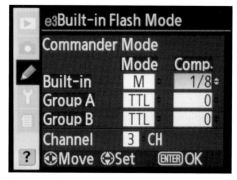

Figure 9.4 - The next screen in CSM e3 lets you pick from four different flash modes: TTL = Through The Lens (normal pop-up flash mode); Manual = Manual flash output (pop-up flash puts out as much light as you tell it to); RPT = Repeating Flash (you program the repeat rate and power for each flash pulse); and C = Commander (controls the other wireless Remote flashes in your system).

Figure 9.6 - In this screen, the D80, D90, D200, D300, and D700 pop-up flashes work as Manual flashes and put out 1/8 power. Group A and B Remote flashes are programmed as TTL flashes at 0.0 (medium brightness). All flashes are "speaking" on Channel 3.

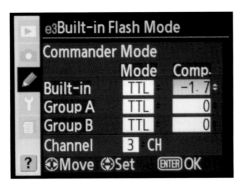

Figure 9.7 - Here, the built-in (pop-up) flash is set for TTL mode at a flash compensation of -1.7 stops. This means that the pop-up flash provides very subtle fill flash while the other flashes put out 0.0 EV (medium brightness).

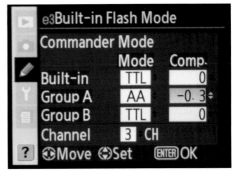

Figure 9.9 - Here, Group A flashes are set to operate in AA mode. This means that they won't use the camera's TTL Matrix Meter to calculate exposure. Rather, each flash calculates its own exposure automatically. Only SB-800 and SB-900 flashes can be AA Remotes. SB-600 and SB-R200 flashes do not have that capability.

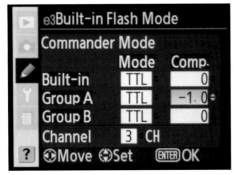

Figure 9.8 - The built-in (pop-up) flash is set for TTL mode and puts out enough light for a 0.0 (medium) exposure. Group A flashes put out -1.0 and Group B flashes put out 0.0.

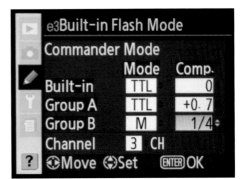

Figure 9.10 - Here, Group B flashes are set up as Manual strobes and put out 1/4 power. The built-in (pop-up) flash is a regular TTL flash at 0.0, and the Group A flashes are TTL at +0.7.

Here is an important note about your camera's pop-up flash. Let's say you configure the pop-up as a Commander unit and place an SB-800 or SB-900 on the camera's hot shoe (figure 9.11). In this scenario, the big flash takes over and disregards everything you program into the camera's menu. For example, if you have the D300 pop-up flash programmed as a Commander flash but then place an SB-900 on the hot shoe as a TTL BL Dedicated flash, the SB-900 takes over. The reason is that the D300's pop-up flash is in the down position and isn't operable.

An important item to remember about the D80/D90/D200/D300/D700 is that you can mount an SB-800, SB-900, or SU-800 on the camera as a Commander unit and control up to three different Groups (A, B, C) on four different Channels (1, 2, 3, 4). Also remember that your camera's pop-up flash can only control two Groups (A and B).

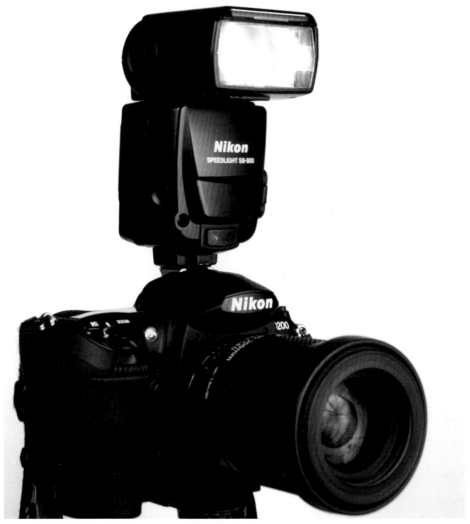

Figure 9.11 - When you place an SB-800 or SB-900 on the camera's hot shoe, it will override the camera's pop-up flash settings in the Custom Settings Menus

Using the D40, D40x, D50, or D60 as a Commander

These cameras don't have the ability to command remote flashes with their pop-up flashes. Still, they *are* compatible with the Nikon wireless system as long as you mount an SB-800, SB-900, or SU-800 as the Commander flash. In this setup, they work exactly like the D70, D80, D200, D300, D700, D2, D3, and F6 cameras when a Commander unit is attached. You can control three Groups (A, B, C) and four Channels (1, 2, 3, 4) from the back of the SB-800, SB-900, or SU-800.

Using the D2-series or D3-series as a Commander

Nikon's professional bodies like the D2 or D3 do not have pop-up flashes, so they cannot control Remote flashes unless you attach a Commander flash unit such as the SB-800, SB-900, or SU-900 (figure 9.12). These cameras work exceptionally well in the wireless flash system and yield superb results.

One of my favorite things about the D2 and D3 cameras is how quickly they control the entire wireless flash system. It is truly a professional setup and speedier than Flash Gordon flying Dr. Zarkov's rocket ship. The pre-flashes happen so quickly that they are almost imperceptible.

When you use an SB-800, SB-900, or SU-800, you have full control of the Nikon wireless system. You can command up to three Groups (A, B, C) and four Channels (1, 2, 3, 4).

Using the F6 as a Commander

This camera does not have a pop-up flash, so it cannot control other flashes unless you mount a Commander flash unit like the SB-800, SB-900, or the SU-800. The F6 is the only Nikon film camera that allows you to take advantage of the CLS wireless flash system.

Just like all of the other cameras compatible with CLS, the F6 allows you to control three Groups (A, B, C) and four Channels (1, 2, 3, 4). The F6 is not only just as capable as the D2 or D3, but also just as speedy as its digital counterparts.

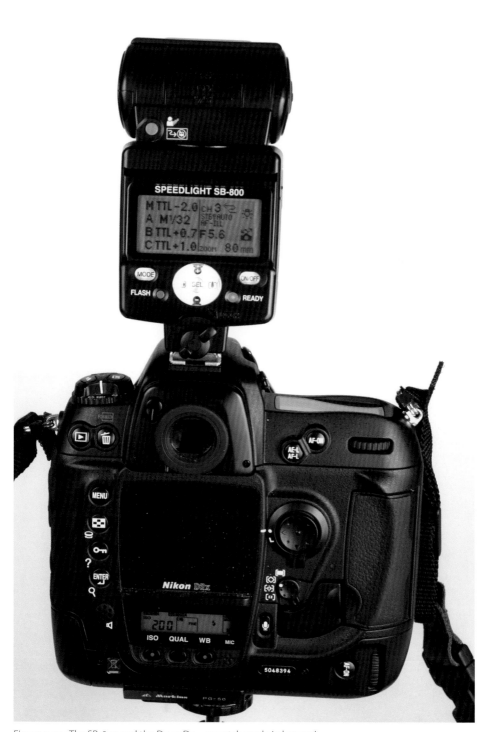

Figure 9.12 - The SB-800 and the D2 or D3—a match made in heaven!

Flash Beeps

The beeps will set you free!

Why do I have an entire chapter dedicated to beeps? Because they are important! Specifically, it is important to listen to the beeps that come after the flash sequence because they tell you how your Remote flashes performed. When I set up my flashes for wireless Remote photography, I keep the beeps turned on so I can audibly tell if they are working properly. (Note: the Custom Settings Menus sections in chapters 4, 5, and 6 show how to turn on the beeps for the SB-600, SB-800, and SB-900.)

The only time the SB-600, SB-800, and SB-900 flashes beep is when they are configured as Remote units. In other words, if you have an SB-600 mounted on your D300 as a regular Dedicated TTL BL flash, it won't beep. If, on the other hand, you configure the SB-600 as a Remote flash, the beeps will be automatically activated.

Here is a summary of the beep sounds you will hear from the flashes when you configure them as wireless Remotes:

1. Standard Beeps
 a. Two quick beeps and one long beep. "Beep beep ... beeeeeeep"
 - In wireless TTL mode, this beep sequence means everything went well with no mistakes. The first two beeps mean the flash fired properly. The third beep (the long one) means the capacitor is fully charged and ready to fire again. Note that the READY light illuminates after the long beep.
 b. Single long beep. "Beeeeeep"
 - This beep sound occurs when the flash is in Manual Remote mode and you successfully trigger the flash. It indicates the capacitor is fully charged and ready to fire again. The READY light illuminates after this single long beep.

2. Error Beeps
 a. Eight beeps in a row in rapid succession. "Beep beep beep beep beep beep beep beep"
 - This beep sequence means the flash fired, but it dumped 100% of its energy for the photograph. You can assume that the shot is underexposed because the flash did not have enough power to light up the scene (figures 10.1, 10.2, and 10.3). After the beeps, look at the upper right corner of the flash's LCD panel to see how far underexposed the shot was. If you miss the value (it disappears in a few seconds), you can recall it by following these steps:
 1. SB-600 - Press MODE and ZOOM buttons together
 2. SB-800 - Press MODE and SEL buttons together
 3. SB-900 – Press Function Button 2

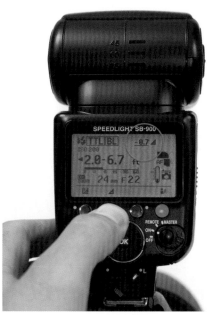

Figure 10.1 - To recall an underexposure value on the SB-900, press Function Button 2. The value shows in the upper right corner of the LCD. In this case, the flash is -0.7 EV underexposed.

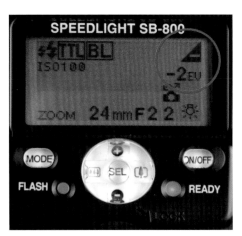

Figure 10.2 - To recall an underexposure value on the SB-800, press the MODE and SEL buttons together. The value shows in the upper right corner of the LCD. In this case, the flash is -2 EV underexposed.

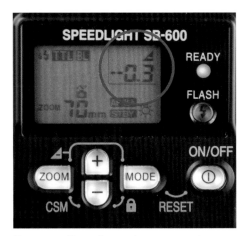

Figure 10.3 - To recall an underexposure value on the SB-600, press the MODE and ZOOM buttons together. In this case, the flash is -0.3 EV underexposed.

- There are a number of ways to fix this error. Since it happens because the flash didn't have enough power to light up the scene, the goal is to get more light to the subject. Here are your options:
 1. Get the flash closer to the subject
 2. Take off the diffusion dome
 3. Increase the lens aperture (e.g., shoot at f/5.6 rather than f/8)
 4. Zoom the flash head so it is more telephoto (e.g., set it for 50 mm rather than 24 mm)
 5. Set the camera's ISO to a higher value (e.g., change to ISO 400 from ISO 200)

b. High/Low beep. "Beeep Bwooop Beeep Bwooop"

- This sequence generally means that you have instructed the Remote flash to operate in an incorrect mode (figure 10.4). For example, if you set the Commander flash to tell an SB-600 Remote to operate in AA mode, the SB-600 sounds a high-low beep error message because it can't work in AA mode. Only an SB-800 or SB-900 can operate in wireless AA mode.

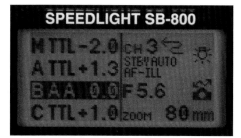

Figure 10.4 - If you configure Group B as an AA flash, but the flash is an SB-600, you get a high/low beep as an error message. It sounds like "Beeep bwooop beeep bwooop." Only SB-800 or SB-900 flashes can be configured as AA flashes.

Figure 10.5 - An SB-600 Remote flash does not have the ability to operate in AA mode. If you try, you get the high/low error beep.

White Balance and Gel Usage

White balance doesn't have to be complicated. In fact, it is very simple once you boil it down to the basic elements.

The goal of white balance is to filter ambient light so that colors look natural. Generally speaking, if you take a photo of a white object, the proper white balance settings render it as white in the final photo. The white object should not look either too blue or too red. Rather, it should appear white. Simple!

Since this book is about using Nikon CLS flashes, you need to understand what color they are so you can learn to balance the colors in the overall scene. Nikon flashes have a color temperature of about 5400 degrees Kelvin. Kelvin values can be a bit confusing, so let me try to clarify them (table 11.1).

If you haven't paid much attention to color temperature before, now is the time to do so. Color temperature refers to something called black body radiation. Scientists like to talk about things that glow in the dark, and they also like to characterize those things with sophisticated-sounding names. Let's say we heat up a colorless mass, a.k.a. a black body, to 3200 degrees Kelvin (for reference, molten lava is about 1360K). At 3200K, the black body gives off a yellow/orange light. In contrast, at 7000K, the black body gives off a very blue light.

OK, let's apply this knowledge to the real world. An incandescent light bulb—the same as the one in your living room—has a color temperature of about 3000K and gives off a yellow/orange color (table 11.1). If you are standing outside on a cloudy, overcast day, the color temperature would be around 6500K, and the light would have a bluish color. If you take photos of your daughter in these two situations without changing the white balance, you will probably be unhappy with the resulting color casts. For example, the photos you took in the incandescent light will have an orange cast, while the photos you took on the cloudy day will have a blue cast.

Modern cameras have the ability to balance the light so the resulting colors are neutral. In other words, you can balance the color of the light so that a white subject actually looks white in the final image. So, if your ambient light is blue because you are photographing on a cloudy day, add in some red to "neutralize" the blue. Conversely, if the ambient light is yellow/orange like an incandescent bulb, add in some blue to make the final colors neutral. Realize that I use the term "neutralize" loosely here, but the goal is to avoid photographs with strong color casts.

Now for the more complicated stuff: i.e., learning how to use the white balance tools properly. Most cameras have multiple ways to control white balance, ranging from simple to pretty complicated. The controls are:

1. Automatic White Balance
2. Factory Preset White Balance
3. Custom (or Preset) White Balance
4. Kelvin Values

In the following sections, I cover each of these white balance methods in more detail.

Kelvin Color Temperature Scale

Type of Light Source	Color Temperature in Kelvin values
Candle Flame	1,500
Incandescent Light Bulb	3,000
Sunrise, Sunset	3,500
Midday Sun or Flash	5,400
Bright Sun, Clear Sky	6,000
Cloudy Sky, Shade	7,000
Blue Sky	9,000

Table 11.1 - Kelvin color temperature scale

Automatic White Balance

All digital cameras have some type of Automatic White Balance (Auto WB) control that allows you to "set it and forget it". Auto WB (figure 11.1) uses the camera's RGB Matrix metering system to look at the colors of the scene and then quickly calculate how to adjust the final colors so white looks white.

The trouble with Auto WB is that it changes its color correction for every picture you take. For example, let's say you are taking photographs at a wedding. In one picture, the bride stands in front of a red wall. In the next picture, she stands in front of a blue wall. You mostly care about the color of the bride and her dress, and not so much about the color of the wall.

Figure 11.1 - This is Automatic White Balance (Auto WB) as shown on a D200. This function is inconsistent from shot to shot and is a big frustration for JPEG shooters. Don't shoot Auto WB if you need consistency.

In each of these scenarios, the camera adjusts white balance based on all the colors in the scene. For the photo of the bride in front of the red wall, the camera adds a blue filter, making the bride look blue (not a good thing). For the photo with the blue wall, the camera adds the opposite color, red. Neither scenario is good, and both require you to do color correction after the fact.

The truth is, Auto WB is too variable for situations where you need consistency from shot to shot (figure 11.2). Many people recommend shooting in RAW (NEF) mode and adjusting white balance later at the computer. That approach is fine if you have just a few images to adjust, but what if you have hundreds or thousands after a trip or an assignment?

It makes sense to set the color white for a fixed value such as "Preset", "Incandescent", or "Kelvin" in the camera, right from the get-go. That way, all your photos remain consistent and you don't have to waste precious hours at the computer fixing white balance later. My strong recommendation is always to get the photos as close to perfect in the camera as possible.

This leads us to the next level of white balance control: factory presets.

Figure 11.2 - The images on the left were taken with a D70 using Auto WB. The images on the right were taken with a D2X using Auto WB. In both cases, the colors vary significantly from shot to shot. That doesn't cut it in my book!

Factory Preset White Balance

Almost all Nikon digital cameras come with Factory Preset WB settings that cover most lighting scenarios you are likely to come across. These settings are:

- Incandescent
- Fluorescent
- Direct Sun
- Flash
- Cloudy
- Shade

Using these settings is very easy. If the lighting for the scene is a flash, set your white balance for "Flash". If the lighting for the scene is incandescent light, then choose "Incandescent". It really is that simple. Set your white balance for the type of light in your shot.

I use these settings extensively on my camera and find them to be pretty accurate for much of my work. In the studio, setting the White Balance to "Flash" is sometimes all I need to get great colors.

Each of the Factory Presets can also be fine tuned. Usually, you can accomplish this by pressing the White Balance button on the camera, then rotating the subcommand dial (the front dial). You will see numbers like -1 or +2 on the LCD panel of cameras like the D80, D200, or D2-series. On newer Nikons like the D90, D300, D700, and D3, you will see values like A1 or B3 (figures 11.4 and 11.5). These values allow you to warm up the image by adding red or cool down the image by adding blue. The concept is actually very simple:

WB Fine Tuning for D70, D80, D200, or D2-series
- adds red (warming)
+ adds blue (cooling)

WB Fine Tuning for D90, D300, D700, or D3-series
A adds amber (warming)
B adds blue (cooling)

Figure 11.3 - Each of the Factory Preset WB settings has its own picture icon. This one is Cloudy WB.

Figure 11.4 - The left image shows how to bias the Cloudy WB Factory Preset on the D200 to be a little bit warmer (redder) by going Cloudy -1. The right image shows how to bias it to be a little bit cooler (bluer) by going Cloudy +2.

Figure 11.5 - Here is what White Balance fine tuning looks like on the D300. The A2 means that an amber filter has been added.

Figure 11.6 - Here is a warmer shot at Cloudy -1 taken with a D2X

Figure 11.7 - Here is a cooler shot at Cloudy +2 taken with a D2X

If I am traveling and creating stock photographs, I set the camera for Cloudy -1 or Cloudy +2 (figures 11.6 and 11.7). This adds a bit of warmth and an extra hint of color to my images. If I am using a flash, these settings can help warm up the shot.

Custom (or Preset) White Balance

There always comes a time in your photography when "pretty accurate" isn't good enough. For example, let's say you need to photograph a product that has a certain color associated with it, or a famous actor for a magazine (happens all the time, right?). In these situations, you must make sure your white balance is as accurate as possible. That's when Custom (Preset) White Balance comes into play.

Note that this white balance setting has two names, Custom WB and Preset WB; they mean the same thing. On Nikon cameras, this function is referred to as PrE or Preset (figure 11.8).

All Nikon digital SLRs have the ability to collect a Custom WB reading by taking a "capture" of a white card or a gray card. You can use either white or gray because they are both neutral colors. When you point your camera at a white or gray card and take a preset white balance, you tell the camera to

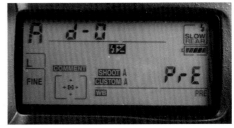

Figure 11.8 - Custom WB is shown by the letters PrE on the camera's LCD

make color adjustments so the card turns out white or gray. This is accomplished by following these steps:

1. Set camera white balance to PrE
2. Let go of WB button
3. Press WB button again until you see a blinking PrE (figure 11.8)
4. Aim camera at white or gray card
5. Press shutter release
6. Look for the word "Good" on the LCD panel (figure 11.10)
7. Take picture

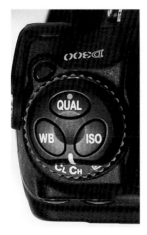

Figure 11.9 - The WB button on the D700. Push this button and rotate the camera's main command dial until you see PrE.

Figure 11.10 - After you take the photo of the white or gray card, you should see the word "Good" on the camera's LCD

When you capture a Custom WB, it is only good for photographs taken in the same lighting conditions. If you change the lighting conditions, the Custom WB no longer gives you good colors, and you need to reset the Custom WB. The Custom WB stays in your WB memory until you overwrite it with a new value.

When you photograph in a controlled lighting situation—e.g., your studio with SB-600 and SB-900 flashes set up in umbrellas—capture the Custom WB exactly as outlined above. Get your lights arranged, set up your Commander flash to fire all the Remotes, place the gray card where your subject will be sitting, and then capture the Custom WB. It's so simple and quick that there is no excuse for not doing it.

There are lots of times, though, when using Custom WB just isn't practical. For example, it would be difficult for a wildlife photographer to use Custom WB. Imagine some guy walking up to a lion, placing a gray card by its face, sauntering back to the Land Rover, capturing the Custom WB, walking back to the lion, walking back to the Land Rover, and then taking photos. It isn't going to happen!

Fortunately, other tools allow you to do Custom WB in the field, such as Expo Disc (www.expodisc.com). Place this white translucent disc in front of your lens to capture a Custom WB. The difference is that you aim the disc at the light source rather than at a gray card.

So, use Custom WB when you have the time to do so or when it makes sense. Use the Factory Presets (cloudy, sunny, etc.) when you have to move quickly or when it isn't practical to place a card in the scene, or pull out an Expo Disc.

There are some great products you can use to capture Custom WB. One of my favorites is the Lastolite EzyBalance gray target. This is a well-designed unit that folds up for

portability, but also expands nicely when unfurled (figure 11.11). The EzyBalance card also has an autofocus target in the middle, making it easy to photograph with your AF system turned on.

If you ever find yourself without a gray target, then feel free to use a white piece of paper, a white bed sheet, or even a standard 18% gray card (figures 11.12 and 11.13). Please recognize that if the item you use to capture Custom WB is not perfectly neutral in color, the WB will be off.

Some photographers like to use WarmCards (figure 1.14). You can buy a set of these cards at www.vortexmedia. com. Their purpose is to add some red to the scene when you set Custom WB. You use WarmCards exactly as you would use a standard gray or white card. The end result is warmed-up skin tones and perhaps more pleasing photographs.

Figure 11.12 - You can use any white object to set Custom (Preset) WB. A piece of paper is often just what the doctor ordered.

Figure 11.13 - A standard gray card will also work just fine to set Custom WB

Figure 11.11 - Using the Lastolite EzyBalance gray target is simple. Just place the target by your subject, or have your subject hold it. Always point the target directly at the camera. Image © Lastolite, www.lastolite.com.

Figure 11.14 - WarmCards are used in the same way as normal gray cards, but they bias the camera's Preset WB so that the final result is warmer (redder)

Kelvin Values

Sometimes you just know what the white balance is for a given environment. For example, let's say you commonly photograph your son's band concerts in the same auditorium every time. After a while, you notice that you get the best results when the white balance is set to 4200K. If so, you can simply dial that value into your camera (figure 11.16). You accomplish this by pressing the WB button and rotating the main command dial until the letter K shows up on the LCD panel.

It won't take you long to start looking at light sources and quickly recognizing what 3200K or 8000K looks like.

 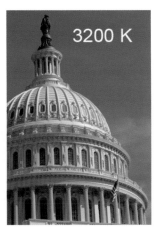 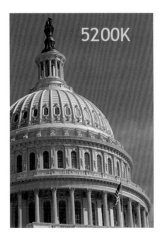

Figure 11.15 - Setting WB for a scene based on Kelvin values can be tricky. If you know what the actual value should be, then you can use a higher Kelvin value to add warmth or a lower Kelvin value to cool it down. This shot was taken in direct sun, so the Kelvin value should be around 5200K for accurate colors.

Figure 11.16 - This is what your camera's LCD panel will look like when you set the Kelvin value for WB

NOTE

Note that not all Nikon DSLR cameras can choose actual Kelvin values. For example, the D40, D40x, D50, D60, D70, and D70s do not have that ability. The D80, D90, D200, D300, D700, D2-series, and D3-series do have that ability.

Using Gels

Let's say you are taking a Slow + Rear Sync flash photograph in a room with mixed lighting. The ambient light might consist of fluorescent ceiling lights. If you want to use your flash, you must deal with two different colors of light: fluorescent (3800K) from the overhead lights and flash (5400K) from the strobe. How do you set the white balance for this scenario? Lots of people wimp out,

set the camera for Auto WB, and hope that Nikon figured it out for them. But the best answer is to use gels to modify the color of the light from your flash so it matches the color of the light in the room (figures 11.17 and 11.18).

As mentioned before, all light sources have different colors associated with them. Flashes have a blue cast, incandescent bulbs have a yellow/orange cast, and most

Figure 11.17 - These are the different types of gels in the SJ-1 gel pack that fit with the SB-800. Clockwise from upper left:
Red = Creative lighting gel.
Blue = Creative lighting gel.
FL-G1 = Color balance gel for fluorescent lighting.
Amber = Warming gel.

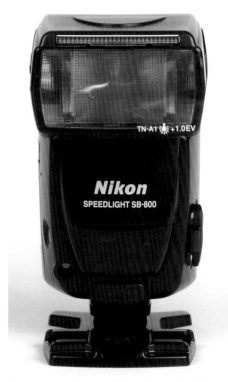

Figure 11.18 - The gels for the SB-900 are encoded with color information right on them. When you set Auto WB on the camera, it automatically changes the white balance so it coincides with the gel. You can purchase the SJ-3 gel pack complete with fluorescent, tungsten, blue, red, amber, and yellow gels.

Figure 11.19 - SJ-1 gels fit directly into the SB-600 or SB-800 flash head. Insert them below the wide angle diffusion panel. The gel shown is the tungsten gel.

fluorescent bulbs have a green cast. If you are taking a photograph in Slow + Rear Sync and the ambient light is tungsten at 3200K, then you have a color mismatch. Your goal should be to make the flash color (5400K) match the background color (3200K).

Nikon sells two different types of gels designed to help solve color issues in the field. The SB-600 and SB-800 use SJ-1 gels, while the SB-900 uses SJ-3 gels. You can purchase these gels at most high-end camera stores. Their benefit is that they are already cut to the correct size for your flash. You can also use gels from other manufacturers, e.g., Bogen, Lee, and Roscolux, to accomplish the same thing.

Gels fit into the flash as shown in figure 11.19. Just slide them underneath the wide angle diffusion panel.

Table 11.2 shows the different types of gels included in the SJ-1 and SJ-3 packs.

Making the flash color match the color in your scene is actually pretty easy. Figures 11.20 and 11.21 show a real-world example of how gels allowed me to make a product shot that mixed ambient incandescent light with a flash.

Here are the steps:

1. Set camera WB for ambient light conditions
 - If ambient light is incandescent (tungsten), then set camera WB for incandescent
 - If ambient light is fluorescent, then set camera WB for fluorescent
2. Insert colored gel into flash (under wide angle diffusion panel)
 - Use TN gel for tungsten (incandescent)
 - Use FL gel for fluorescent
3. Take photo

SJ-1 and SJ-3 Gel Pack Contents

FL-G1 (fluorescent)
FL-G2 (fluorescent)
TN-A1 (Tungsten)
TN-A2 (Tungsten)
Blue
Yellow
Red
Amber

Table 11.2

Figure 11.20 - This product shot for toy guitars shows how important it is to gel your flash. For this shot, I mixed an incandescent lamp with an SB-800 in the foreground. The first image (left) shows the exposure with just the incandescent light. For this image, the camera's WB is set to Incandescent. The second image (middle) shows what happens when I turn on the Remote SB-800 flash with no gel. The flash's light is much bluer than the incandescent light, and you can see that here. The last shot (right) has the appropriate color balance. The SB-800 flash has an incandescent (tungsten) gel that matches the incandescent lamp. The camera's WB is set for incandescent (tungsten). All the colors match, and life is good.

Figure 11.21 - Here is the simple location setup I used for the product shot of the guitars. The umbrella on the left has a Remote SB-800 with a tungsten gel set for CH1, Group A. The light stand on the right is a standard house lamp with a 100 watt incandescent light bulb. The camera is a D200 set to Slow + Rear Sync at f/8 and ISO 400. I used the D200's pop-up flash as the Commander unit.

Figure 11.22 - A red gel was placed on a Remote flash and pointed at the background. The main lights were not gelled, so the color on the face is natural. Camera WB was set to Flash. The Commander unit was an SB-800 mounted on top of the camera. The SB-800 key light on the left side was set for CH2, Group A with TTL and +1.3. The SB-600 fill light on the right side was set for CH2, Group B with TTL and +0.3. The SB-600 background light was set at CH2, Group C with Manual Power at 1/16. Camera exposure was set for Aperture Priority f/3.5, and flash shutter sync was set for Normal.

Figure 11.23 - A red gel was placed on a Remote flash and pointed at the background. The main light had a yellow gel (Why? I don't know. We were playing with gels at a flash workshop). Camera WB was set to Flash. The camera was a D70 with a 24-120 mm lens. The Commander unit was the D70 pop-up flash. All of the remote flashes were set for CH3, Group A. Camera exposure was set for Aperture Priority, and flash shutter sync was set for Normal.

The basis for all color correction is to make the flash color the same as the ambient light color. Simple. Well, actually, not so simple. You may have noticed that there are multiple hues of tungsten gels as well as multiple hues of fluorescent gels. The reason is that not all light bulbs are created equal. For example, you can purchase fluorescent light bulbs that are balanced for 4400K, 5000K, or 6500K. In order to get your colors to match correctly, you might have to choose the FL-G2 gel instead of the FL-G1 gel.

There are many times when you want to be creative with your lighting and add interesting colors to the background. You can also use gels for this purpose. The SJ-1 gel pack includes red, blue, yellow, and amber colors that you can use to creatively light the scene. Figures 11.22, 11.23, and 11.24 show some examples of creative gel usage.

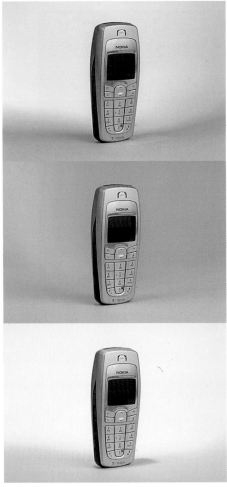

Using Gels with the SB-900

The SB-900 has new technology that allows it to automatically detect the type of gel inserted into the flash head. Nikon does this by manufacturing the gels with built-in identification codes (figure 11.25). In order to fully use the new technology, you need one of Nikon's newest professional level cameras; the D700 or D3. Automatic gel detection and white balance control do not work on the D40, D60, D300, D2X, F6, etc.

The idea with the new gels is to allow you to set your camera to Automatic White Balance and let the camera do the color correction for you. For example, if you are shooting in fluorescent light, you add the fluorescent gel to the flash. With the gel mounted, the camera and flash together determine the color temperature of the scene and automatically correct the color cast of the subject. The goal is to eliminate some of the confusion around color temperature and white balance.

Many professional photographers don't feel comfortable leaving color balance decisions up to the camera's auto white balance technology. I fall into this camp, but this new automated gel technology is compelling. Time will tell if it stands the test of professional photographers.

Figure 11.24 - These three images show how gels can be used for creative product lighting. The Commander light was the pop-up flash on a D200. The background light was a gelled SB-800. Flash mode was Manual, power was 1/32, CH1, Group A. There were two foreground SB-600 lights behind white umbrellas set for TTL BL, +1.3, CH1, Group B. The camera's pop-up flash was turned off (- - -). White balance was set for Custom (PrE) from a standard gray card. I captured the WB setting with the background gel flash turned off so it wouldn't impact the color of the Custom WB. Camera exposure was set for Aperture Priority, and flash shutter sync was set for Normal.

Figure 11.25 - You can see the built-in identification codes on the bottom of the SB-900 gels

Here is how to use the new SB-900 gels on your D700 or D3:

1. Fold the gel along the dotted line (figure 11.26)
2. Insert the gel into the plastic filter holder (figure 11.27)
3. Snap the filter holder onto the front of the SB-900 (figure 11.28)
4. Make sure the flash acknowledges that the new filter is mounted by looking at the LCD panel (figure 11.29)
5. Set camera to Auto WB or Flash WB (figure 11.30)
6. Take picture

Figure 11.28 - Snap the filter holder onto the SB-900

Figure 11.26 - Fold the gel along the dotted line

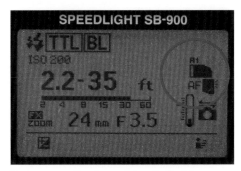

Figure 11.29 - Check to see that the flash has acknowledged the gel

Figure 11.27 - Insert the gel into the plastic filter holder

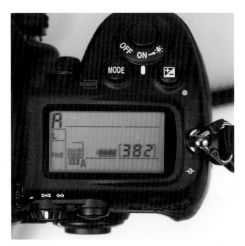

Figure 11.30 - Set camera to Auto WB or Flash WB

Batteries and Power Options

Battery technology has come a long way in the last few years, and we now have more options than ever before to power our Nikon flashes. My preference is to use rechargeable batteries since their cost is low and their performance is high. The SB-600, SB-800, and SB-900 use AA cells, while the SU-800 and SB-R200 use CR-123 cells. I find that I can buy good quality AA rechargeables for around $1.00 per cell and CR-123 batteries for around $4.00 per cell.

Battery Choices for SB-600, SB-800, and SB-900

You can use any AA-type battery in your SB-600, SB-800, or SB-900. Nikon specifically states that you can use the following AA batteries:

- Alkaline
- NiCd (Nickel Cadmium)
- Lithium
- Ni-MH (Nickel Metal Hydride)

I personally choose Ni-MH batteries for a number of reasons. First of all, they don't have any memory effects like NiCd batteries. Second, they have great capacity. Finally, they are relatively inexpensive (figure 12.1).

My AA rechargeables tend to last for one to two years of regular use, and then I purchase new ones. At about $1.00 each, I get lots of life for my money.

When You Need More Capacity

There are times when it makes sense to increase your battery capacity. For example, when you photograph a sporting event or a wedding, you may need to take rapid-fire flash shots. The standard four AA batteries in the flash just won't keep up in fast shooting situations. In these scenarios, it makes sense to purchase a larger battery pack (figures 12.2 and 12.3).

I recommend four models:

1. Nikon SD-8A (www.nikonusa.com)
2. Nikon SD-9 (www.nikonusa.com)
3. Black Box (www.aljacobs.com)
4. Tuxedo (www.aljacobs.com)

Figure 12.1 - I buy my batteries from Thomas Distributing (www.thomas-distributing), eBay (www.ebay.com), or any other website where I can find good deals. I recommend using 2700 mAh batteries or higher since they provide the most usage per charge. I labeled this group of batteries "C" (see text).

Figure 12.2 - The SD-8A holds a total of six AA cells. This battery pack greatly reduces recycle time for your flash and allows you to shoot for longer periods of time.

Figure 12.3 - Al Jacobs' Black Box battery pack (www.aljacobs.com)

These larger battery packs dramatically decrease your flash's recycle time and allow you to take many more flash photos per charge than straight AA cells. One of the benefits of these models is that they are specifically designed to recycle your flash at a sustainable rate. In other words, their electrical current is low enough so you don't have to worry about overheating your flash and frying its circuitry. Some other brands of external flash batteries have been known to completely toast the flash's circuits. You may get faster recycle times from the other brands, but you also risk ruining your flash.

Battery Management

In my camera bag, I organize and label the batteries in groups. Once the batteries are labeled together, they stay together for the rest of their lives (figures 12.1 and 12.4). I do this so I don't mix up different battery types in the field. For example, one battery might be 2700 mAh and another might be

2000 mAh. If these two batteries are mixed in the flash, the 2000 mAh battery will go dead first and start to reverse charge. This will cause the 2000 mAh battery to fail and soon become totally unusable (won't take a charge). So, it makes sense to keep your batteries together as a group for the long haul.

Another thing I do is store all my batteries in the box pointed in the same direction if they are fully charged (figure 12.5). Once the batteries have discharged during use, I put them back into the box in alternating directions. This allows me to see quickly which box is charged and which box is dead when I am shooting at an event.

For charging my AA cells while traveling, I use a portable four-cell charger. Back at my office, I have a larger eight-cell charger made by MAHA called the MH-C801D (www.thomas-distributing.com). The charging of each cell is independently controlled by a computer chip to provide the best results. However, most general battery chargers do just fine and should have your batteries charged in a couple of hours (figure 12.6).

Figure 12.4 - I organize all of my AA batteries in groups so I don't mix them up in the field

Figure 12.5 - I keep my charged batteries pointed in the same direction. When they are dead, I alternate the direction so I can quickly see whether or not to use them.

Battery Choices for SU-800 and SB-R200

The SU-800 and SB-R200 use small CR-123 batteries for operation. Typically, these are Lithium ion and very high performance. If you purchase single-use Lithium ion batteries, they can be very pricey at around $4.00 each. That's a lot of money to throw away after each use.

Rather than go with the single-use CR-123 batteries, I buy RCR-123A Lithium ion rechargeables from Delkin Devices (www. delkin.com). They cost around $10.00 each, but they last for years of recharging. In addition, the Lithium battery technology makes the batteries very stable so they don't slowly discharge over time. I also recommend purchasing the CR-123s from Thomas Distributing, where you can get the batteries and a recharging stand for a good price (www.thomas-distributing.com).

Figure 12.6 - The MAHA MH-C801D battery charger (www.thomas-distributing.com)

Figure 12.7 - Delkin Devices' eFilm Lithium ion rechargeable CR-123 batteries are a great fit for the SU-800 and SB-R200 (www.delkin.com)

Camera-Based Functions for Your Flash

This chapter covers the settings you can make in your Nikon SLR that affect flash photography. Each of them is important to know, and many of them can help improve your photographs. Let's go through them one by one.

FV Lock

FV Lock stands for Flash Value Lock, a feature that allows you to set the flash output value once and continue shooting while retaining the same flash output. Nikon bills it as a way to set the exposure with the subject in the center of the frame, and then recompose the picture so the lighting is accurate when the person is off-center (see graphic below).

I have found a different use for FV Lock that helps prevent people's eyes from closing during the normal iTTL pre-flash. Sometimes the pre-flashes cause people to close their eyes before the *real* flash (figure 13.1). When you push the FV Lock button (figures 13.2 and 13.3), the flash fires a pre-flash that the camera subsequently remembers. Then, you can continue shooting *without* the pre-flashes.

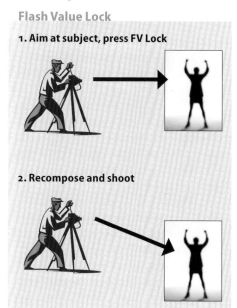

Flash Value Lock

1. Aim at subject, press FV Lock

2. Recompose and shoot

Figure 13.1 - Sometimes Nikon pre-flashes cause your subjects to close their eyes. Use FV Lock to prevent this problem!

Figure 13.2 - Here is the FUNC button on the D300

Figure 13.3 - Here is the AE-L/AF-L button on the D80

FV Lock Button by Camera Model

Camera Model	Camera Button to Activate	How to Activate FV Lock
D40, D40x, D60	N/A	N/A
D50	AE-L/AF-L	CSM 14
D70	AE-L/AF-L	CSM 15
D80	AE-L/AF-L or FUNC	CSM 16 or CSM 18
D90, D200, D300, D700	FUNC	CSM f4
D2-series,		
D3-series	FUNC	CSM f4
F6	FUNC	CSM f4

Table 13.1

To access the FV Lock button, go into your camera's Custom Settings Menus. Table 13.1 shows how to activate FV Lock for various Nikon cameras.

Here's how to use the setting:

1. Turn on flash
2. Aim camera at subject
3. Push FV Lock button (FUNC or AE-L/AF-L button). The flash will fire once. This is the pre-flash.
4. Recompose photograph as necessary
5. Take picture

You can continue taking pictures with this FV Lock setting, and the camera won't perform any more pre-flashes. If you want to cancel the FV Lock value, just press the FV Lock button again to clear the camera's memory.

Auto FP High Speed Sync Mode

When you take photos in brighter light, you can exceed your camera's maximum shutter synchronization speed. Every camera body has a maximum shutter sync speed, and the value differs depending on which model you own. For example, the D70 has a maximum shutter sync speed of 1/500 second, while the D3 has a maximum shutter sync speed of 1/250 second (table 13.2).

While these shutter sync speeds are relatively fast (at least by historical standards), they do severely limit you when you want to use fill flash on bright, sunny days. Nikon has provided a way around this issue on its higher-end cameras called Auto FP High Speed Sync. This mode allows you to have full TTL control of your flashes at shutter speeds faster than Normal Sync speed (i.e., 1/250 second). The D300 and D700 allow you to shoot at up to 1/320 second in Auto FP. The only downside is that the flash works at a lower power output, but I don't see any reason not to use this setting.

How to Activate Auto FP High Speed Sync by Camera Model

Camera Model	Maximum Shutter Sync Speed (in seconds)	Auto FP High Speed Sync Capability	How to Activate Auto FP High Speed Sync
D50	1/500	No	N/A
D40, D40x, D60	1/200	No	N/A
D70	1/500	No	N/A
D80	1/200	Yes	CSM 25
D90	1/200	Yes	CSM e5
D200	1/250	Yes	CSM e1
D300, D700	1/250 1/320 (with reduced GN)	Yes	CSM e1
D2-series, D3-series	1/250	Yes	CSM e1
F6	1/250	Yes	CSM e1

Table 13.2

The D40, D50, D60, and D70 do not have the ability to activate Auto FP. It is only available on the D80, D90, D200, D300, D700, D2-series, D3-series, and F6. For those camera bodies, activate Auto FP High Speed Sync by going into the Custom Settings Menus and selecting Auto FP. Table 13.2 shows how to activate Auto FP High Speed Sync for your camera.

Auto FP High Speed Sync is only active and available when you mount an external Dedicated flash on your camera, such as an SB-600, SB-800, or SB-900. This is important

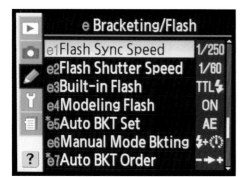

Figure 13.4 - On the D200, D300, D700, D2, and D3 cameras, change CSM e1 to add Auto FP High Speed Sync

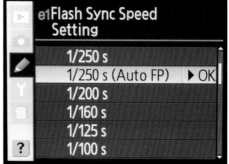

Figure 13.5 - Choose 1/250 second (Auto FP) for TTL photography at shutter speeds faster than 1/250 second. The D300 and D700 allow you to choose 1/320 second Auto FP as well.

for D80, D90, D200, D300, and D700 owners because Auto FP High Speed Sync won't work with the camera's pop-up flash. It also means that if you use the pop-up flash as a Commander, the fastest sync speed available is 1/250 second (or 1/200 second on the D80).

You can still use a flash in Commander mode on the D80, D90, D200, D300, D700, D2, D3, or F6 and utilize Auto FP High Speed Sync for the wireless Remote flashes.

NOTE

One final note about this function: once you make the change in your camera's Custom Settings Menus, your flash shows a new FP icon on the LCD (figures 13.6, 13.7, and 13.8). This is your indication that Auto FP High Speed Sync is active. You can now synchronize the TTL flash up to shutter speeds of 1/8000 second for those fast action photos!

Figure 13.6 - The new screen on the SB-600 after you select Auto FP

Figure 13.7 - The new screen on the SB-800 after you select Auto FP

Flash Sync Speed

Flash Sync Speed represents the maximum, or fastest, shutter speed your camera will use in any flash sync mode (figure 13.9). Most of the time, you want to set it either at the fastest standard shutter speed, or for Auto FP High Speed Sync (as in the section above), to get even faster shutter speeds for sports photography.

The D40, D40x, D50, D60, D70, D80, and D90 do not allow you to change this setting in the Custom Settings Menus. The D200, D300, D700, D2, D3, and F6 do allow you to make this change by setting CSM e1. The range of settings on these cameras for CSM e1 is from 1/60 second to 1/250 second, including Auto FP High Speed Sync (again, see previous section).

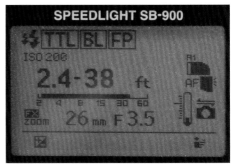

Figure 13.8 - The new screen on the SB-900 after you select Auto FP

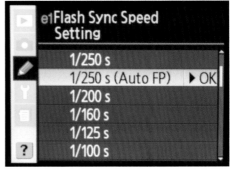

Figure 13.9 - Flash Sync Speed is normally the fastest shutter speed that will synchronize with your flash

I recommend leaving this value set for Auto FP High Speed Sync for most of your photography, unless you have a specific reason to limit your shooting to a slower sync speed.

Flash Shutter Speed

Flash Shutter Speed represents the minimum (slowest) shutter speed your camera will use when it is set for Normal Sync mode (see chapter 3). You might also refer to this as your "studio sync" speed.

For years, many studio photographers have synced at 1/60 second, which has become somewhat standard. However, some photographers like to sync at different speeds. Some choose 1/125 second or 1/250 second to eliminate as much ambient light as possible. Other photographers like to sync at 1/15 second to "drag the shutter", which lets in some ambient light.

There is no correct sync speed, but if you want an easy answer, I suggest you just leave the camera set to the default: 1/60 second. Table 13.3 shows how to access this screen on your camera, and figure 13.10 shows an example screen shot of CSM e2.

Flash Shutter Speed Settings by Camera Model

Camera Model	CSM Setting (in camera menu)
D40, D40x, D60	N/A (default is 1/60 second)
D50	N/A (default is 1/60 second)
D70	CSM 21
D80	CSM 24
D90	CSM e1
D200, D300, D700	CSM e2
D2-series, D3-series	CSM e2
F6	CSM e2

Table 13.3

Figure 13.10 - CSM e2 defines what your slowest (longest) shutter speed will be when you shoot in Normal Sync mode. I typically leave all my cameras set to 1/60 second.

Flash Off

There are many times when your flash is mounted on your camera and you want to take a picture without the flash firing. Normally, you just turn the flash off and then take the picture. Easy, right?

Well, it gets even easier: on the higher-end Nikons like the D200, D300, D700, D2, and D3, you can program the FUNC button to temporarily deactivate the flash while you are pressing it (figure 13.11). For example, at a wedding you might see a great photo of the bride that would look better in ambient light. It is much quicker to press the FUNC button to disable the flash rather than reaching up to turn it off. Really, it's just a speed thing that helps you work more efficiently. Table 13.4 shows how to program the FUNC button to cancel the flash.

Figure 13.11 - This is the FUNC button on the D2X. You can configure it to cancel the flash when an SB-600, SB-800, or SB-900 is attached.

How to Activate Flash Off by Camera Model

Camera Model	Button to Activate Flash Off	CSM Setting (in camera menu)
D40, D40x, D50, D60, D70	N/A	N/A
D80	FUNC	CSM 16
D90	FUNC	CSM f3
D200, D300, D700	FUNC	CSM f4
D2-series, D3-series	FUNC	CSM f4
F6	FUNC	CSM f3

Table 13.4

Modeling Light with DOF Preview Button

As you already know (because you read this entire book from start to finish!), the SB-800 and SB-900 activate a Modeling Light when you push the Modeling Light button on the back of the flash.

The higher-end Nikon SLRs also allow you to activate the Modeling Light by pressing the Depth of Focus (DOF) Preview button. This works with an SB-600, SB-800, or SB-900 mounted on the camera. Also, pressing the DOF Preview button activates all of the wireless flashes together (figure 13.12).

To activate the Modeling Light function, you must go into your camera's Custom Settings Menus and turn it on (table 13.5).

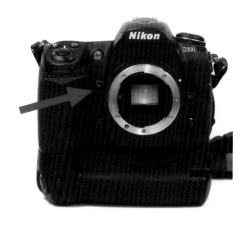

Figure 13.12 - Pressing the DOF Preview button on the D80, D90, D200, D300, D700, D2, D3, or F6 activates the flash's Modeling Light

How to Activate Modeling Light by Camera Model

Camera Model	Button to Activate Modeling Light	CSM Setting (in camera menu)
D40, D40x, D50, D60, D70	N/A	N/A
D80	DOF Preview	CSM 26
D90	DOF Preview	CSM e3
D200, D300, D700	DOF Preview	CSM e4
D2-series, D3-series	DOF Preview	CSM e4
F6	DOF Preview	CSM e4

Table 13.5

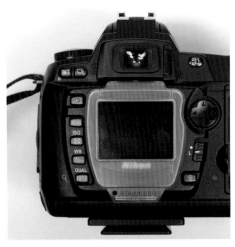

Figure 13.13 - D70 BKT button

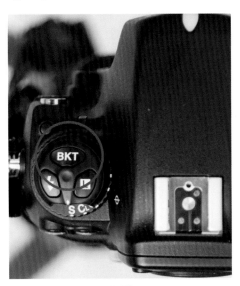

Figure 13.14 - D2 or D3 BKT button

Figure 13.15 - D200 BKT button

Flash Bracketing

I'm not talking about using a bracket to hold the flash; I'm talking about bracketing your flash exposures by using the camera's automatic bracketing capability. Each of the modern Nikon cameras has an auto bracketing function. Turn it on by pressing the Bracket (BKT) button on the top of your camera and rotating the command dials (figures 13.13, 13.14, 13.15).

Before you use the bracketing function, you need to set up your camera so it brackets according to your wishes. Table 13.6 shows how to do this.

How to Activate Flash Off by Camera Model

Camera Model	CSM Setting (in camera menu)
D40, D40x, D60	N/A (camera does not support bracketing)
D50, D70	CSM 12
D80	CSM 13
D90	CSM e4
D200, D300, D700	CSM e5
D2-series, D3-series	CSM e5
F6	CSM e5

Table 13.6

Note that you can choose from these bracketing settings:

- AE & Flash
- AE Only
- Flash Only
- WB Bracketing

Most of the time when you bracket, you will use Exposure Bracketing, called AE Only (figure 13.18). In other words, you vary the shutter speed or aperture to generate a series of shots that are darker, medium, and brighter.

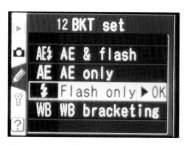

Figure 13.16 - CSM 12 on the D70

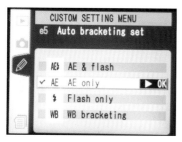

Figure 13.17 - CSM e5 on the D2X. Choose Flash Only to bracket just the flash output. AE Only keeps flash output constant but changes your shutter speed for each picture, as shown in figure 13.24.

Figure 13.18 - This is an Exposure Bracketing (AE Only) sequence. The top picture was taken at f/5.6, 1/125 second; the picture in the middle was taken at f/5.6, 1/60 second; and the bottom picture was taken at f/5.6, 1/30 second.

In addition to Exposure Bracketing, you can also bracket (vary) the output of the flash for different photographs. If you set bracketing for Flash Only, then each photograph you take will have a different brightness of flash, but the base exposure (shutter speed and aperture) will remain constant throughout the sequence. Figure 13.19 shows this sequence. If you choose AE & Flash, the camera will vary the exposure (shutter speed and aperture) as well as the flash output.

Invariably, the question arises: How should I set bracketing up for real-world shooting? My answer is you typically won't use flash bracketing for real-world shooting unless your subject is very still. Flash bracketing only makes sense when you have a studio arrangement or when you have a macro photography arrangement with everything attached to tripods and light stands. This is important because you don't want your subject moving around between shots.

Figure 13.19 - Here is a flash bracketing sequence. The photo at the top was taken at -1.0; the middle photo was taken at 0.0; and the bottom photo was taken at +1.0. The setup used a D200 with SB-800 and SB-600 wireless remote flashes mounted on light stands and 32-inch umbrellas. The bracketing values were programmed in the D200 Commander flash at CSM e3.

Case Studies and Examples

14

The goal of this chapter is to help you understand how to put together everything you've learned about flash photography in some common shooting scenarios.

From a philosophical standpoint, you should *generally* endeavor to make your flash photography subtle, soft, and gentle. Flash photography often turns off new photographers because they get poor results. At least once a week, a photographer makes a comment to me such as, "I don't like to use flash photography because it washes out my daughter's face", or "I get a shadow behind Grandma's head".

The truth is, there are both good and bad ways to use flash. Most of the bad ways involve on-camera flash. Most of the good ways involve getting the flash off the camera and diffusing the light.

This chapter shows you a number of real-world examples using flash photography. I describe how each shot was taken, breaking it down to its individual elements so you can understand everything that went into each image. I cover on-camera flash, off-camera flash, remote flash, and even pop-up flash. Here goes!

Event Photography: On-Camera Flash Combined with Ambient Window Light

Event photography can include weddings, family reunions, high school dances, or golf tournaments. At these events, you typically want a fairly lightweight, portable setup so you can mingle with the crowd to get shots of the action.

In general, I recommend using a flash bracket to get some separation between the camera and the strobe. However, there are many times when you have to settle for mounting the flash on the camera's hot shoe. When this situation arises, use a diffusion dome or a bounce card, or try bouncing the flash off the ceiling or wall. Also, if there is window light, you can blend your flash with the ambient light to get very nice results.

The image in figure 14.2 was taken at a wedding with a D2X and Dedicated SB-800 mounted directly on the camera. I used a diffusion dome and pointed the flash head up toward the ceiling. I set the flash for TTL BL and dialed the power way down to about -1.7 so the fill was very subtle. Also, I made sure to rotate the camera so the flash was on the left side of the image, to fill in the shaded side of her face.

I set the camera for Aperture priority and Slow + Rear Sync to allow for a mix of ambient light and flash. In addition, I set the ISO to 400 for faster shutter speed so I could hand-hold the camera.

Figure 14.2

Setup Details

- Camera: D2X
- Exposure Mode: Aperture Priority
- Meter Mode: Matrix
- Aperture: f/2.8
- Shutter Speed: 1/200 second
- ISO: 400
- White Balance: Cloudy -1
- Lens: 80-200 mm f/2.8
- Sync: Slow + Rear
- Flash: SB-800
- Flash Mode: TTL BL
- Flash Comp: -1.7
- Accessories: Diffusion dome
- Image Quality: JPEG Fine Large

Event Photography: Single Flash on Flash Bracket in Low Light Situations

Unfortunately, quite a few public events take place in dark rooms. I run into this situation when I photograph birthday parties, Christmas dinners, and most weddings. In these scenarios, there isn't much ambient light, and I am left using just my flash. I really like to utilize a flash bracket to get adequate height separation between the flash and the lens.

To make the shot in figure 14.3, I used a Stroboframe Quick Flip flash bracket and an SB-800 flash. Since it is a vertical shot, I rotated the bracket so the flash was above the camera. I also had a diffusion dome attached to the SB-800 to soften the light. I decided not to bounce the flash off the ceiling since it was about 20 feet high and yellowish in color. Instead, I aimed the diffusion dome directly at the bride. (If I had bounced the flash off the ceiling, the images would have been too yellow.)

Also, since the ambient light was so low, I was concerned about a long shutter speed. To remedy this, I changed the shutter sync to Normal, which defaults the shutter speed to 1/60 second. I had the bride pretend to throw the bouquet and took the shot.

This shot also demonstrates that you can get very nice results even at ISO 800. Don't be afraid to use higher ISOs in order to get your shot.

Figure 14.3

Setup Details

- Camera: D2X
- Exposure Mode: Aperture Priority
- Meter Mode: Matrix
- Aperture: f/5.0
- Shutter Speed: 1/60 second
- ISO: 800
- White Balance: Flash
- Lens: 24-120 mm f/4-5.6
- Sync: Normal
- Flash: SB-800
- Flash Mode: TTL BL
- Flash Comp: 0.0
- Accessories: Diffusion dome, SC-17 TTL cord, Stroboframe Quick Flip flash bracket
- Image Quality: JPEG Fine Large

Travel Photography: Single Dedicated Flash on TTL Cable

Overcast days are a photographer's best friend when it comes to outdoor photography because they provide nice, low contrast lighting. However, this lighting can frequently result in dark eye sockets when photographing people. To avoid this problem, it helps to use some type of fill flash.

The photo in figure 13.4 was taken at a pumpkin patch on a cloudy day in October. I used a D70 with an SB-600 flash attached to an SC-17 TTL cord. In order to provide a little bit of fill light I hand-held the flash above my head and off to the left. The flash mode was TTL BL and the power was set to -1.7, so the flash was subtle.

Holding the flash up high makes any resulting shadow fall behind and below the subject. Even in bright situations like this, you can sometimes see the shadow in the background, so I like to do as much as I can to eliminate it.

I used a white balance of Cloudy -1 to add some warmth to the cool blue light from the overcast sky.

Since the D70 has a very fast shutter sync speed of 1/500 second, I could shoot the image at 1/400 second and not worry about blowing out the image with the flash. Other cameras like the D200 and D2X need to be configured for Auto FP High Speed Sync (CSM e1) to shoot faster than 1/250 second with flash.

Figure 14.4

Setup Details

- Camera: D70
- Exposure Mode: Aperture Priority
- Meter Mode: Matrix
- Aperture: f/5.6
- Shutter Speed: 1/400 second
- ISO: 200
- White Balance: Cloudy -1
- Lens: 24-120 mm f/4-5.6
- Sync: Slow + Rear
- Flash: SB-600
- Flash Mode: TTL BL
- Flash Comp: -1.7
- Accessories: Sto-Fen diffusion dome, SC-17 TTL cord
- Image Quality: JPEG Fine Large

Travel Photography: Single Dedicated Flash on TTL Cable

I like to take many of my travel photos after sunset. About 30-45 minutes after the sun drops below the horizon, the sky turns a deep blue color and provides a perfect backdrop for silhouettes.

I also like to travel as light as possible, so I don't generally take much lighting equipment with me on the road. My bag is usually loaded with one or two cameras, three lenses, and one or two flashes.

The image in figure 14.5 was taken in Ft. Lauderdale, Florida with a D2X and a Dedicated SB-800 flash. I attached the flash to an SC-17 TTL cord and held it with my right hand as high as possible above the grass. I used my left hand to trip the shutter.

With a 12-24 mm lens mounted, I set the camera down in the grass and started firing away. Because I couldn't look through the viewfinder, I had to guess on the composition for each image. I took a number of shots before everything came together in terms of the level horizon, the trees, and the appropriate exposure.

The flash was set to TTL BL and -0.3. I kept the flash power a little bit high because I wanted some of the light to fall on the closest palm tree.

Figure 14.5

Setup Details

- Camera: D2X
- Exposure Mode: Aperture Priority
- Meter Mode: Matrix
- Aperture: f/5.6
- Shutter Speed: 1/15 second
- ISO: 250
- White Balance: Cloudy -1
- Lens: 12-24 mm f/4
- Sync: Slow + Rear
- Flash: SB-800
- Flash Mode: TTL BL
- Flash Comp: -0.3
- Accessories: Diffusion dome, SC-17 TTL cord
- Image Quality: NEF (RAW)

Travel Photography: D200 Commander and SB-800 Wireless Remote

Shots like the one in figure 14.6 are actually pretty complicated. The reason is because there is such a wide contrast range, in this case between the white clouds and the dark shadows under the shark. I wanted to fill in the shadows with fill flash. If I let the camera do all the thinking for the exposure and flash output, it would have underexposed this image and I would have had to bring it into Photoshop for post-processing.

To make this shot, I set up the D200's pop-up flash as a Commander unit (CSM e3). Then, I used an SB-800 as a TTL Remote unit and dialed down the power to -0.7 by using the D200's CSM e3.

In addition, I increased the camera's exposure compensation to +1.0, which increased the amount of ambient light coming into the camera. I did this in order to make the clouds appear bright white. This is an important step, because the TTL system on cameras tends to make bright white scenes come out a bit underexposed.

To summarize, I used flash compensation at -0.7 to provide a nice fill flash for the shadows, and camera exposure compensation at +1.0 to make the clouds and building bright white.

Use this same approach for photographing bright snow or sunny beaches.

Figure 14.6

Setup Details

- Camera: D200
- Exposure Mode: Aperture Priority
- Meter Mode: Matrix
- Aperture: f/8
- Shutter Speed: 1/180 second
- ISO: 100
- White Balance: Cloudy -1
- Lens: 12-24 mm f/4
- Sync: Slow + Rear
- Flash: SB-800
- Flash Mode: TTL BL
- Flash Comp: -0.7
- Camera Exposure Comp: +1.0
- Accessories: Diffusion dome, SC-17 TTL cord
- Image Quality: JPEG Fine Large

Residential Scene: Commander and Remote

I wanted to get this high contrast residential scene to fall into the dynamic range (brightness range) of the D2X image sensor. Since the flowers in the foreground were in the shade of a tree, I knew fill flash would be required to get a usable shot.

I mounted an SB-800 as a Commander on the D2X and then hand-held a Remote SB-600 up high and to the left. The Commander unit was set for - - - (Off) so that it wouldn't contribute to the final exposure.

I also wanted to keep some good detail in the clouds, so I underexposed the ambient light a little bit. Normally, I would set the exposure (shutter speed and aperture) so the clouds were exposed at +1.7 stops, but in this case I held them at about +1 so they were a bit dark. I set the flash compensation at -0.7 so it wouldn't blow out the details in the red tulips.

Since this type of shot needs maximum depth of field, I would normally set the aperture for f/22. However, the wind was blowing and I didn't want to risk any motion blur in the flowers, so I set the aperture for f/14 in order to get a 1/60 second shutter speed.

Figure 14.7

Setup Details

- Camera: D2X
- Exposure Mode: Aperture Priority
- Meter Mode: Matrix
- Aperture: f/14
- Shutter Speed: 1/60 second
- ISO: 100
- White Balance: Cloudy -1
- Lens: 12-24 mm f/4
- Sync: Slow + Rear
- Commander Flash: SB-800 set to - - -
- Remote Flash: SB-600 set to TTL BL, -0.7
- Camera Exposure Comp: +1.0
- Accessories: Diffusion dome
- Image Quality: NEF (RAW)

Outdoor Portrait: Pop-up Flash

As much as I dislike using the pop-up flash for my photos, there are times when circumstances demand it. I was at a wedding doing video work for a family member and wasn't the hired photographer. My wife was there taking general photos with a D70 and didn't have an SB-600 or SB-800, so she took the image shown in figure 14.8 with just the D70's pop-up flash.

The flower girl was looking very pretty that day, but the sun was out and it was about 12:00 noon. So, my wife took the flower girl underneath a large tree for some soft shade light. Then, she set the D70 sync to Slow + Red-eye and used the pop-up flash at -2.7 output. This was done so that the pop-up flash power would be very low and the resulting photograph would show just a hint of fill flash. This is the key to using the pop-up flash: dial the power way down.

The result is a very nicely exposed image, and the flash is very subtle.

Figure 14.8

Setup Details
- Camera: D70
- Exposure Mode: Aperture Priority
- Meter Mode: Matrix
- Aperture: f/5.3
- Shutter Speed: 1/500 second
- ISO: 400
- White Balance: Auto
- Lens: 24-120 mm f/4-5.6
- Sync: Slow + Red-eye
- Flash: D70 pop-up
- Flash Mode: TTL
- Flash Comp: -2.7
- Camera Exposure Comp: +0.0
- Accessories: None
- Image Quality: JPEG Fine Large

Outdoor Portrait: Single Flash as Remote, D200 as Commander

You can take great portraits with just one Remote flash off-camera. In this situation (figure 14.9), I had the subject stand partially underneath a tree to provide nice, soft light. I then used an SB-800 Remote flash powered at -1.7 to provide a little bit of fill for the eyes. The Commander unit was a D200 and I set the pop-up flash to - - - so that it wouldn't fire during the actual exposure.

I used Slow + Rear for the shutter sync just in case there was any motion blur (if there was, it would have blurred to the rear of the motion, which looks natural).

As always, I used a diffusion dome on the hand-held SB-800 to soften the light. I also used Cloudy -1 for my white balance so that the subjects would look nice and warm.

Figure 14.9

Setup Details

- Camera: D200
- Exposure Mode: Aperture Priority
- Meter Mode: Matrix
- Aperture: f/2.8
- Shutter Speed: 1/250 second
- ISO: 200
- White Balance: Cloudy -1
- Lens: 80-200 mm f/2.8
- Sync: Slow + Rear
- Flash: D200 Commander and SB-800 Remote
- Flash Mode: TTL
- Flash Comp: -1.7
- Camera Exposure Comp: 0.0
- Accessories: Diffusion dome mounted to SB-800 Remote
- Image Quality: JPEG Fine Large

Outdoor Portrait: One Commander, Multiple Remotes

The great thing about Nikon's Creative Lighting System is how easy it is to quickly set up a photograph. The image at right was taken outdoors with three Remote Speedlights: a key light on the right, a fill light on the left, and a hair light in the background.

This image (figure 14.10) was taken with a D2X, an SB-800 Commander, and three wireless Remote flashes. I used Manual exposure and set the ambient light exposure to 1/125 at f/8. This effectively darkened the background trees so they were about 1.3 stops below a medium exposure (0.0). I did this to make the subject have good separation from the background.

Then, I added the flashes. The key light (flash on the right) was set at TTL + 1.3. The fill light (flash on the left) was set to TTL +0.3. The hair light (flash in back) was set to M 1/64.

I placed a twig on the ground where I wanted my young model to stand and then went about taking pictures. Total time for setup, photos, and takedown was about 15 minutes. That's fantastic!

Setup Details
- Camera: D2X
- Exposure Mode: Manual
- Meter Mode: Matrix
- Aperture: 8
- Shutter Speed: 1/125 second
- ISO: 400
- White Balance: Cloudy
- Lens: 24-120 mm f/4-5.6
- Sync: Slow
- Commander Flash: SB-800 set to - - -
- Key light (right): SB-800 TTL +1.3
- Fill light (left): SB-600 TTL +0.3
- Hair light (back): SB-800 M 1/64
- Accessories: three light stands, two 32-inch umbrellas
- Image Quality: JPEG Fine Large

Figure 14.10

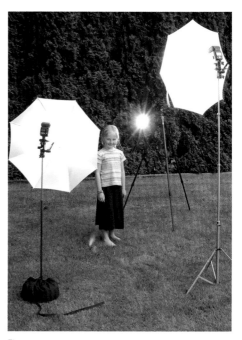

Figure 14.11

Indoor Portrait: Single Commander on Cable and Single Flash as Remote

If you ever decide to add an additional flash to your kit, then I highly recommend purchasing a TTL cable as well. A TTL cable allows you to place the Commander flash in an umbrella and then use the second flash as a wireless Remote in its own umbrella.

This image (figure 14.12) was a Christmas portrait of the young lady for her mother. I set up a short stool about six feet away from my background (a white bed sheet). The lights I used for this were the SB-600 and the SB-800. The SB-800 Commander was connected to my D70 with an SC-17 TTL cable and then mounted on a light stand with a 32-inch umbrella. The SB-600 remote was positioned to the left side on a light stand behind an umbrella. I also used a 42-inch gold reflector on the lower left (you can see the third catch light in the girl's eyes).

I set all the flashes for Manual output so the TTL system wouldn't be confused by the bright white portion of her dress.

The photo at the lower right shows this setup without the umbrellas.

Figure 14.12

Setup Details
- Camera: D70
- Exposure Mode: Manual
- Meter Mode: Matrix
- Aperture: f/5.6
- Shutter Speed: 1/60 second
- ISO: 200
- White Balance: Custom (using a gray card)
- Lens: 24-120 mm f/4-5.6
- Sync: Normal
- Flash1: SB-800 Commander on cable, Manual 1/4 power
- Flash 2: SB-600 Wireless Remote, 1/8 +0.3
- Accessories: Two 32-inch umbrellas, SC-17 TTL cord, two light stands, 42-inch gold reflector
- Background: White queen-sized bed sheet duct taped to wall
- Image Quality: JPEG Fine Large

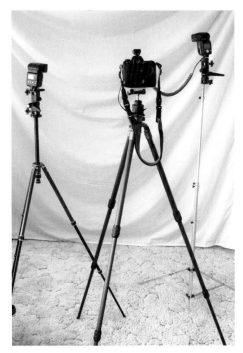

Figure 14.12.5

Indoor Portrait: Commander and Multiple Remotes

Here is a portrait that utilized a total of four Speedlights. The image was taken at a hotel, and the background was a white wall. The subject was positioned about six feet away from the wall.

The image was captured with a D70 with an SB-800 Commander flash mounted on the camera's hot shoe. I wanted to have a little bit more drama in terms of light and shadow, so I dialed the fill flash on the right (Group B) down pretty low.

Flash 1 (Group A) was positioned to the left side and was set as a TTL unit at +1.3. It was mounted on a light stand and shot through a 32-inch umbrella.

Flash 2 (Group B) was positioned to the right side as TTL -0.3. I intentionally dialed the power down to create a nice shadow effect on the side of his face. It was mounted on a light stand and shot through a 32-inch umbrella.

Flash 3 (Group C) was set on a stand at 1/16 power and pointed at the background. I used a red gel to turn the white wall a brilliant red.

Figure 14.13

Setup Details
- Camera: D70
- Exposure Mode: Aperture Priority
- Meter Mode: Matrix
- Aperture: f/3.5
- Shutter Speed: 1/60 second
- ISO: 320
- White Balance: Flash
- Lens: 80-200 mm f/2.8
- Sync: Normal
- Commander Flash: SB-800 set to - - -
- Remote Flash 1, left side: Group A, SB-800, TTL, +1.3
- Remote Flash 2, right side: Group B, SB-600, TTL, -0.3
- Remote Flash 3, background: Group C, SB-600, Manual, 1/16
- Camera Exposure Comp: 0.0
- Accessories: Three light stands, two 32-inch umbrellas for the key and fill flashes, red gel for the background SB-600
- Image Quality: JPEG Fine Large

Product Shot: Multiple Remote Flashes

I like tools. This is an old belt sander that my father gave me many years ago (figure 14.14). It makes a great industrial product shot.

I used four flashes for this shot: an SB-800 Commander on my D200 set for - - -; an SB-800 Remote on the left side set for Manual; an SB-600 Remote on right side set for Manual; and an SB-800 Remote in the back set for Manual with a blue gel.

The two front flashes were set up behind umbrellas and positioned on light stands. I added a blue gel for the rear flash and attached it to a plastic clamp that I modified with threaded bolts (see chapter 13).

Setup Details

- Camera: D200
- Exposure Mode: Manual
- Meter Mode: Matrix
- Aperture: f/8
- Shutter Speed: 1/60 second
- ISO: 400
- White Balance: Flash
- Lens: 24-120 mm f/4-5.6
- Sync: Normal
- Commander Flash: SB-800 set to - - -
- Remote Flash 1, left side: Group A, SB-800, Manual, 1/16 +0.7
- Remote Flash 2, right side: Group B, SB-600, Manual, 1/16 +0.7
- Remote Flash 3, background: Group C, SB-800, Manual, 1/64 -0.7
- Camera Exposure Comp: 0.0
- Accessories: two light stands, two 32-inch umbrellas, one plastic clamp, blue gel for the background SB-600
- Image Quality: NEF (RAW)

Figure 14.14

Macro Photography: Two Remotes, D200 as Commander

Using Nikon's wireless flashes for macro work is a dream come true. Setting up the flashes is quick, and changing the power ratios on each is simple.

The D200 pop-up flash can be configured as a Commander unit and can control two Remote groups. I made these adjustments at CSM e3.

In this image of a flower, I placed an SB-800 Remote on a Bogen Superclamp and attached it to my tripod leg. On the other side, I placed an SB-600 Remote on a small travel tripod. I programmed the SB-800 as a TTL flash at 0.0 and the SB-600 as a TTL flash at -0.7. Both remote flashes had diffusion domes. I set the D200 pop-up Commander for - - - and hand-held the camera during the shot.

Setup Details

- Camera: D200
- Exposure Mode: Aperture Priority
- Meter Mode: Matrix
- Aperture: f/5.6
- Shutter Speed: 1/80 second
- ISO: 400
- White Balance: Flash
- Lens: 24-120 mm f/4-5.6
- Sync: Normal
- Commander Flash: D200 set to - - -
- Remote Flash 1, left side: Group A, SB-800, TTL, +0.0
- Remote Flash 2, right side: Group B, SB-600, TTL, -0.7
- Camera Exposure Comp: 0.0
- Accessories: Bogen Superclamp, two diffusion domes, small table-top tripod
- Image Quality: NEF (RAW)

Figure 14.15

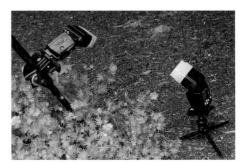

Figure 14.15

Lighting Kit and Product Recommendations

Here are some simple kit recommendations for those who want to put together a lighting system. This page summarizes each kit, and the next few pages show which products I recommend (and use).

Kit Recommendations

Economy Kit
- 1 flash (SB-600)
- 1 stand (8 feet)
- 1 umbrella
- 1 umbrella bracket

Lightweight Location Kit
- 2 flashes (SB-800 plus an SB-600 or SB-900)
- 2 stands (12 feet)
- 2 umbrellas (32 inches)
- 1 gold/white reflector (42 inches)
- 2 umbrella brackets

Lightweight Event Photography Kit
- 1 flash (SB-800 or SB-900)
- 1 TTL cable (SC-17 or SC-28)
- 1 flash bracket (Stroboframe Quick Flip)
- 1 umbrella bracket
- 1 umbrella (32 inches)
- 1 battery pack (Al Jacobs Black Box or Nikon SD-9)

Home Studio Kit
- 1 backdrop stand
- 1 Commander flash (SU-800)
- 3 flashes for key, fill, background/hair (SB-600, SB-800, or SB-900)
- 2 umbrellas (42 inches or larger)
- 1 light box
- 1 gold/white reflector (42 inches or larger)
- 2 umbrella brackets

Figure 15.1 - For this group shot I needed to get my umbrellas and SB-800 flashes up as high as possible. The tallest person's head on the top step was about 10 feet above the floor where I was standing. I used a 12-foot stand to make the shadows fall behind and below the subjects.

Product Recommendations

Light Stands

Eight-foot stands are the minimum size to buy for general use. However, even these will be too short for big events and some wedding photography. To take photographs like figure 15.1 you really need at least 12-foot stands. I recommend Bogen aluminum light stands, such as their Model 3336 (figure 15.2, www.bogenimaging.us). They are relatively lightweight and also pretty durable. You can buy them at most camera stores for around $85.

Figure 15.2 - The Bogen Model 3336 is a great 12-foot light stand for the money

Figure 15.3 - This 32-inch umbrella folds up nice and small for most of my travel and location photography needs. I use Photoflex and Westcott umbrellas.

Figure 15.4 - This is an umbrella bracket that mounts to a light stand. It is also called a shoe mount multiclamp. I use Photoflex models.

Umbrellas

Thirty-two-inch umbrellas are a great size for travel (figure 15.3). I can fit two 32-inch umbrellas in standard rolling luggage. If you are putting together a home studio, I recommend buying 42-inch umbrellas or larger. Whenever you want to diffuse the light from a flash, larger is better if you can afford it. The umbrella brands I use are from Westcott (www.fjwestcott.com) and Photoflex (www.photoflex.com).

Umbrella Brackets

Figure 15.4 shows a standard umbrella bracket, also called a shoe mount multi-clamp. They are incredibly simple and very

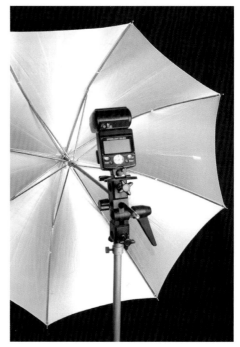

Figure 15.5 - Here's how the whole system comes together. Mount the umbrella bracket on top of the light stand. Then, insert the umbrella shaft into the bracket. Mount the flash on top of that. When you use Nikon CLS wireless flashes, this system is incredibly portable and versatile!

inexpensive. You can buy them at just about any camera store for less than $20. Their purpose is to securely hold the umbrella and flash on the top of the light stand.

Light Boxes

Many photographers prefer to use light boxes because of the clean catch light and the ability to control light spill. Because of the light box design, light lands only where you aim it, not on the background or the ceiling. There are many brands of light boxes, but I find Photoflex models to be lightweight, easy to use, and an excellent value (figure 15.6).

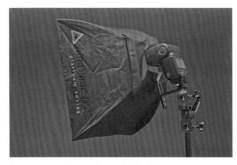

Figure 15.6 - Notice how the flash mounts onto the back of the light box. Whatever brand you purchase, make sure that you also get the metal Speedlight adapter, like this one from Photoflex, that mounts the flash to the lightbox.

Reflectors

No lighting kit can be complete without some type of reflector. I like to use a 42-inch model from Photoflex, which in my opinion is the minimum size for portraits (larger is better). The model I own is a gold/white unit: one side is gold and the other side is white. I use the white side when I photograph subjects where I don't want to influence the color–for example, very tan people who don't need additional color. I use the gold side when I think the subject needs a bit more color—for example, people who don't get a lot of sun (like me) (figure 15.7).

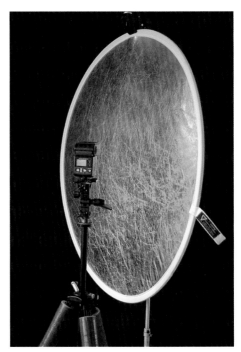

Figure 15.7 - Photoflex 42-inch reflector. I am bouncing a SB-600 Remote flash off the reflector and towards the subject—simple and effective. The reflector is held on a light stand with a Bogen Superclamp.

Clamps and Brackets

A good supply of clamps and brackets is a must for any flash photographer. You want to be able to fasten your flash to just about any object. The standard clamp used by many is the Bogen Superclamp (figures 15.8 and 15.9). It is truly a great product and built like a Sherman tank. I also own a large supply of plastic clamps that I purchase at hardware stores (figure 15.10). They hold lights, backgrounds, and reflectors with ease. I modify a few clamps by adding 1/4" x 20 threaded screws into the handle. This allows me to attach a flash to the clamp as shown in figure 15.10.

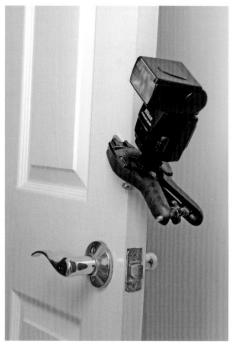

Figure 15.10 - With a simple plastic clamp, you can put a flash just about anywhere! Here, an SB-800 is attached to the clamp with an AS-19 stand.

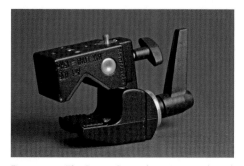

Figure 15.8 - The Bogen Superclamp is a tough and flexible product that attaches to tripod sockets, light stands, tables, doors, and more

Figure 15.11 - I purchase standard plastic clamps at hardware stores and modify them with 1/4" x 20 threaded screws to mount my flashes

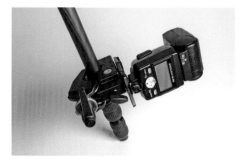

Figure 15.9 - Bogen Superclamp on the leg of a tripod. I've attached an SB-800 and the AS-19 stand that comes with it on top of the Superclamp.

Common Questions and Answers

Q: Does my D70 pop-up flash contribute to the exposure when it operates as a Commander?

A: Yes it does, but its output is very low during the final exposure so you generally don't have to worry about it too much (see next question). From a technique standpoint, the farther away you place the D70 from the subject, the less effect the pop-up flash has in the final exposure.

Q: Is there any way to eliminate the output from the D70 pop-up flash in Commander mode?

A: No. But there are a couple of simple ways to mask the output from the pop-up flash. The first method is to use the Nikon SG3-IR flash blocker. This will block the visible light from the pop-up flash and only allow UV/IR light to pass through.

The second method is similar, but much less expensive! Follow these steps:

1. Cut off a strip of exposed film leader (yes, film)
2. Tape film over front of pop-up flash
3. Take picture

Q: Does my D80, D90, D200, D300, or D700 pop-up flash contribute to the exposure when it operates as a Commander?

A: It depends. You can program the pop-up flash to be only a Commander and not contribute to the exposure by setting it for - - - in the Custom Settings Menus (CSM). Alternatively, you can have the flash contribute to the exposure by setting it for TTL or M in CSM.

Q: How do I manage Remote flashes if there are two other people in the room with D70 cameras who want to use Remote flashes?

A: Since the D70 only communicates on one frequency, Channel 3 Group A, this is a problem! There are only a couple of good solutions:

- Tell the other people to turn their Remote flashes off while you are shooting
- Buy an SB-800, SB-900, or SU-800 as a Commander so you can use different Channels and Groups

Q: Why doesn't my Remote flash fire?

A: Here are some common causes:

- Pop-up flash is in the down position
- Wrong Channel
- Wrong Group
- Remote flash is turned off
- Remote batteries are dead (READY light is not illuminated)
- Remote flash sensor is turned away from Commander flash

Q: Why does my SB-800 or SB-900 still flashes when I have it configured for - - - (Off) in Commander mode?

A: When the Commander flash is configured for - - -, you have told it not to fire only during the actual exposure. This means it won't fire when the shutter is open. The purpose of the Commander unit is to send out instructions to all of the Remote flash units through light pulses. So you still see light coming from the Commander before the exposure, but not during the exposure.

Q: Why is the background is so dark?

A: You probably have your camera set for Normal Sync. In this mode, the shutter speed defaults to 1/60 second, which is probably too fast to allow any ambient light into the camera.

Q: Why does my subject look so dark?

A: Generally, the subject looks dark because the flash does not have enough power to light it up. Here are some common ways to solve this problem:

- Get the flash closer to the subject
- Increase the power (flash compensation)
- Increase your camera's ISO
- Zoom your flash more telephoto
- Choose a larger aperture (e.g., f/2.8 or f/1.8)

Q: Why is my subject is so blurry?

A: You probably have your camera set for Slow Sync or Slow + Rear Sync. In these modes, the camera exposes for the ambient light and then pops the flash for fill flash. There are a number of ways to remedy this "problem":

- Increase your ISO
- Choose a larger aperture (e.g., f/2.8 or f/1.8)
- Tell your subject to hold still
- Change your sync mode to Normal, which will default your shutter speed to 1/60 second without necessarily exposing for the ambient light

Q: Why are my colors blue (or red or some other weird color cast)?

A: There are a couple answers to this question.

1. Your white balance isn't set correctly. If you are using flash, then you generally should set your white balance to "Flash". Then again, that isn't always the best answer, especially if you are trying to balance the colors with ambient light. See chapter 11 for more information on white balance and gel usage.
2. You are using Slow Sync, which allows lots of ambient light into the photograph. If the ambient light is blue or red or some other color, then your photograph will have that same color cast.

Q: I see my Commander flash firing, but I don't see any Remote flashes responding. I've checked Channels and Groups, but nothing works. Why?

A: This problem always happens when the Commander flash's batteries get low. Change the batteries in the Commander and everything will work just fine, assuming the Channels and Groups are all configured properly.

Q: Why does my SB-600 makes all those loud beeps, but I can't see any light coming from it?

A: Most often this is because your Commander flash is telling your SB-600 Remote to operate in AA mode. However, the SB-600 can only operate as a TTL or Manual flash when it is configured as a Remote. It does not have the ability to work in AA mode.

Q: Why don't any of the buttons on my flash work?

A: You have activated the button lock feature on your flash. For the SB-600, press the MODE and - keys simultaneously to unlock the buttons. For the SB-800, press the ON/OFF and SEL keys. For the SB-900, press Function Button 1 and Function Button 2.

Q: Why won't my flash head zoom when I place it on my camera?

A: There are a number of reasons this might be happening:

- Your Wide Angle Flash Adapter is out
- You mounted a diffusion dome on the SB-800 or SB-900
- Your flash isn't fully attached to the camera's hot shoe
- You set the flash for M Zoom
- You turned off the zoom function in the flash's Custom Settings Menus

Q: Why does my flash go into Standby mode so quickly?

A: The SB-600, SB-800, and SB900 flashes go into Standby mode quickly in order to save power. This is a good thing. They are programmed by the factory to be in Auto Standby mode, which means they power down when the camera's light meter shuts off. To change this, go into the flash's Custom Settings Menus and configure them to your wishes.

Note: the flashes won't go into Standby mode when they are configured as Wireless Remotes.

Nikonians Gold Membership

Enter the following voucher code to obtain a *50%* discount for a Nikonians Gold Membership:

~ *G2144* ~

gold

Nikonians® - *Worldwide home for Nikon users*

nikonians.org

With over 140,000 members from over 160 nations, Nikonians.org is the largest Internet community for Nikon photographers worldwide.

member

Credits for Chapter Opening Images

Chapter 1
Gerry Mulligan (Gerry M)
Nikon D300, 17-55mm f2.8,
SU-800 commander on camera.
Three SB-800 remote flashes
(left, right, below).

Chapter 2
Mike Hagen (Mike_Hagen)
Nikon D300, SB-800 remote off camera
triggered by D300 pop-up in commander
mode.

Chapter 3
James Symmonds (chimphappyhour)
Nikon D300, Tokina 12-24mm f4,
SB-800 remote with a snoot. Triggered by
D300 pop-up commander.

Chapter 4
Mike Hagen (Mike_Hagen)
Nikon D300, 12-24mm f4,
SB-800, Harbor Digital Design diffuser.

Chapter 5
Mike Hagen (Mike_Hagen)
Nikon D2X, 28-75mm f2.8,
SB-800 commander on camera,
SB-800 remote off camera in 42" umbrella.

Chapter 6
James Symmonds (chimphappyhour)
Nikon D80, Tokina 100mm macro,
two SB-800 remote flashes triggered by
D80 pop-up commander.

Chapter 7
Gerhard Rossbach
Nikon D700 and Nikon SB800 flash
with a handheld softbox

Chapter 8
Mike Pastore (Aviatorbumm)
Nikon D300, 105mm f2.8,
SB-800 commander on camera
bounced off a gold/white reflector,
SB-600 remote flash off camera
under the flower.

Chapter 9
Mike Hagen (Mike_Hagen)
Nikon D300, 28-75mm f2.8,
SB-600 flash on camera,
Sto-Fen flash diffuser.

Chapter 10
Mike Hagen (Mike_Hagen)
Nikon D70, SB-600 remote flash off
camera in 42" umbrella triggered by
D70 pop-up commander.

Chapter 11
Mike Hagen (Mike_Hagen)
Nikon D300, SU-800 commander on camera,
two SB-800 remote flashes off camera at full
power, tungsten gel on flashes to add color to
foreground.

Chapter 12
Mike Hagen (Mike_Hagen)
Nikon D700, 70-200mm f2.8,
SB-900 on camera, Nikon flash diffuser.

Chapter 13
Mike Hagen (Mike_Hagen)
Nikon D300, 28-75mm f2.8,
SU-800 commander on camera,
SB-800 remote in 32" umbrella.

Chapter 14
Gerhard Rossbach
Nikon D700 and Nikon SB800 flash
with a handheld softbox

Chapter 15
Mike Hagen (Mike_Hagen)
Nikon D300, 50mm f1.8,
SU-800 commander on camera,
two SB-800 remotes off camera in
42" umbrellas.

Chapter 16
Mike Hagen (Mike_Hagen)
Nikon D70, 70-200mm f2.8,
SB-600 on camera, Sto-Fen flash diffuser.

Index